VIENNA

Vienna is the place where crass opposites form a harmonious whole. Here on Stephansplatz Hans Hollein's postmodern Haas Haus contrasts elegantly with the Gothic cathedral and "Gründerzeit" palace.

WITH PHOTOS BY JÁNOS KALMÁR AND TEXT BY GEORG SCHWIKART

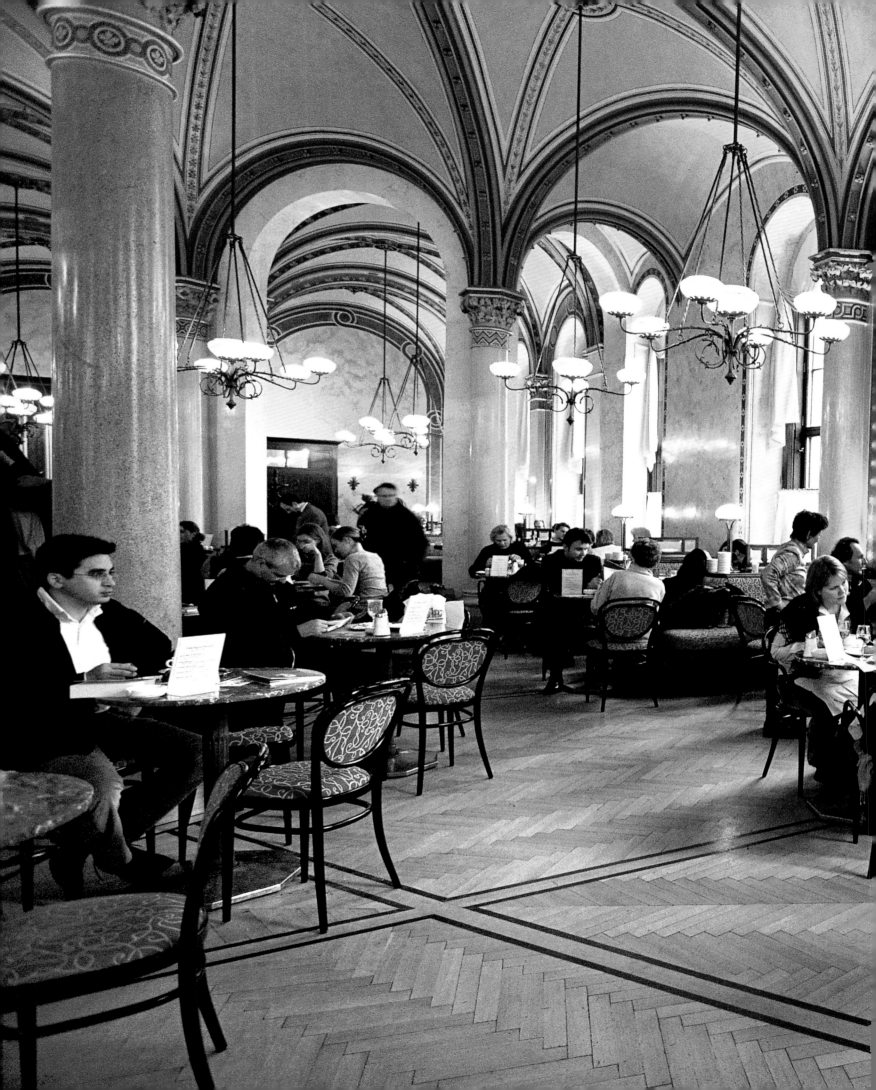

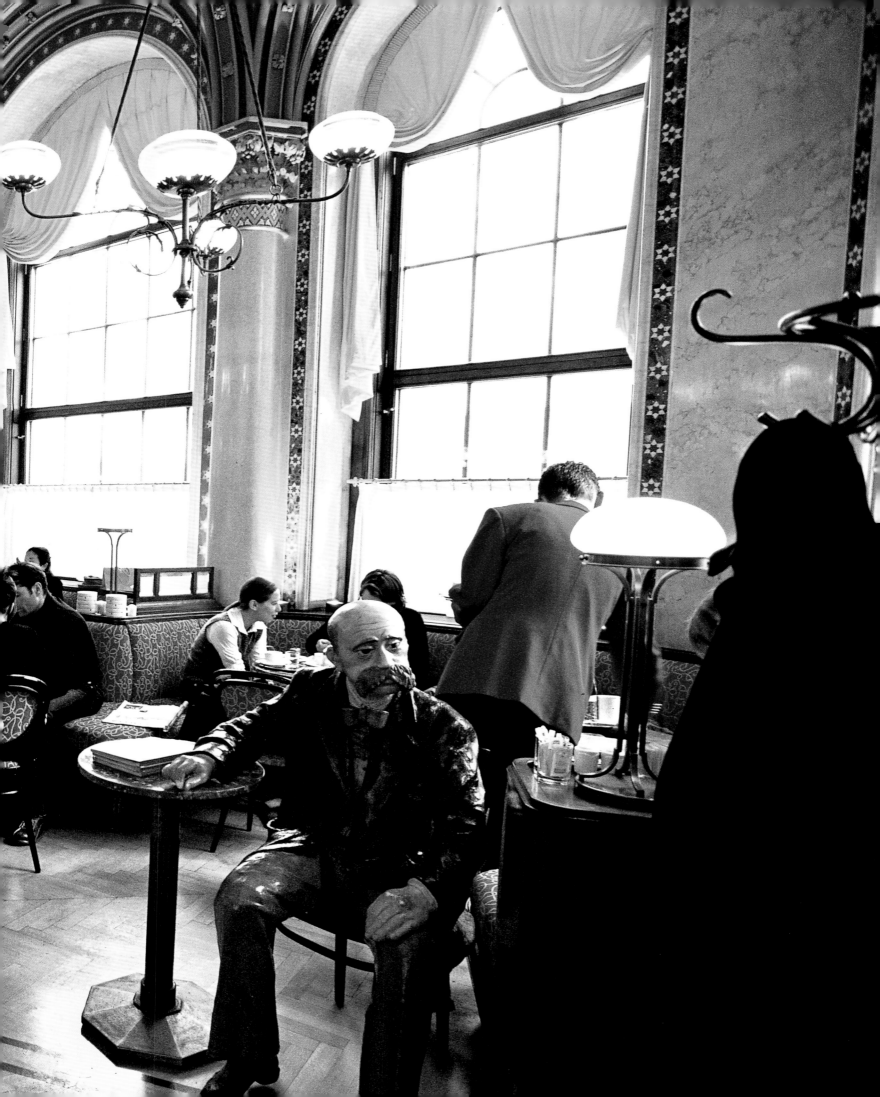

CONTENTS

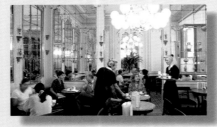
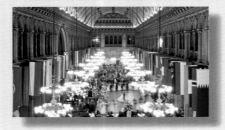

First page:
"Mozart" selling tickets for a concert. The original Wolfgang Amadeus would probably be delighted to find that his music is still enjoyed by huge audiences in the city where he once lived and worked.

Page 8/9:
The epitome of the Viennese coffee house: Café Central on Herrengasse. The table to the right of the entrance is occupied by a life-size model of poet Peter Altenberg who liked to give the café as his place of address.

Page 12/13:
Friedensreich Hundertwasser's KunstHaus-Wien is both museum and work of art. Many of the exhibits it houses are no less spectacular than the exterior.

Page 14/15:
Vienna at dusk, photographed from the roof of the Kunsthistorisches Museum (Museum of Art History), with the parliament and town hall buildings lit up. Beyond are the rolling hills of the Vienna Woods.

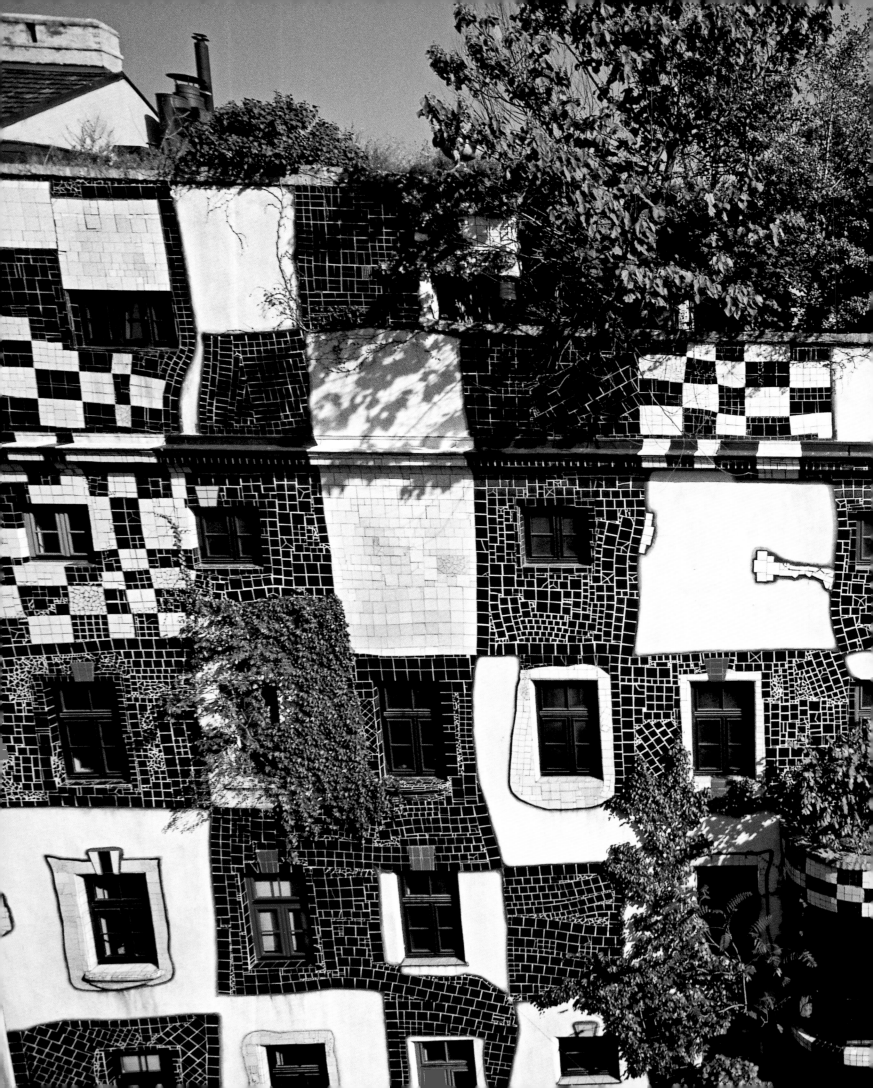

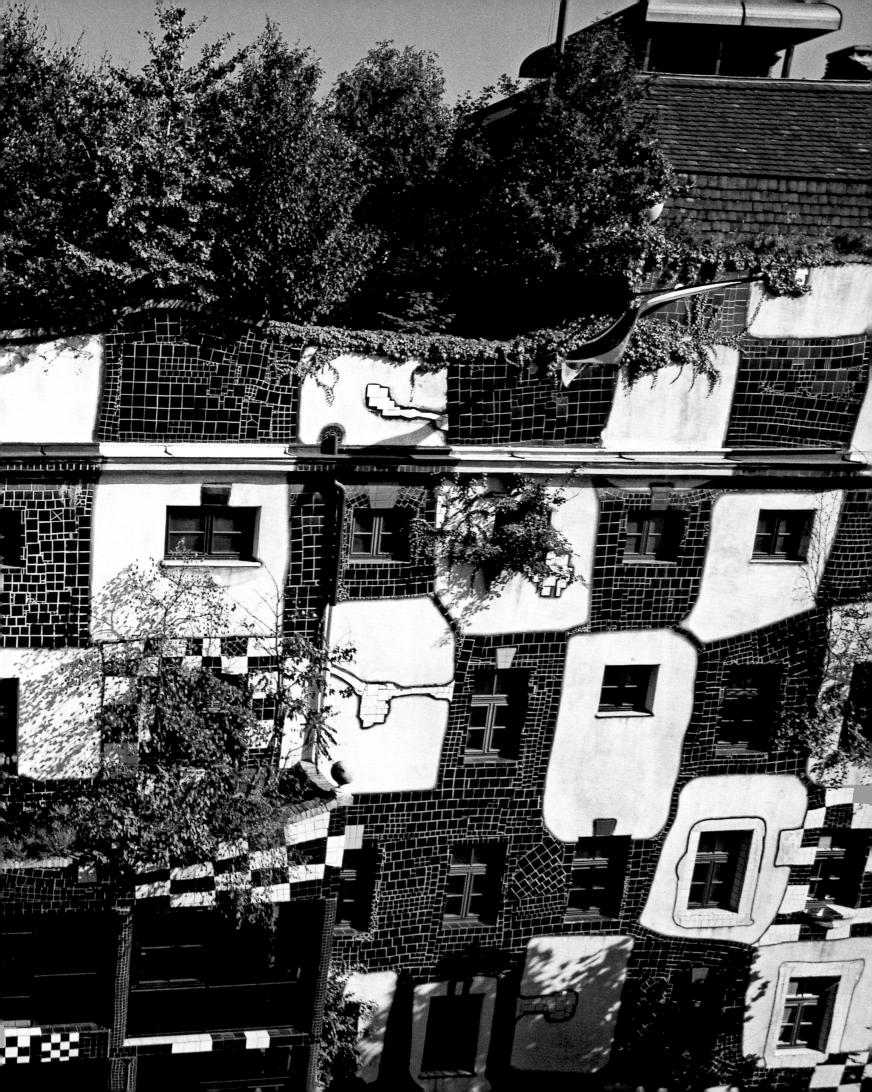

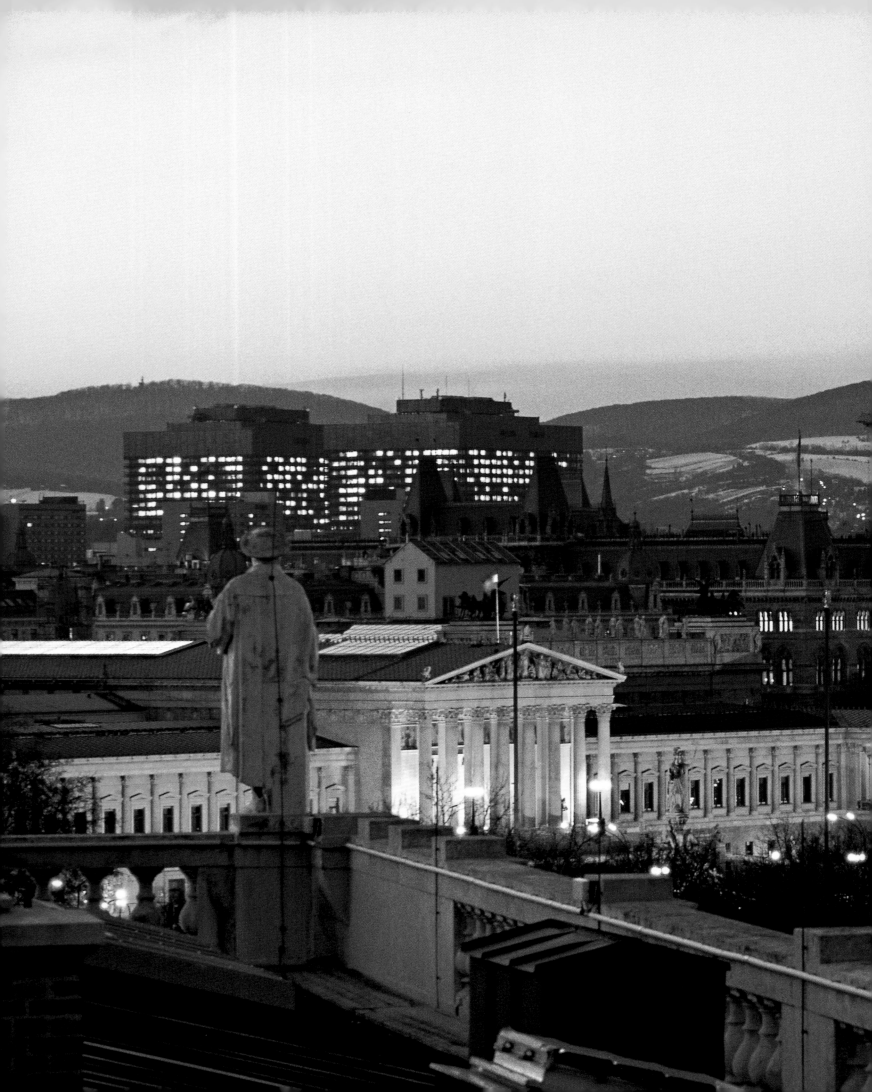

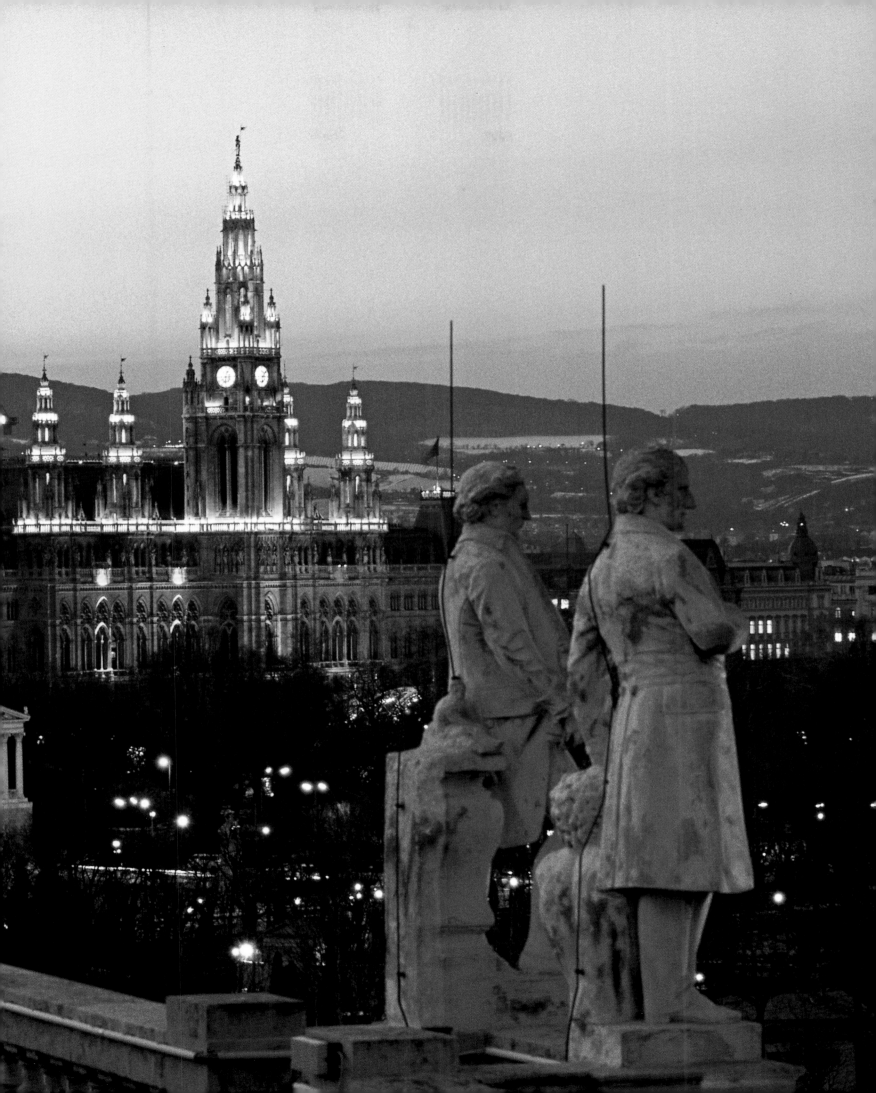

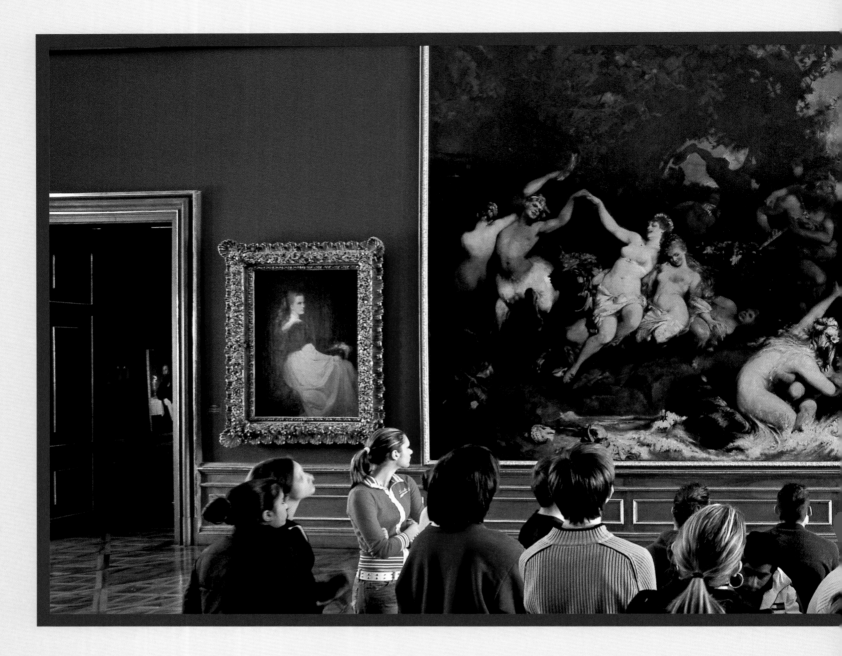

VIENNA – MYSTERY AND PHENOMENON

Vienna is both a mystery and a phenomenon. Trying to unlock its many secrets is an almost futile exercise in this city of crass opposites. Yet Vienna is a master in reconciling the irreconcilable and down the centuries a society has emerged whose cultural diversity is beyond compare.

What New York is to the New World, Vienna was to the old: a melting pot of the Germanic, Slavonic and Mediterranean. Once the royal capital of an empire which in c.1730 stretched from Flanders to Walachia Minor and from Silesia to Sicily, upon its fall in 1918 Vienna became a mere metropolis, the reduced nucleus of a suddenly modest republic. Its cosmopolitan roots remain, however;

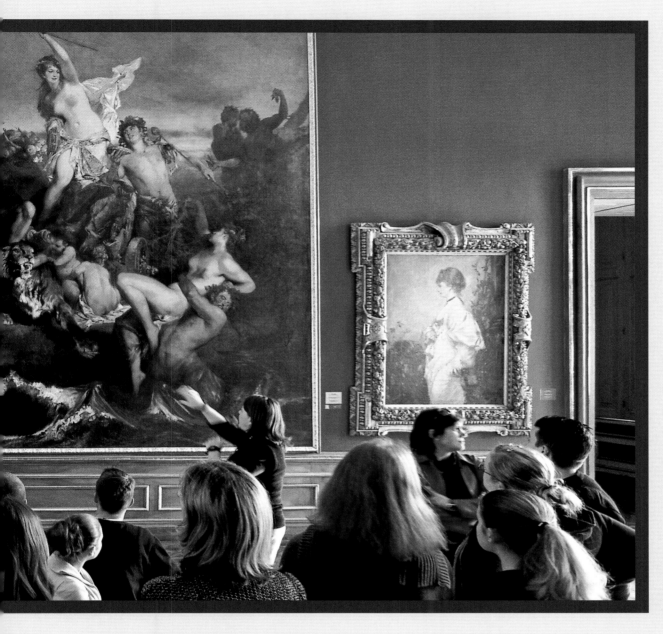

Vienna is a veritable eldorado for lovers of the arts with several dozen museums packed with paintings, sculptures and graphics from all ages and epochs. People come here from all over the world to see famous works such as Hans Makart's "Triumph of Ariadne" on display at the Österreichische Galerie (Austrian Gallery).

scattered across the 415 square kilometres (160 square miles) and 23 districts of the city are 1.6 million permanent residents from all corners of the globe who are joined by no less than 2.5 million foreign visitors a year.

The Viennese are rightly proud of their cultural inheritance. Yet despite this – at least according to a travel guide published in 1962 – their generally cheerful and affable disposition "doesn't stop the Viennese from being first-class whingers. They are unhappy with themselves, their surroundings, the weather, the government, the trams and general blows of fate, complaining about anything and everything. Yet woe betide the visitor who dares to criticise Vienna or anything to do with it; no-one here will stand for it."

Vienna has something for everyone – even its critics. If the only words you can find for Vienna are riddled with sarcasm, consider yourself part of a long tradition. The Viennese dialect in particular is regularly given a pasting. In a metropolis like Vienna a Babylonian mix of languages is par for the course; newcomers from Austria and abroad, however, eventually adopt the long, warm, soft vowels of the local lingo. And that's where the trouble starts. Swiss writer Jürg Amann once remarked that it wasn't just the Viennese who were so difficult to put up with in Vienna but also their

Above:
In 1884 Emperor Francis Joseph gave his wife Elisabeth the Hermes Villa in the Viennese suburb of Lainz. The empress eagerly pursued her hobbies here, keeping her minuscule figure in trim at this magnificent gym painted with Pompeiian frescoes by August Eisenmenger, Hugo Charlemont and Adolf Falkenstein.

Right:
In Vienna Emperor Francis Josef is omnipresent. The man who moulded Austria's history like none other, during the 68 years of his reign he instigated many dramatic political and social changes. His wife Elisabeth was also very much in the limelight.

"twisted language which calls itself German and is even printed in the newspapers. You have to be very careful that you don't succumb to it – to the exotic temptation of inaccuracy." The Viennese themselves, however, weigh their "inaccurate" words in gold; the Viennese vernacular is just as treasured here as the many artistic and historic treasures which make this city absolutely unique.

ARCHITECTURAL HIGHLIGHTS

Vienna's architecture alone is the epitome of u-niqueness. The Hofburg, Schönbrunn and Belve-dere are gems of the baroque, the Stadtbahnstation and Postsparkassenamt masterpieces of the Vien-na Secession. Some of the hotels and department stores are positively palatial. Among its more un-usual edifices are the famous Hundertwasserhaus and Arik-Brauer-Haus, not to mention the Karl-Marx-Hof and other communal residential hous-ing built by the local council in the first few decades of the 20th century. The Donauturm and UNO City add a modern touch to the overall ensemble, with new meeting old when the spires of the Gothic cathedral twinkle in the glass

facade of Hans Hollein's postmodern Haas Haus on Stephansplatz.

Underground, too, Vienna is worth a visit. The chil-ling city sewers are open to the public for a special "Third Man" tour where in 1948 scenes from the classic film of Graham Greene's novel were shot. As your tour guide will undoubtedly point out, however, at half-time during a big match being shown on TV this is not the best place to be ...

On a more fragrant note a good half of the city is made up of forest and parks, the largest of them being the Prater with its famous big wheel. The

local countryside, too, is part of the contradictory Viennese melange, the main attractions being the Vienna Woods, the green oasis of the capital and the easternmost foothills of the Alps in whose rolling hills the city is embedded to the west, and the expansive plateau of Marchfeld spreading off into the east and the puszta of Hungary.

Vienna is far too complex for all of it to be met with approval. Some things about it are fascinating, others touching; others, however, are unpleasant or even repulsive. Vienna is a dream – or as some of the Viennese might put it, a nightmare. Vienna is waiting to be discovered, to be conquered – but beware! A piece of advice from one philosopher urges: "This pill is bitter. Throw it away. Here thorns line the wayside. Avoid them. That is all. Do not ask why such things have been put on earth." These were the words of Marcus Aurelius, the Roman emperor who spent his last days on earth in Vienna in 180 AD. It's almost as if the Viennese have made his pragmatic utterances their personal creed ...

ROMAN CAMP VINDOBONA

200 years before Marcus Aurelius's demise the Romans marched into the Celtic territory of Noricum, roughly the equivalent of modern Austria, setting up camp at the settlement of Vindobona which dates back to the 5th century BC. The Danube formed the northern boundary of the Roman Empire. Traces of the Romans are still visible today in the older parts of Vienna; it was also the Romans who introduced vines and the art of winemaking to the Danube area in c. 280. After the fall of the Roman Empire the region was fought over by Huns, Goths, Bavarians and Magyars. Under Margrave Leopold III the Babenbergs, who had ruled Austria since 976, seized control of Vienna. In 1221 Vienna was granted a town charter and in 1237 made a free city of the Holy Roman Empire, only to fall to Otakar II, king of Bohemia, not long after this, who in the last years of his reign began building the mighty Hofburg. In 1276 Otakar was killed in the Battle of Marchfeld against King Rudolf I of Habsburg, catapulting the

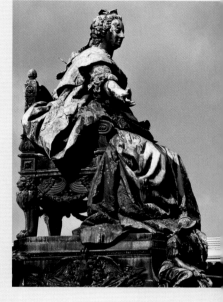

Above:
Maria Theresa, who in 1745 bestowed upon herself the title of "Roman empress", was a dynamic politician, a patron of the arts and education and the mother of 16 children. A giant statue was erected in her honour between the museums of art and natural history in 1888.

Left:
The armoury at the Museum of Art History houses the imperial collection of arms and hunting implements, with armour, firearms and other weaponry spanning five hundred years of military history.

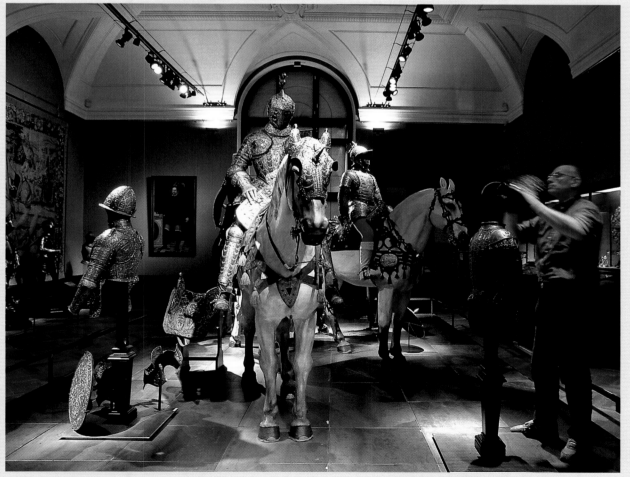

Habsburgs to power as rulers of Austria until 1918. Between 1452 and 1806 the Habsburgs were also emperors of the Kingdom of Germany in the Holy Roman Empire. The Gothic period saw Vienna blossom and grow, marred only by an outbreak of the bubonic plague in 1349. Construction was started on St Stephen's Cathedral in 1304 and in 1365 the university was founded. From 1485 to 1490 King Matthias Corvinus of Hungary took up residence in Vienna. King Maximilian I (1459–1519) later drove the Hungarians out of Austria.

In 1529 and 1683 Vienna was besieged by the Turks. Historians have consistently interpreted these events as turning points in the history of Europe; these were the ultimate battles between

Below:
Vienna wouldn't be Vienna without music. The famous New Year's Day concert, broadcast all over the world, is just one of the many popular events held at Theophil Hansen's Musik-vereinsgebäude (the Society of Friends of Music building).

Right:
In the mid-19th century Heinrich von Ferstel built the mock-Venetian Palais Ferstel to accommodate Vienna's national bank and stock exchange. The glass Freyung-Passage is now a shopaholics' paradise, with one exclusive boutique after another catering for discerning clients.

the warring factions of Islam and Christianity. Vienna became the bulwark of Christian Europe and proved itself strong, mighty and victorious, despite the huge sacrifice made by its inhabitants. The Turks were forced to concede defeat. Legend has it that they left in their wake several sacks of coffee which allegedly laid the foundations for a new cultural – and peaceful – institution: the Viennese coffee house.

Vanquisher of the Turks Prince Eugene of Savoy raised the Habsburg empire to even greater heights. Following the end of the Turkish siege under Grand Vizier Kara Mustafa in 1683 the magnificent baroque edifices which still dominate the

skyline today were built: the Belvedere, Karls-kirche and Schloss Schönbrunn.

Thanks to the Pragmatic Sanction which permitted women to ascend to the throne, in 1740 Maria Theresa, archduchess of Austria, queen of Hungary and Bohemia and "Roman empress" from 1745, succeeded her father Charles VI. She bore 16 children, six of which died in childhood. Following the death of her husband Francis Stephen of Lorraine in 1765 she wore mourning for the rest of her life. She abolished torture and made primary education compulsory.

THE BIRTH OF THE WINE TAVERN

Her son Emperor Joseph II instigated a great number of reforms. He abolished serfdom, levied taxes on the aristocracy and the clergy, permitted Protestants, Orthodox Christians and Jews to practise their religion, reformed the civil, health,

church and funeral services, opened Vienna's general hospital in 1784 and in the same year granted vintners a privilege they still hold today, namely that they may serve their own wine to the public for 300 days of the year. The Austrian wine tavern or "Heuriger" was born. The musical world, too, peaked with Gluck, Haydn and Mozart producing their greatest works during the Age of the Enlightenment.

In 1804 and 1809 Vienna was occupied by Napoleon. Upon his downfall the Congress of Vienna was held in 1814 and 1815 under the auspices of Count von Metternich, during which the map of Europe was redrawn. State chancellor

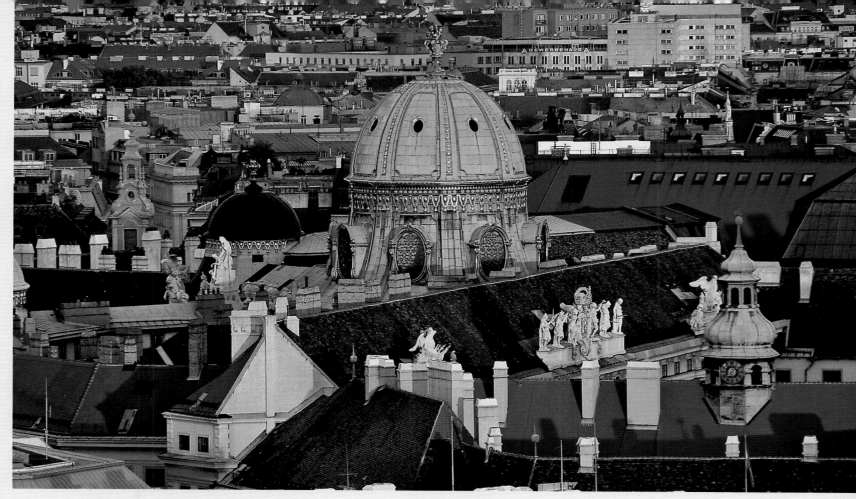

Metternich stabilised the absolutist regime through suppression and censorship. While Beethoven and Schubert penned one masterpiece after another the Viennese waltzes of Joseph Lanner and Johann Strauß the Elder took Europe by storm. The revolution of 1848 forced Metternich to step down; Emperor Ferdinand I also abdicated, leaving the throne in the hands of his nephew Francis Joseph I.

During his long reign (1848–1916) the population of Vienna topped one million. In 1857 demolition of the old city defences was begun and the Ringstraße with its stately buildings erected in its place. The immediate and later more distant suburbs were incorporated as part of the greater city. The World Exhibition was staged at the Prater in 1873, with the Burgtheater and Hofoper becoming the leading theatres of Europe. During this period music emerged from Vienna which was to delight audiences all over the world: the works of the masters of the waltz, Viennese operetta from "Die Fledermaus" to "The Merry Widow" and symphonies of monumental proportions by Brahms, Mahler and Bruckner. And in Empress Elisabeth ("Sissi") the royal family had produced a member

upon whose fated life the vultures of the gutter press would today swoop down with utter joy.

THE INTELLECTUAL HISTORY OF EUROPE

Vienna mirrors the intellectual history of Europe, home to thinkers from Nestroy, Grillparzer and Stifter to Schnitzler, Hofmannsthal, Karl Kraus and Robert Musil to Stefan Zweig, Joseph Roth and Franz Werfel, to name but a few. It was here that Sigmund Freud began his psychoanalysis and Theodor Herzl developed his vision of an independent Jewish state. In 1905 pacifist Bertha von Suttner, resident in Vienna, became the first woman to win the Nobel Prize for Peace which she herself initiated, while Russian revolutionary Leo Trotsky sat playing chess in Café Central. Medic Karl Landsteiner discovered blood groups here in c.1900 and was himself given the Nobel Prize in 1930. Philosophers Ludwig Wittgenstein and Karl Popper and zoologist Konrad Lorenz all came from Vienna.

The assassination of heir apparent Duke Francis Ferdinand of Austria and his wife Sophie in Sara-

Viewed from the top of the town hall, the dome of the Michaelertor, the Hofburg's city gate, glimmers green and gold in the evening light. In front of it Roman foundations have recently been excavated.

Above:
One Turkish tourist in 1665 wrote of the many "curious and wonderful things" he had seen in Vienna. His words are still appropriate today – as any visit to the Saturday flea market on Naschmarkt will demonstrate.

Right:
Vienna in miniature: St Stephen's Cathedral and the giant Ferris wheel in the Prater park symbolise the past and the present, piety and pleasure.

jevo in June 1914 triggered the outbreak of the First World War and the end of Habsburg rule. In the post-war redistribution of land Austria was reduced to a mere sixth of its original size. The country was made a republic and Emperor Charles I was exiled to the Atlantic island of Madeira where he died in 1922. The international economic crisis of the 1920s also seriously affected Austria, with unemployment and political unrest sparking off revolts and attempted putsches; despite these difficulties Golden Age Vienna sill managed to lay out new parks, build public baths, set up nursery schools and even erect council housing, the most architecturally significant of which is probably the Karl-Marx-Hof.

In 1933 Chancellor Engelbert Dollfuss dissolved parliament and in 1934 passed a new constitution making Austria a clerical, fascist corporate state. In the Anschluss of 1938 Adolf Hitler annexed Austria to Germany's Third Reich. Two thirds of the Jewish population and countless critics of the regime fled the country, among them practically all of Vienna's leading writers, artists, scientists and intellectuals.

Under Nazi rule the Höhenstraße was built, making the Vienna Woods accessible to motor vehicles. In the spring of 1945 air raids demolished large swathes of the city centre. St Stephen's Ca-

thedral was badly damaged by artillery and fire. The stage at the state opera house burnt down on March 12 1945, seven years to the day on which German troops marched into Austria. On April 13 1945 the Russians seized control of the city. Of Vienna's 200,000 Jews only 200 saw the war out in the city itself. Like Germany Austria was split into four zones of occupation, with Vienna controlled by all four Allied powers, the Russians, Americans, British and French. In 1955 sovereignty was returned to Austria which in its new state treaty pledged to remain neutral. Vienna later became the third seat of the United Nations on completion of UNO City in 1979.

Following the collapse of the Iron Curtain Vienna has now returned to where it once was, moving back from its isolated position on the edge of the free world to the centre of a rapidly unifying

Europe. As in many countries elsewhere, however, the political and cultural power of the Roman Catholic church, once so mighty, has continued to dwindle, with just 60% of the population now belonging to a Christian church – Catholic, Protestant or Orthodox – 8% Muslim, 0.5% Jewish and around 30% either non-denominational or unwilling to give details.

ANCIENT CULTURE MEETS AUSTRIAN CUISINE

Austria's rich and diverse cultural spectrum is also mirrored in its national cuisine which down the centuries has assimilated ingredients and recipes from Southern Germany, Bohemia, Hungary, Italy, Southern Slovakia and Turkey. The average Viennese family can today of course dine at culi-

nary establishments common to any major city in the world; there are pizzerias, Chinese restaurants, fast-food chains and snack bars in abundance, but there are also a number of delicious local specialities not to be missed.

Meals here traditionally begin with soup, often beef broth with dainty semolina dumplings, dark liver dumplings or slithers of pancake. Genuine "Wiener Schnitzel", an absolute favourite, is always an escalope of veal (as opposed to pork) coated in breadcrumbs and served with potato salad. Another classic meat dish is "Tafelspitz", a tender cut of beef topside which is boiled and usually eaten with apple and horseradish, fried potatoes and chive sauce. "Zwiebelrostbraten" (fried beef with onions) and goulash are other popular dishes – here and elsewhere. Fillet steak is known in Vienna as "Lungenbraten" and a

knuckle of pork or veal as "Stelze". Fish and game are also features of any self-respecting menu as is chicken, fried ("Brathendl"), roasted ("Backhendl") or with paprika ("Paprikahendl"). Wiener sausages are confusingly called Frankfurters; sausage stands will also offer you thick slices of meatloaf, thin, spicy "Debreziner", boiled "Burenwurst" and cheesy "Eitrige" or "Käsekrainer".

Vienna's calorific desserts are usually of Bohemian origin, among them apple or quark strudel, "Palatschinken" (a thin pancake filled with jam or chocolate sauce), apricot, plum or plain yeast dumplings served with cinnamon sugar, poppy seeds or melted butter, and "Kaiserschmarrn", shredded sultana pancake served with stewed apples and icing sugar which is allegedly named after

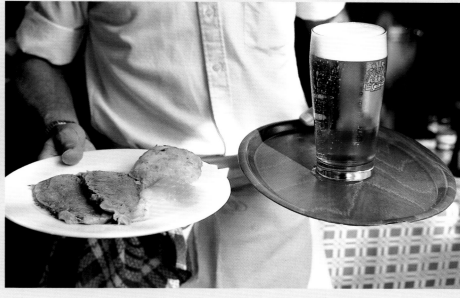

Emperor (Kaiser) Francis Joseph. An absolute delicacy are "Powidltaschtkerln", potato dough turnovers filled with plum jam ("Powidl"), and tiny "Buchteln" of yeast dough with vanilla sauce. Other world-famous sweets can be found in the cake department, the mouth-watering range including "Sachertorte", "Linzertorte", "Dobostorte" and "Malakofftorte", "Krapfen", "Golatschen", "Kipferln" and "Beugeln".

Manners are important in Vienna, especially in restaurants. The waiter isn't summoned with a derogatory click of the fingers or by yelling across a crowded room; he has to be formally addressed

Below:
Entire odes have been devoted to one of Vienna's most popular dishes, the "Tafelspitz". This cut of beef topside is usually served with apple and horseradish and washed down with a glass of local beer.

Centre left:
The scenario at Café Demel today is little changed since JA Lux ironically noted in 1922: "Many an ambitious young man ... who wished to positively contribute to the education of his great mind began his academic career by first finding a suitable café."

The monumental entrance to Vienna's Naturhistorisches Museum (Museum of Natural History) is a glorious prelude to the city's collection of exhibits marking the milestones in the history of our planet.

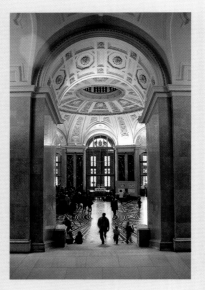

Right:
To get a good look at these lovely ladies you have to bend your head right back and squint up at the ceiling above the Burgtheater's north staircase where Gustav Klimt painted this marvellous mural entitled "The Theatre in Taormina".

Centre:
A gilt bronze statue in Vienna's Stadtpark seems a fitting memorial to king of the waltz Johann Strauß the Younger whose infectious melodies have toes tapping the world over.

as "Herr Ober". Regulars are allowed to call him by his first name – but only if they add a "Herr" in front of it – and may elicit a deferential "Herr Doktor" in return. Courtesy can go too far, however, as poet Georg Trakl once observed. He claimed not to like the Viennese, finding nothing more disgusting "than this forced air of pally politeness. On the tram the conductor tries to get friendly with you and in a restaurant the waiter, and so on and so forth. People shamelessly suck

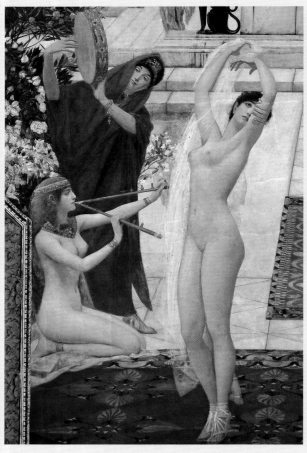

up to you wherever you go with one singular aim in mind – their tip!"

At Austria's many wine taverns or "Heuriger" – whether in the heart of the city or out in the country – tastes and expectations are less particular. Any winery with branches of pine or a wreath hanging up above its entrance is open for business, selling its own wine and select simple fare, such as local bread, sausage, cheese, goose dripping or "Liptauer", a thick spread made of butter, quark, paprika, onions and spices.

Vienna is never boring, whether you explore it on foot, by tram or on the underground, opened in

1978, where the straps hanging from the ceiling swing wildly from side to side as the trains thunder through the tunnels. For a really Viennese experience the city can be toured by horse-drawn carriage or "Fiaker", the drivers of which traditionally wear a bowler hat and sometimes plaid trousers and a velvet jacket. A relatively recent by-law also governs attire for the animals, stipulating the standard issue of "droppings bags" to collect any equestrian refuse.

All year round Vienna has a full social and cultural calendar of events catering for all tastes, from opera and theatre to musicals to pubs and clubs. The Vienna Philharmonic, Vienna Symphony Orchestra and Vienna Boys' Choir are the city's musical ambassadors, famous the world over, and Jazzland under the Ruprechtskirche has jived, bopped and swung to the strains of saxes, horns and rhythm sections since 1972. The absolute highlight of the ball season during Carnival is undoubtedly the Opernball where VIPs swish gowns with the crème de la crème of Viennese society – while the less well-to-do follow the event on TV or go to one of the other 200 organised dances. In May and June Vienna stages its grand festival of premieres, concerts and exhibitions and when the theatres close down for the summer all kinds of music fill the air at the Klangbogen festival.

At the city's ca. 180 museums and galleries there are classics and curios to be admired. There are museums devoted to the funeral, fire brigade and

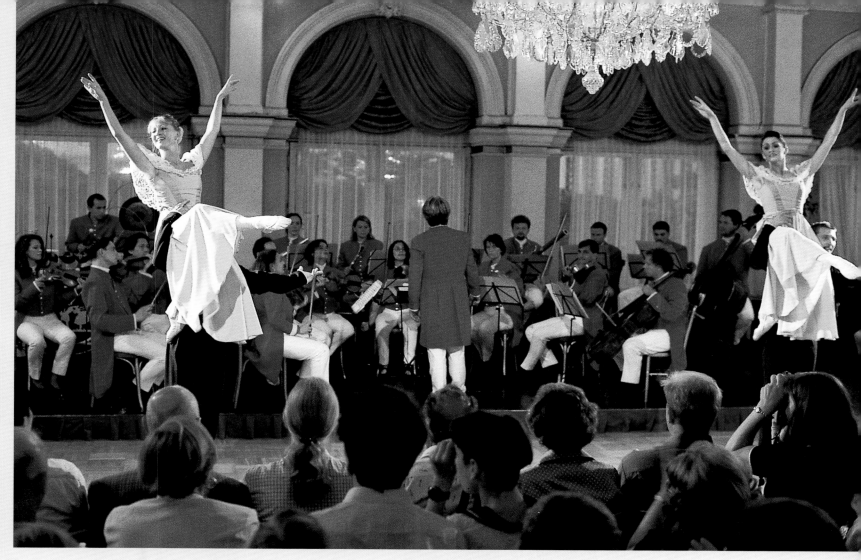

football, to tobacco, thieves and tiles. The Lipizzaner Museum charts the history of the Spanish Riding School and Lipizzaner horses from Lipizza in Slovenia. Shows at the school, opened in 1572, follow a strict protocol. The riders wear brown tail coats, white buckskin breeches, black top boots and a bicorne. It takes years to train the white stallions for the various dressage movements which include the pirouette, levade, courbet and capriole. The high point of the show is the ballet danced by the obedient greys in perfect time to the music.

For those back home visitors to Vienna have a number of stylish souvenirs to choose from. Like any other great metropolis Vienna is not short of boutiques selling haute couture and expensive jewellery. And like elsewhere, the better the address, the higher the price. There are also plenty of traditional Alpine fashions and handicrafts on sale: felt "Loden" jackets, "Lederhosen", petit-point needlework and glass and ceramics, to name but a few. Particularly fine porcelain can be purchased from Augarten, founded in 1718; tiny Lipizzaners

are among the more affordable objects. Collectors of antiques will hit a veritable goldmine in Vienna, with furniture, art, Wiener Werkstätte artefacts and flea market fallout in abundance. Bibliophiles can browse for hours in the many second-hand bookshops. And Vienna's sugary spectrum of sweets also takes some beating; chocolates, candy or the travelling chocoholic's delight, "Sachertorte" packed in a squash-free wooden box, make excellent presents, as do bottles of wine from the sunny slopes of the Vienna Woods, such as Grinzinger or Nußberger.

One extremely satisfied customer to Vienna in 1665 was Evlija Tschelebi from Turkey who went into positive raptures about the cleanliness of the city streets, the honesty of the local merchants, the mildness of the climate and the friendly affability of the indigenous population. To date little has changed. Much could be said about Vienna but it would never be enough to do it justice. Those who've been here will cherish the memory for ever.

Above:
A Johann Strauß concert and ballet at the Kursalon. Erected in the Stadtpark during the 19th century, the building pays homage to the Italian renaissance.

Page 26/27:
One of the absolute architectural highlights of the Vienna Secession is the Postsparkassenamt (post office savings bank) by Otto Wagner from the beginning of the 20th century. The granite and marble slabs of the facade are fastened together by hundreds of clumsy rivets, making it look like a bulky stone treasure chest.

25

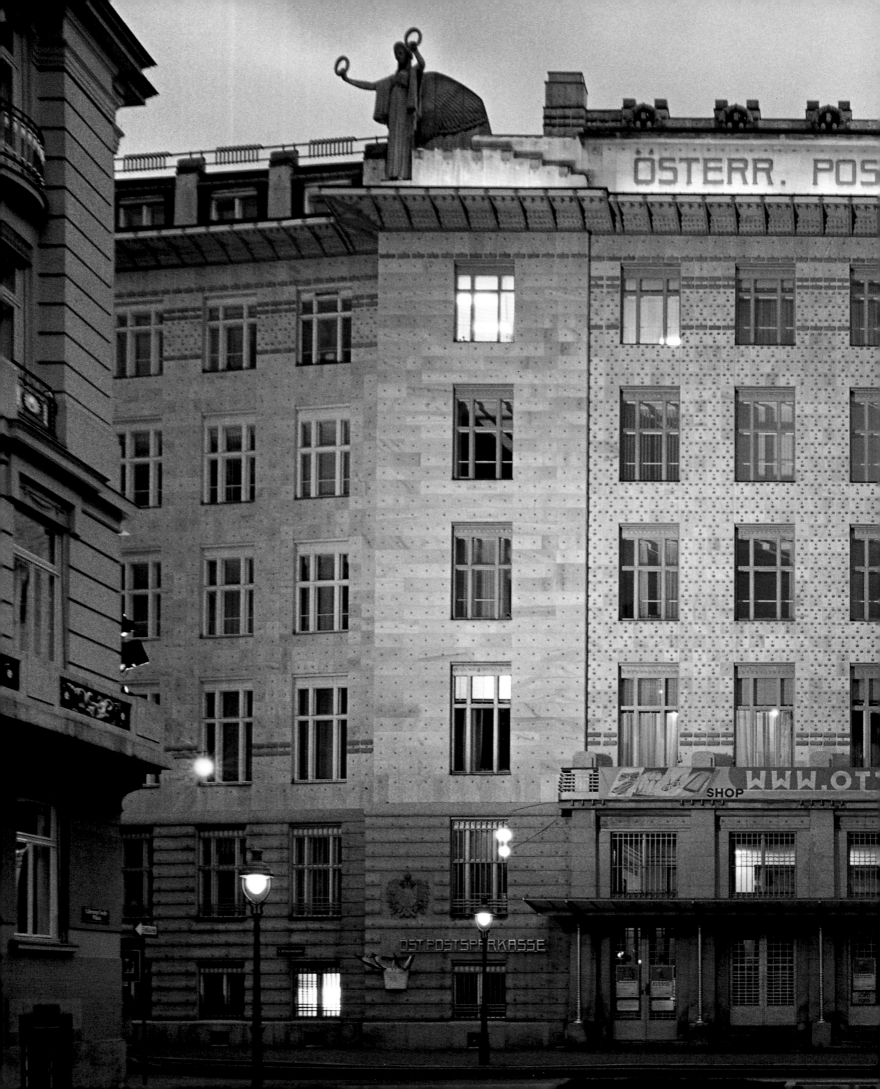

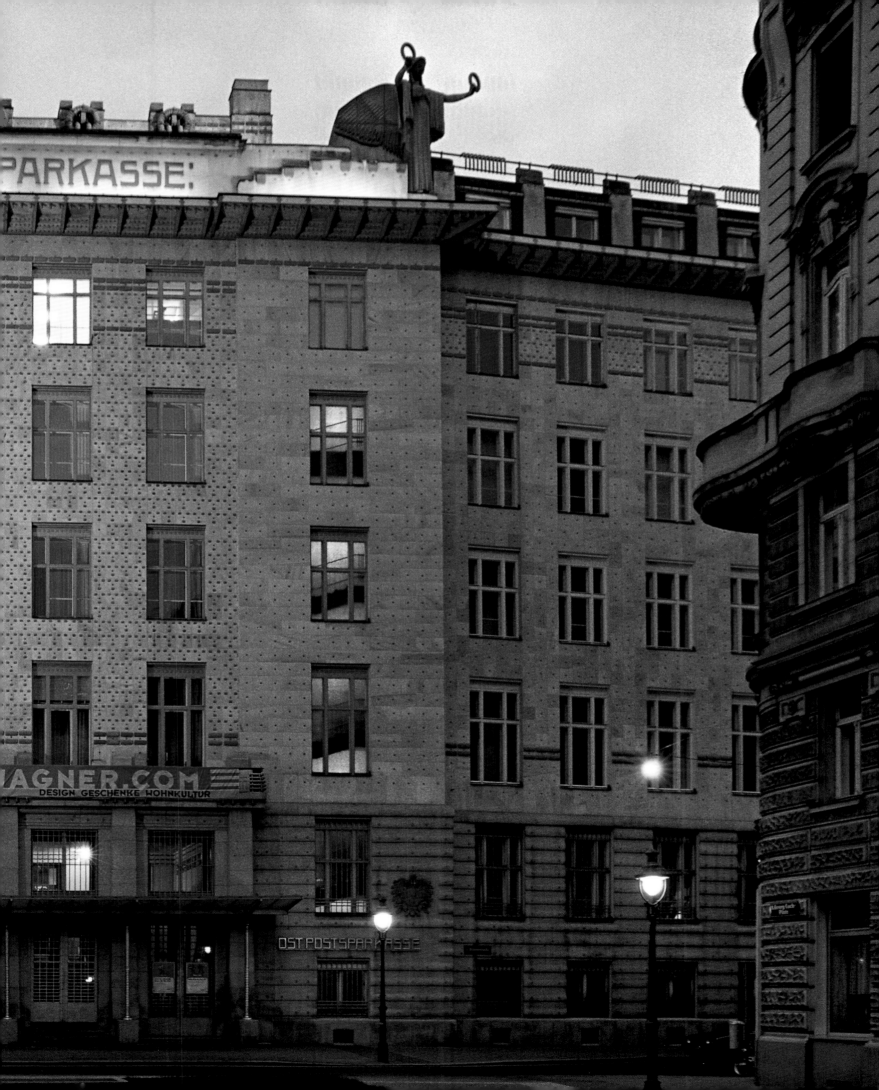

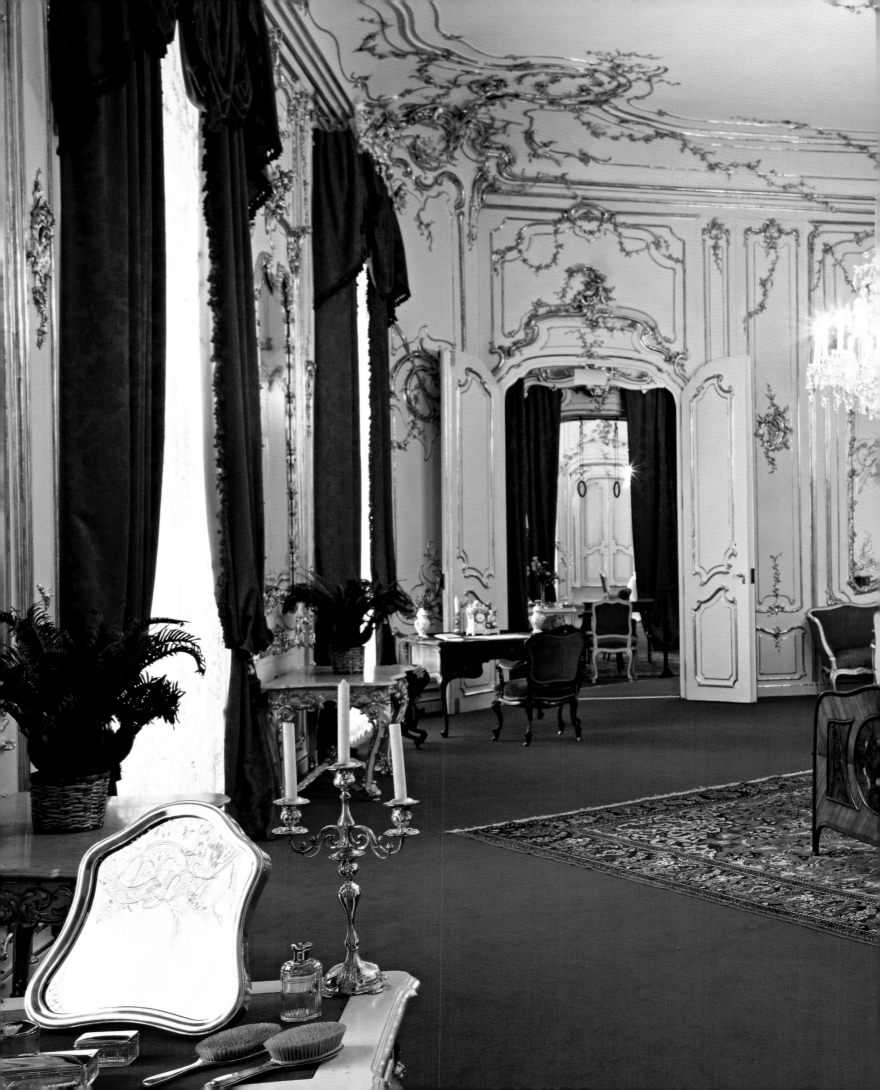

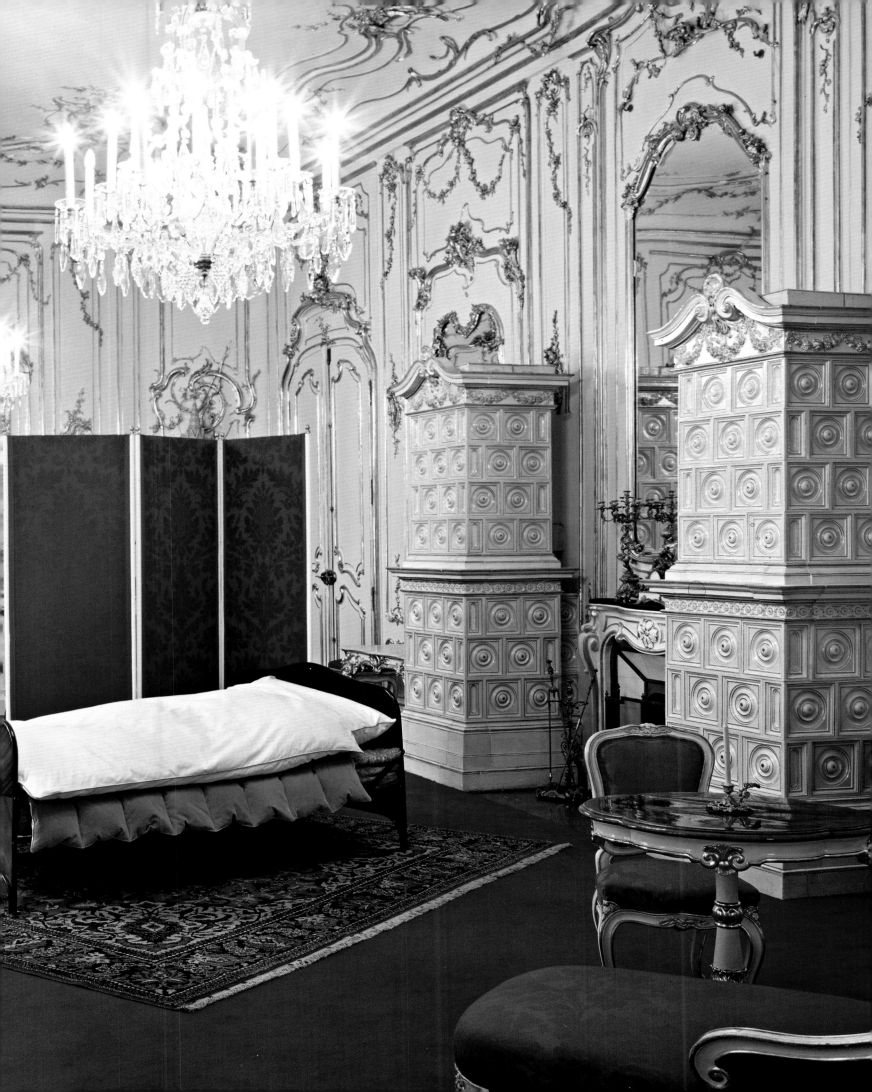

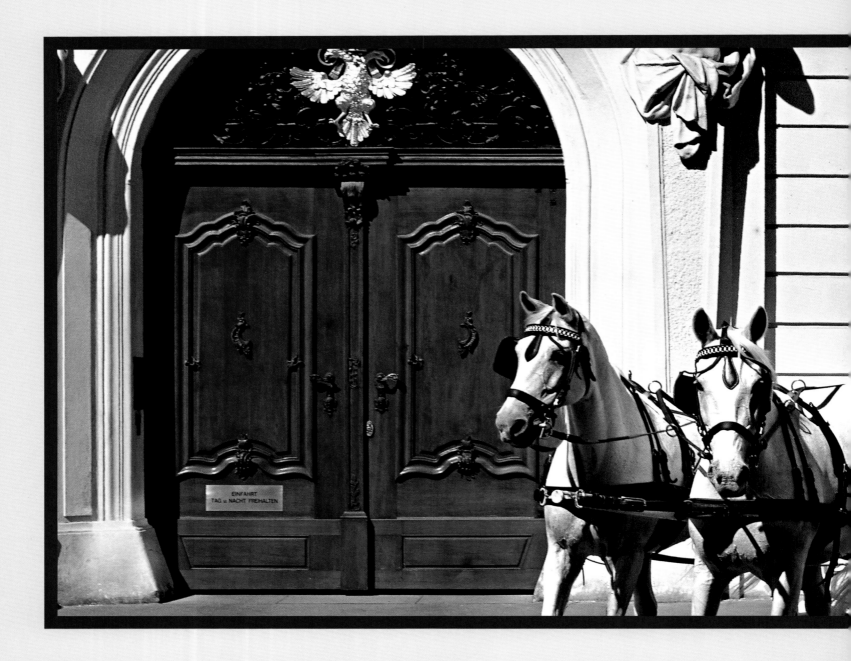

CHURCHES AND COFFEE HOUSES – THE HEART OF THE CITY

The focal point of the city centre and local landmark number one is the Stephansdom (St Stephen's Cathedral). Originally a Romaneque church, from the 13th century onwards it was extended and given its present Gothic design. In 1945 the cathedral was badly bombed; it took seven long years to restore the building to its former glory. 137 metres (450 feet) tall, the long climb to the top of the south tower is rewarded by magnificent views out across Vienna. The much shorter north tower was never finished. It now houses the largest bell in Austria; weighing an impressive 21 metric tonnes, "Pummerin" (the boomer bell) traditionally rings in the New Year.

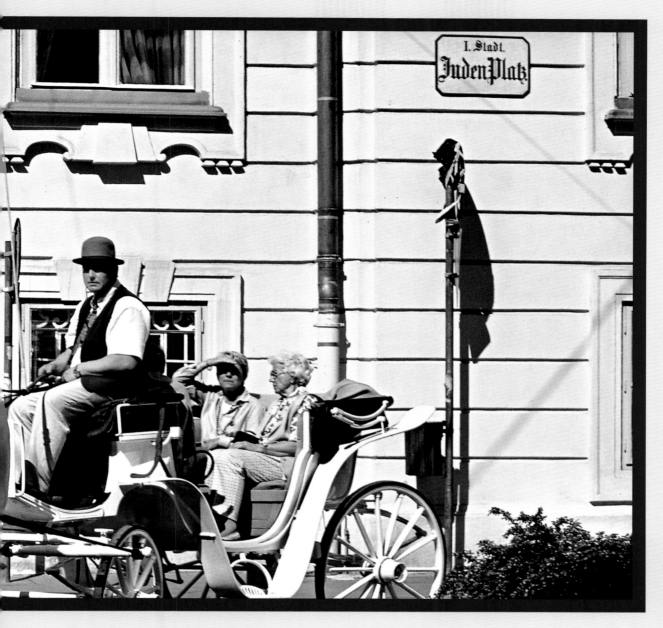

I. Stadt.
Juden Platz.

Page 28/29:
The empress certainly couldn't complain that her bedchamber at the Hofburg wasn't big enough. She still didn't like sleeping here, however, preferring to escape the confines of the imperial court and travel abroad whenever possible.

A horse-drawn carriage outside the Bohemian Royal Chancellery on Judenplatz, built in baroque by Johann Bernhard Fischer von Erlachs.

Inside the cathedral the Gothic high altar is worth seeing, as are the many other works of art from various periods. One of the more popular pieces is the "Fenstergucker" under the pulpit, a self-portrait of master builder of the cathedral Anton Pilgram from c. 1513. For all its religious arte-facts, however, the cathedral fails to effuse a sense of piety; the comings and goings of camera-clicking tourists and the permanent congregation of tired visitors slumped in pews reading newspapers or travel guides smack more of the station forecourt than a place of worship.

St Stephen's also holds the graves of Emperor Fred-erick III (who died in 1493) and Prince Eugene of Savoy. In the catacombs, where up until the 18th century ca. 11,000 people were laid to rest, lie another 15 Habsburgs and the entrails of 56 members of the ruling dynasty which were re-moved during the embalming process. Their hearts are buried in the crypt of the Augustinerkirche, formerly the imperial parish church. The bodies were interred in the imperial burial vault (the Kaisergruft under the Kapuzinerkirche or Capu-chin church) which from 1633 onwards became the official final resting place of the House of Habsburg. Of the 130 sarcophagi, many decorat-ed with elaborate reliefs, the most pompous are those belonging to Empress Maria Theresa and her husband Francis Stephen I of Lorraine. In front of

these stands the tomb of one of their sons, the reformist Emperor Joseph II, whose exaggerated simplicity bears witness to the conflict of the baroque and the Age of the Enlightenment. The last Austrian empress to be buried here in 1989 was Zita, the wife of Emperor Charles I who died at the age of 34 in exile in Madeira in 1922.

From 1279 to the fall of the monarchy in 1918 the House of Habsburg was based at Vienna's Hofburg, a huge complex which was constantly extended up until the outbreak of the First World War. It has no less than 18 wings with a total of approximately 2,500 rooms, among them the National Library with its ornate baroque Prunksaal, the Burgkapelle or royal chapel and the Spanish

Below:
At Café Sacher. Alfred Polgar once wrote of the coffee house that it was "a place of asylum for people who had to kill time before time killed them."

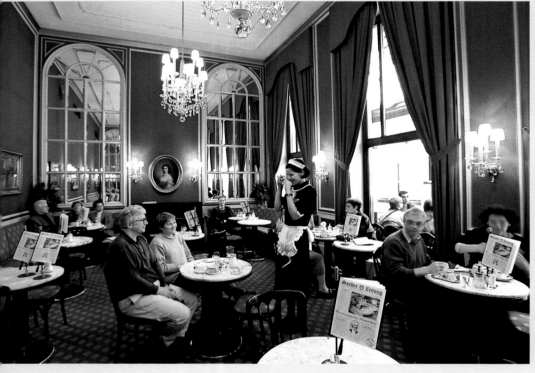

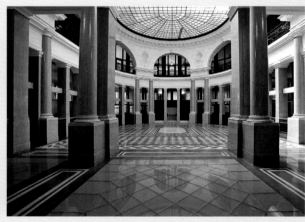

Right:
View of the interior of what was once the Länderbank or federal bank. For over fifty years Otto Wagner designed and built villas, houses, offices, churches and banks. This one from 1883/1884 is now partly used by the Austrian chancellery.

Riding School. Parts of the palace are open to the public, such as the Imperial Treasury, Francis Joseph I's and Elisabeth's private apartments and various museums and collections.

Enclosed by the Leopold wing, the Neue Hofburg (new palace) and the impressive palace gates is Heldenplatz or hero's square, so called after the mounted statues of Prince Eugene and Archduke Charles. To the north is the Volksgarten, at the end of which stands the Burgtheater (palace theatre), built by Gottfried Semper and Karl von Hasenau-

er in the style of the Renaissance between 1874 and 1888. Going to a performance here is one of the most memorable experiences of any trip to Vienna. The same is true of the Staatsoper on Opernring, designed by architects Sicardsburg and van der Null and erected from 1861 to 1869. Partly destroyed during the Second World War, it was reopened in 1955. It's heralded as one of the best opera houses in the world, its history inextricably linked to great names such as Gustav Mahler, Richard Strauss and Herbert van Karajan. Sandwiched between the Staatsoper and the Hof-

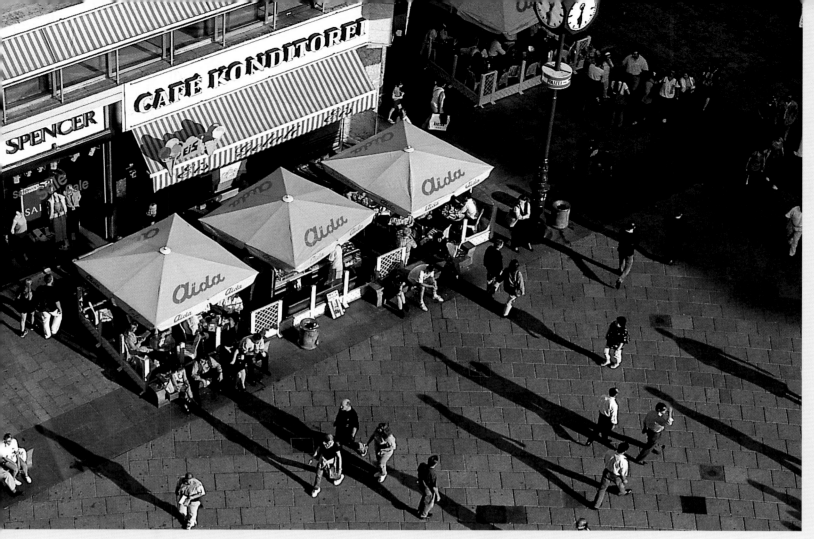

sieges; this was replaced by the present distinctive pyramid roof at the end of the 18th century, visible for miles around. Originally Gothic, the Am Hof church was given a monumental west facade during the 17th century. It was from this loggia that Pope John Paul II gave his Easter blessing in 1983. Between 1702 and 1733 the Peterskirche was built by Lukas von Hildebrandt to replace a church which burned down here in 1661; after Fischer von Erlach Hildebrandt is the most prominent architect of the Viennese baroque.

burg is the Albertina with its famous collection of graphic art, with Alfred Hrdlicka's memorial to the victims of war and fascism outside.

Central Vienna has so many churches that only a few can be mentioned here. The Ruprechtskirche allegedly dates back to 740 and is thus the oldest church in the city. Maria am Gestade once clung to the steep banks of a side arm of the River Danube; its tracery helm roof is an excellent example of Viennese Gothic. The spire of the Gothic Minorite church lost its tip during both Turkish

Away from its many sights and humming pedestrianised areas, such as Kärntner Straße and the Graben with its baroque memorial to the bubonic plague, the centre of Vienna can be surprisingly quiet, especially in its narrow alleys and courtyards where time seems to have stood still. A gentle stroll here will teach you more about the real Vienna than religiously doing the city's main attractions alongside thousands of others will. However you decide to explore Austria's capital, at the end of the day all roads lead to just one place: the coffee house.

33

The cathedral of St Stephen's is a city landmark and the most significant example of Gothic church architecture in the whole of Austria. The south tower, affectionately known as "Steffl" by the locals, rises 137 metres (450 feet) up into the sky.

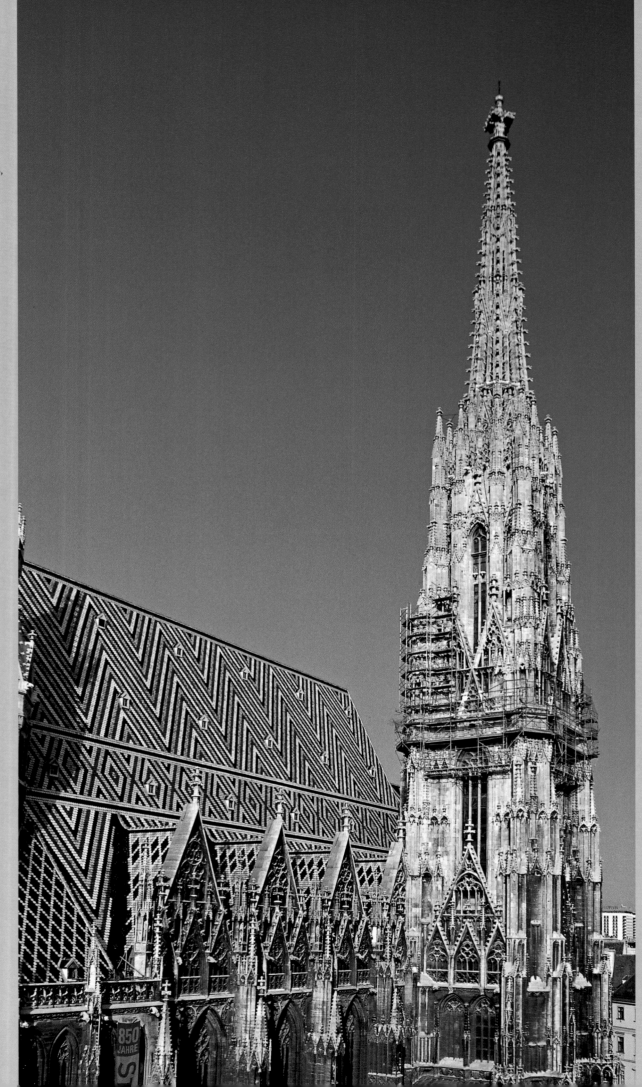

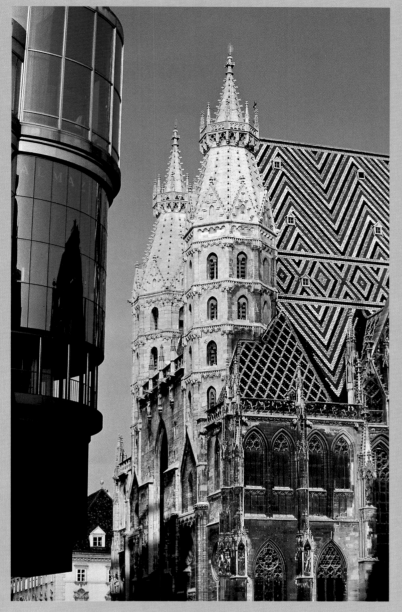

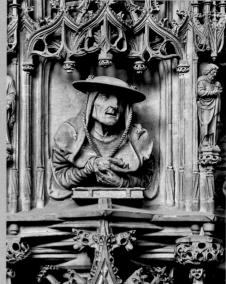

Left:
The Gothic pulpit in the middle of the nave does the masons of the day proud. The base is decorated with images of the apostles and various saints, with the busts of the four Latin Church Fathers rising up above them. The photo shows St Hieronymus or St Jerome.

Below:
The high altar in St Stephen's depicts the stoning of the cathedral's patron saint.

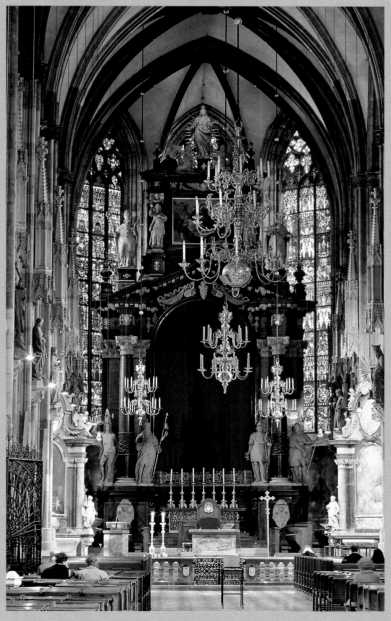

Above:
Here the centuries converge, with the glazed coloured tiles of the cathedral reflected in the modern glass facade of the Haas Haus.

Right:
This Gothic sculpture in the hall beneath the north tower is curiously known as the "God of toothache". Legend has it that students returning home from their nocturnal revelries poked fun at the pained expression on the figure's face and were immediately struck down with terrible toothache.

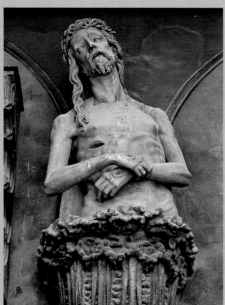

35

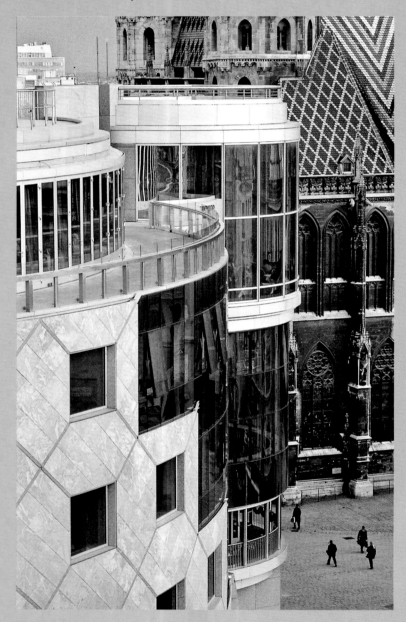

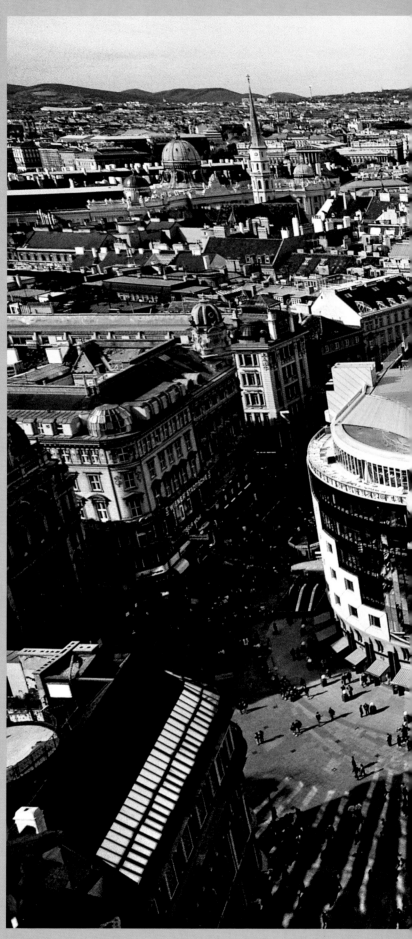

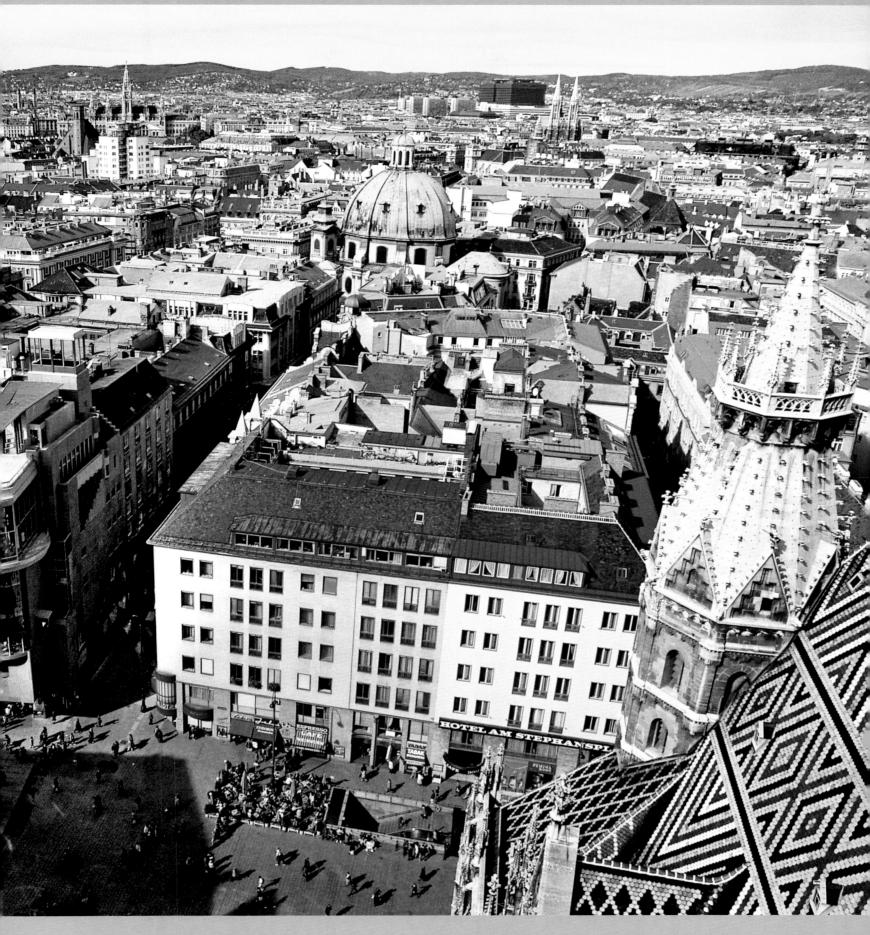

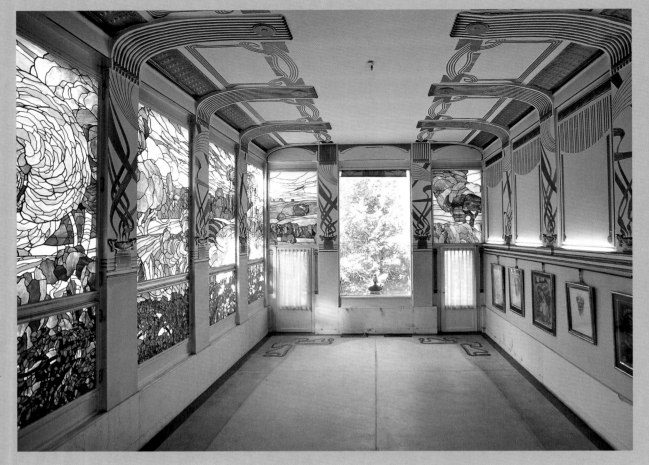

No other architect influenced the Jugendstil period in Vienna as profoundly as Otto Wagner (1841–1918). He began work on this splendid villa – which was to become his private home – in the Viennese suburb of Hütteldorf in 1886. The leaded lights of his studio were designed by contemporary Adolf Böhm.

An impressive flight of steps leads up to Wagner's former villa, now a private museum owned by painter Ernst Fuchs, one of the leading names of the Viennese Fantastic Realism movement who has had the building restored and made accessible to the public.

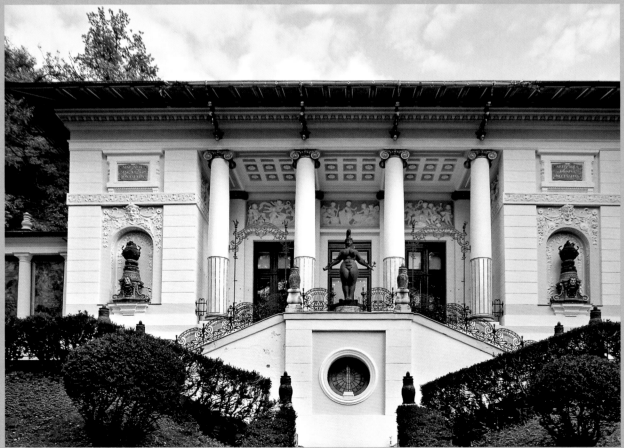

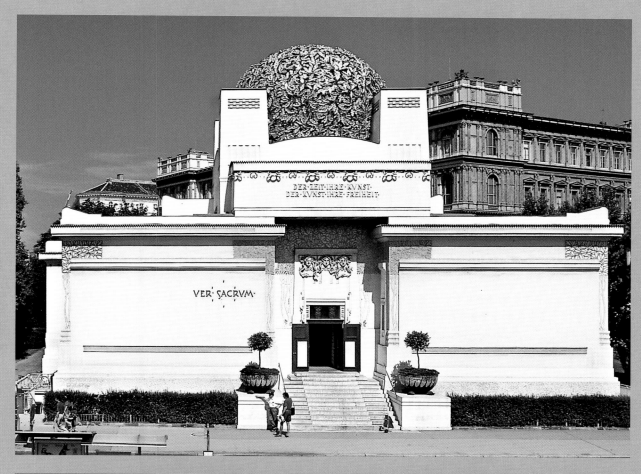

One of the showpieces of Jugendstil in Vienna is the Vienna Secession building with its gilt laurel cupola, known locally as the "golden head of cabbage". Its architect Joseph Olbrich was a pupil of Otto Wagner's.

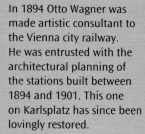

In 1894 Otto Wagner was made artistic consultant to the Vienna city railway. He was entrusted with the architectural planning of the stations built between 1894 and 1901. This one on Karlsplatz has since been lovingly restored.

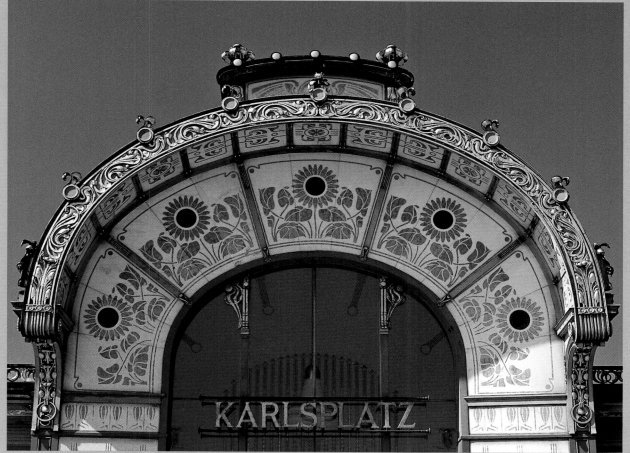

THE VIENNA SECESSION –
JUGENDSTIL IN V

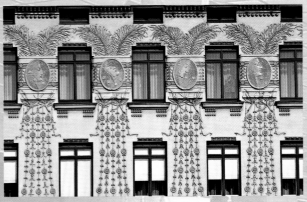

Above:
One of the most beautiful Jugendstil facades in town is the one fronting Linke Wienzeile 38, built by Otto Wagner and decorated with ornate medallions by Kolo Moser.

Centre:
The central hall of the savings bank is one of the highlights of Functionalist architecture. On entering it for the first time Emperor Francis Joseph is said to have dryly remarked: "Strange how well people fit in here."

Below:
The enormous angels marking the corners of Otto Wagner's post office savings bank are the work of Othmar Schimkowitz. The sculptures were the first of their size to be cast in aluminium.

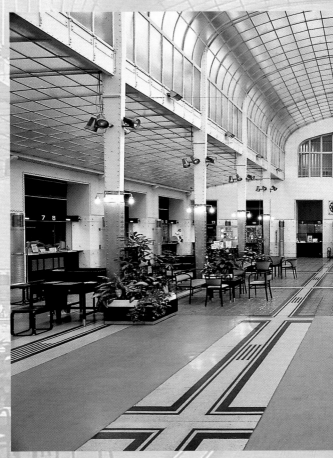

The second half of the 19th century was gripped by Historicism, a fervent emulation of the old forms of Ancient Greece and Rome, the Gothic, Renaissance and baroque. Its artistic pendant was preoccupied with "new art", the Art Nouveau of France and England and the Jugendstil of Germany, Austria and Switzerland. The new movement infiltrated the poetry and music of the day and found its clearest expression in architecture and the applied arts.

In 1861 the artists of Vienna had organised themselves into a professional association, naming themselves "Künstlerhaus" after their headquarters. Conservative rather than progressive in their artistic bent, nineteen of their members, headed by Gustav Klimt and including Otto Wagner and Kolo Moser, withdrew from the group in 1897 to form the Vienna Secession. Thanks to generous funding provided by industrialist Karl Wittgenstein the new organisation was able to open an exhibition hall just one year later in 1898. Joseph Olbrich's Vienna Secession still stands, its elaborate cupola of gilt laurel known in the local dialect as the "golden head of cabbage" and featured on the Austrian 50-cent piece.

This "refuge for art connoisseurs" was where the masters of the modern age gave vent to their creativity, the list of names including Auguste Rodin, Oskar Kokoschka, Ernst Barlach, Franz Marc, Wassily Kandinsky, Marc Chagall, Joseph Beuys and Christo. Many left their mark here; the basement of the Secession, for example, is decorated by an enormously long wall frieze by Gustav Klimt, created in 1902 for the 14th Secession Exhibition as a homage to Ludwig van Beethoven whose ninth Symphony he greatly admired.

SUBLIME SENSUOUSNESS

The Secession is not the only building to illustrate the great significance Jugendstil held for the city of Vienna, about whose "sublime sensuousness" Hugo von Hofmannsthal once enthused. Many facades bear stylistic traces of the period; Jugendstil can even make an artistic feature of a

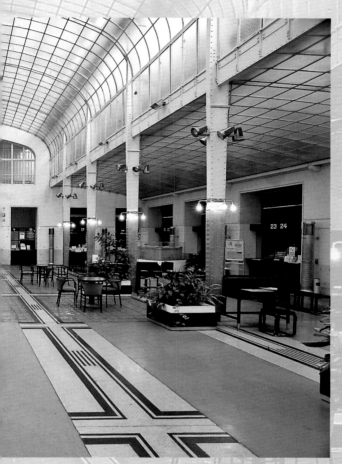

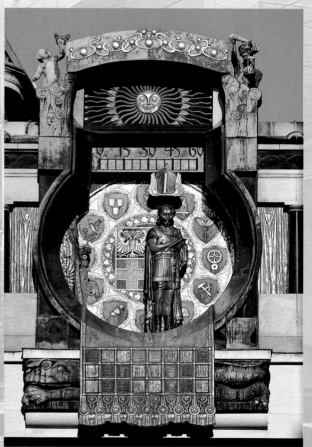

Above:
This collection of buildings on Linke Wienzeile, designed by Otto Wagner, caused a great sensation one hundred years ago.

Left:
The Jugendstil Anker-Uhr on Hoher Markt was created by Franz von Matsch between 1911 and 1917. When the clock strikes the hour, various important Viennese personalities emerge to the sound of the chimes.

simple hotel elevator. The most impressive examples, however, are the edifices designed by Otto Wagner. His city station on Karlsplatz is one of Vienna's most popular photographic motifs. Not far from here is his colourfully floral majolica tile house on Linke Wienzeile. Another Jugendstil highlight is his Am Steinhof church with glass mosaics by Kolo Moser. And in the Karl-Lueger-Gedächtniskirche at the main cemetery Secessionist Max Hegele proves that Jugendstil's abstract geometric variant is ideal for creating sacred spaces.

In 1903 Josef Hoffmann and Kolo Moser set up the Wiener Werkstätte GmbH, a collective of applied artists who were to make Vienna the hub of a new trend in the field of arts and crafts particularly. Many of their designs have become classics, from furniture to jewellery to household appliances. The words of art critic Ludwig Hevesi immortalised in gold above the entrance to the Secession building, still ring true: "To the age its art, to art its freedom".

This graceful artefact is in fact a window catch fashioned by French Jugendstil artist Paul Gasq for the French Embassy in Austria. This and others like it are all that remain of the original furnishings from 1904.

41

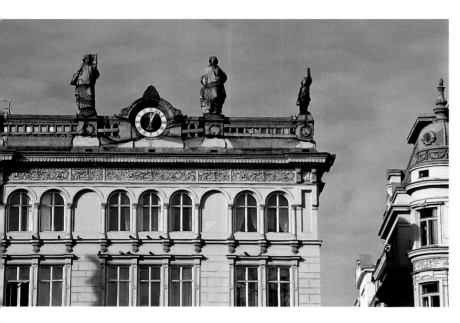

Top left:
Only on looking up do you realise how many artistic treasures can be found adorning Vienna's roofs. These statuesque figures watch over number 20 on Graben.

Centre left:
As the name suggests, the street Graben ("ditch") was once part of the city's Roman fortifications. By the baroque period it had become a stylish city thoroughfare. Today horse-drawn carriages leisurely transport shoppers and tourists past the elegant buildings.

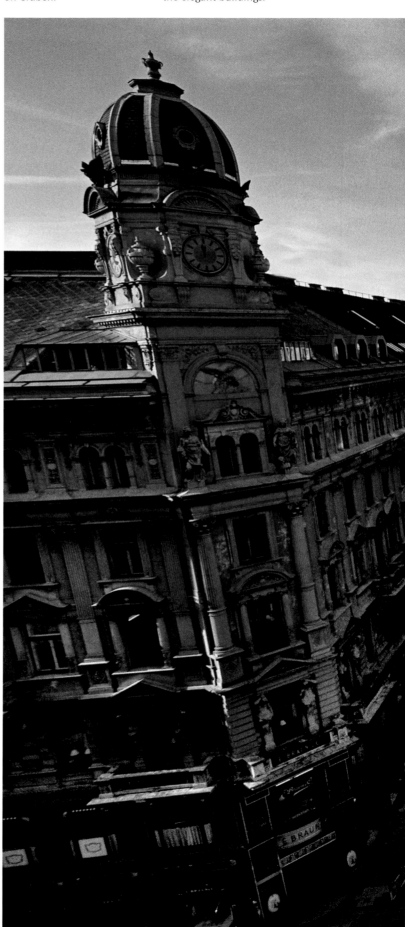

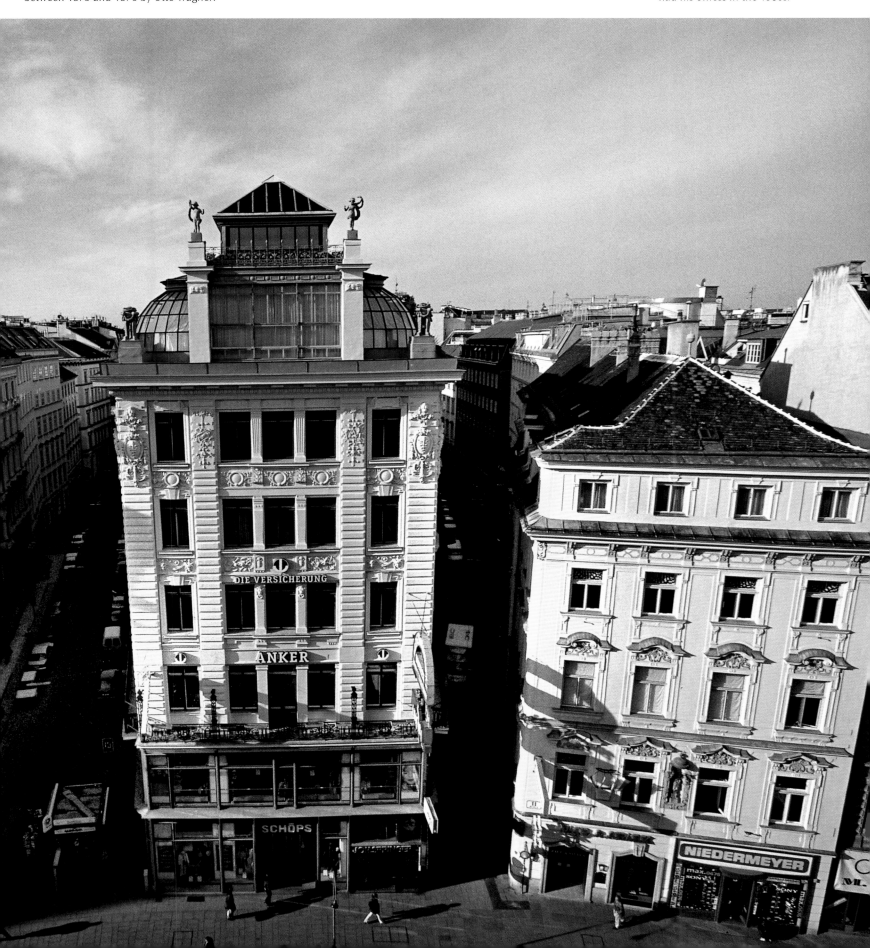

Below:
Several artists, among them
Johann Bernhard Fischer
von Erlach, contributed to the
Pestsäule commemorating
the victims of bubonic plague.
The column was erected by
Emperor Leopold I in 1679.

Below and bottom:
Relaxing to the swinging
rhythms of a local Dixieland
band on Graben after a
hard shop.

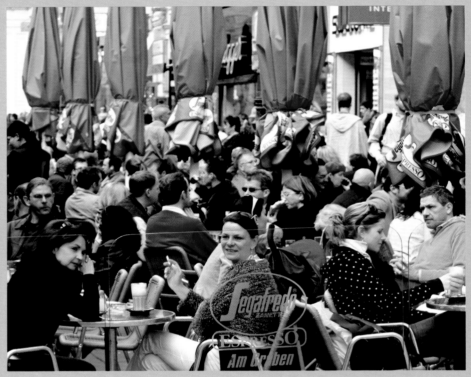

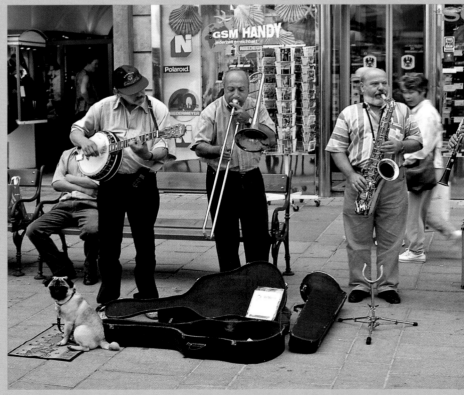

Graben has something of the Mediterranean about it, with plenty of humming street cafés, tinkling, restful fountains – and a place in the shade for one man and his dog.

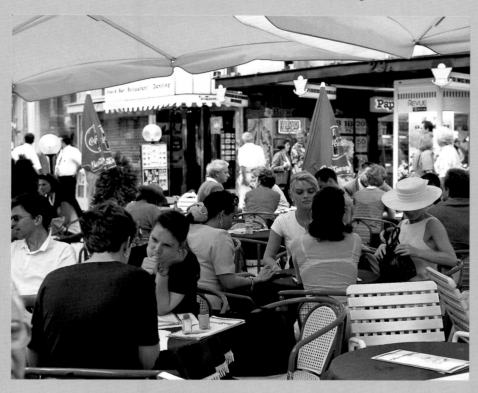

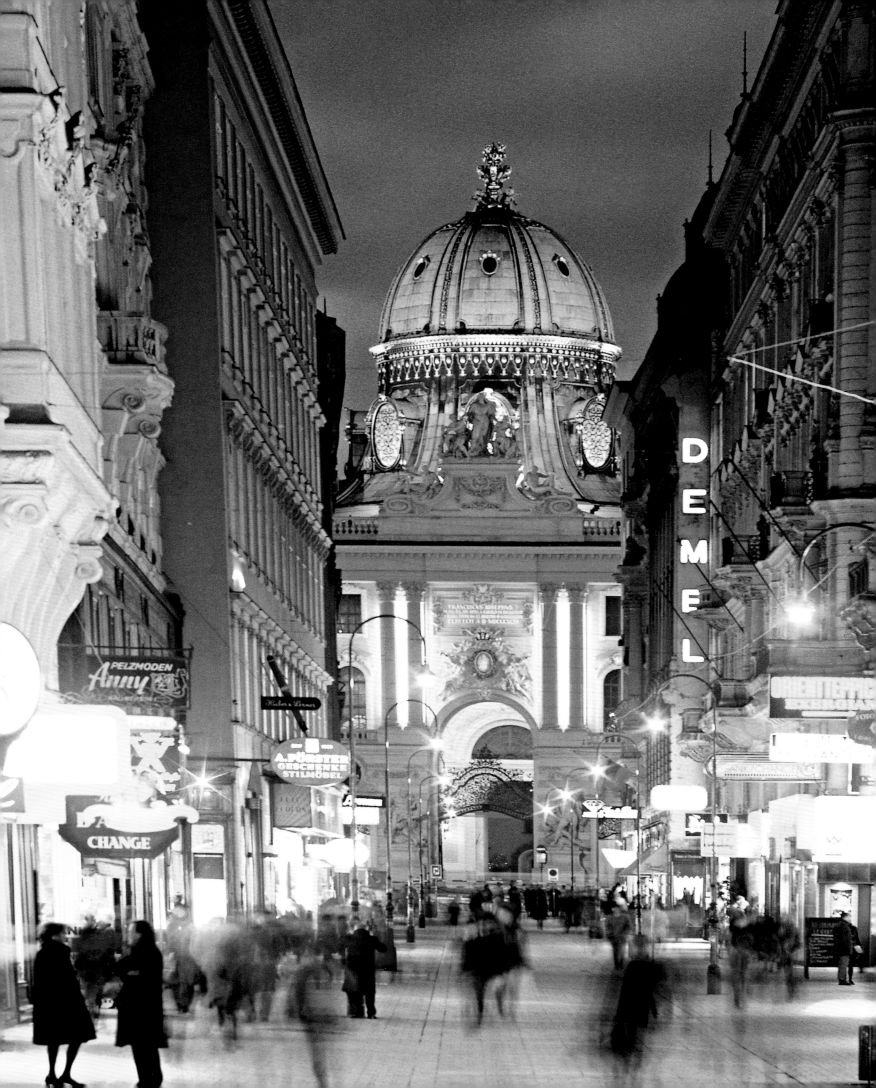

Left page:
Kohlmarkt running between Graben and Michaelerplatz boasts some of the most exclusive and traditional boutiques in Vienna. At end of the street gleams the dome of the Michaelertor.

The high baroque Peterskirche was erected during the reign of Emperor Leopold I at the beginning of the 18th century. It was modelled on its namesake – St Peter's – in Rome.

The ceiling fresco adorning the cupola of St Peter's in Vienna depicts the Ascension of the Virgin Mary and was designed by Johann Michael Rottmayr, one of the master painters of the Austrian baroque.

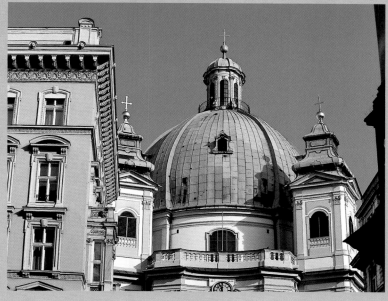

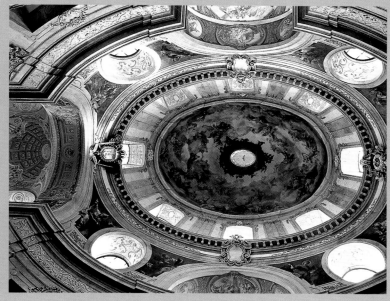

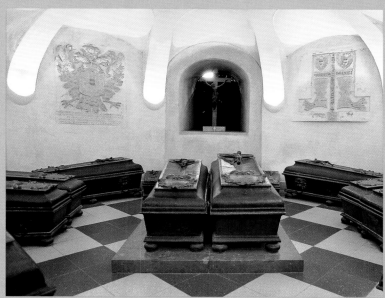

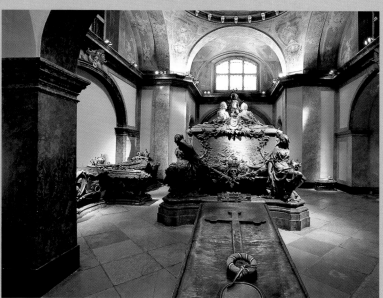

Beneath the choir of St Stephen's lie the imperial catacombs. Rudolph, the cathedral founder, his wife Katharina and several other Habsburgs are buried here, together with the entrails of other members of the ruling dynasty interred in the Kapuzinergruft.

The Kapuzinergruft, the vaults under the Capuchin church, are the final resting place of the House of Habsburg. The ornate double sarcophagus of Maria Theresa and her husband Francis Stephen of Lorraine seems overtly showy compared to the poignantly simple tomb of their ascetic reformer son Joseph II.

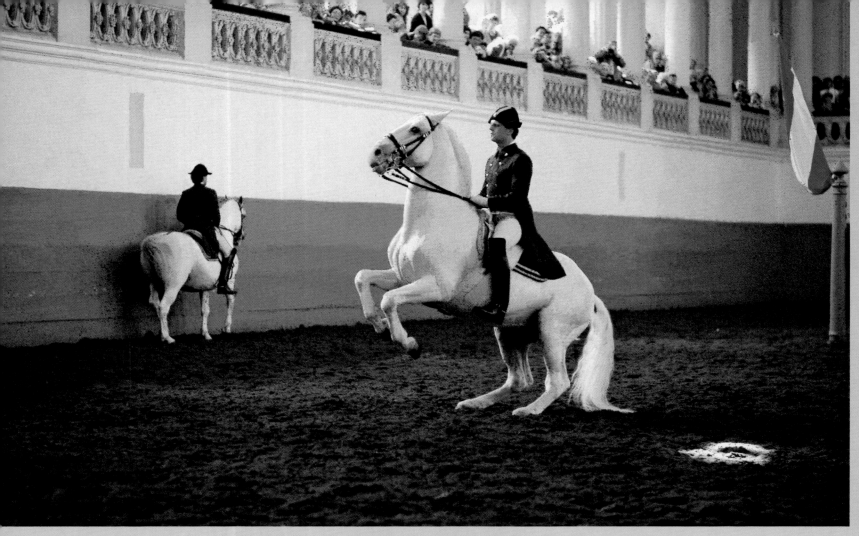

Above:
Performing a levade. The Spanish Riding School was founded in the second half of the 16th century. The present baroque building is from 1735, built by Joseph Emanuel Fischer von Erlach for Emperor Charles VI.

Right:
It takes eight years to train up a horse for the Spanish Riding School. The school has 70 stud Lipizzaner, a breed of horse which can live to the ripe old age of 30. The six sire lines of the animal – Conversano, Favory, Maestoso, Neapolitano, Pluto and Siglavy – are of Spanish, Italian and Arabian descent.

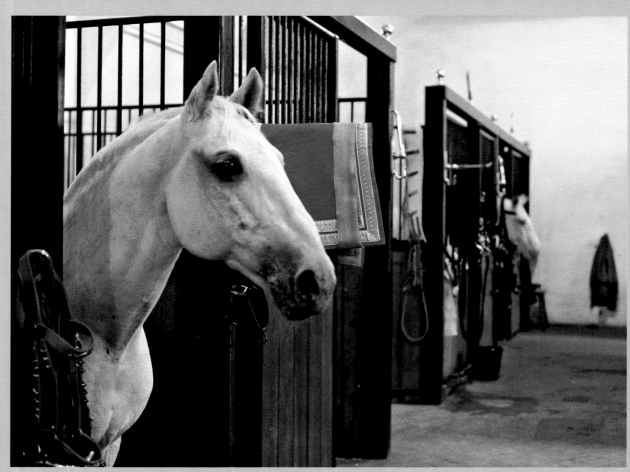

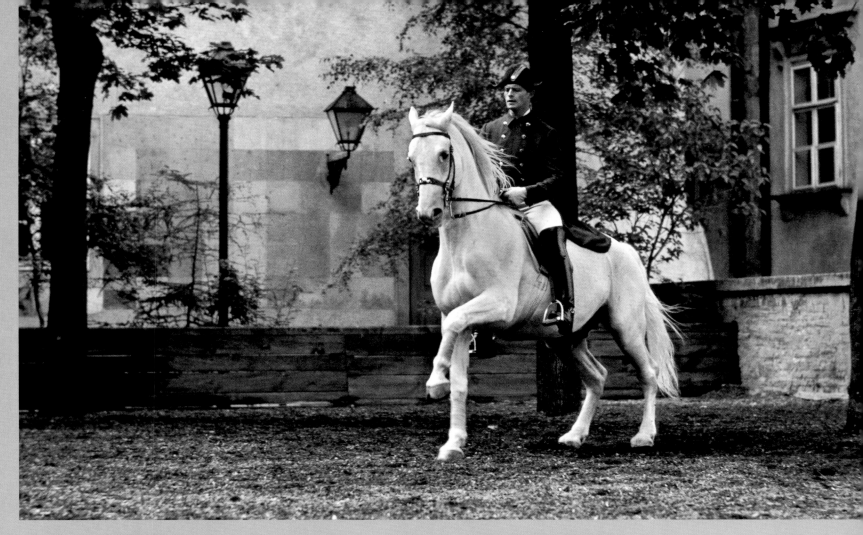

Above:
Perfection calls for the best possible care, daily training – here the morning routine – and absolute trust between man and beast. Strict discipline is also expected of the handlers.

Left:
Even the saddles are polished to a shine and carefully stored when not in use. The horses can be seen in action every weekday morning and on Sundays at special gala shows. More information on this legendary breed is provided by the Lipizzaner Museum housed in the old court chemist's.

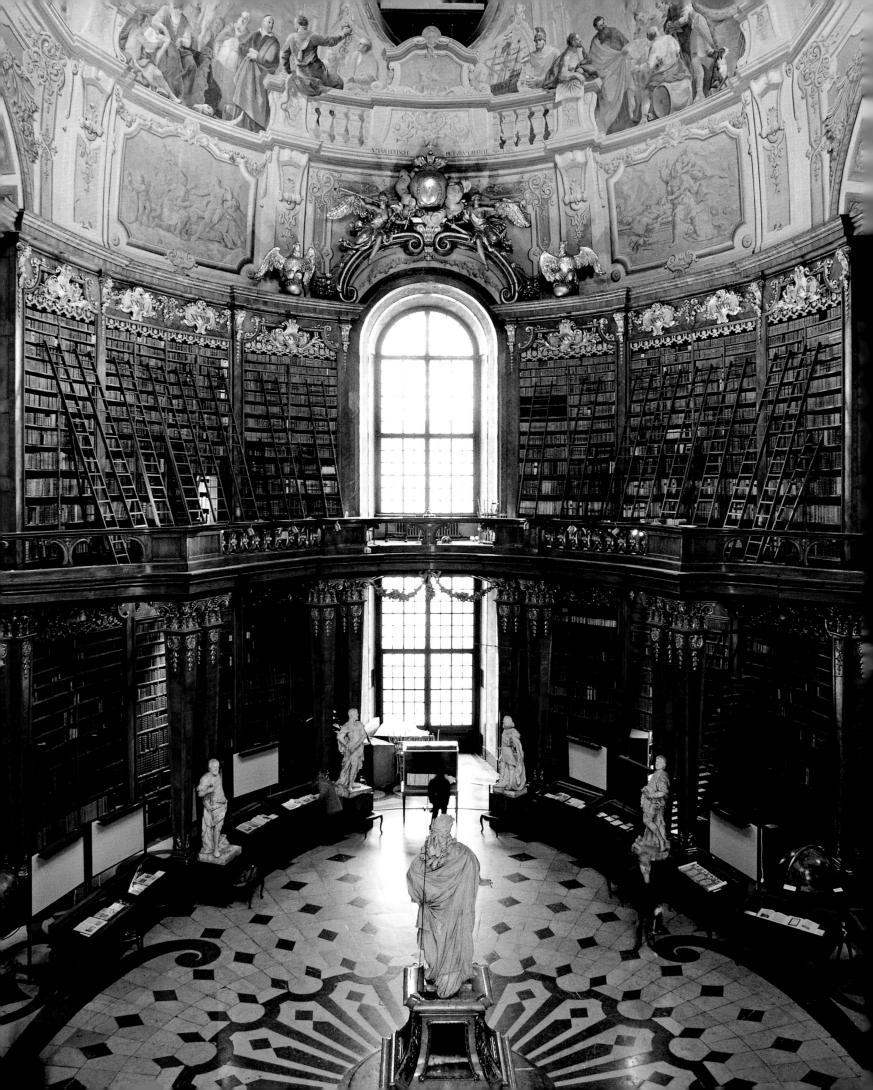

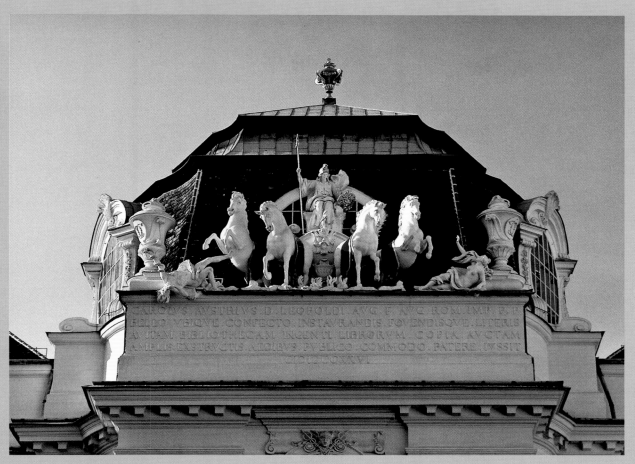

Left page:
One of the most beautiful library interiors in the world can be found at the National-bibliothek (National Library) on Josefsplatz, built between 1723 and 1726 by Johann Bernhard Fischer von Erlach and his son Joseph Emanuel. The central oval shown here contains the private library of Prince Eugene.

Left:
The impressive cupola of the National Library in Vienna, surmounted by Lorenzo Matielli's Quadriga from 1725. Athena, the Greek goddess of wisdom, triumphs over Envy and Ignorance.

Far left:
A concert of Schubert in the Eroica-Saal at Palais Lobkowitz. This resplendent ballroom, a major venue for classical music since 1745, is named after Beethoven's third symphony, which like the forth was premiered here.

Left:
The Michaelerkirche on Michaelerplatz was once the private chapel of the imperial court. Begun in the 13th century, the present facade is from 1792. The figures above the portal by Lorenzo Mattielli depict the angel's fall from grace.

The horse-drawn carriage or "Fiaker" has been a permanent fixture in Vienna for over 300 years. Initially the taxis of the well-to-do, there were once no less than seventy cab stands distributed across the city. Today there are only about half a dozen left. Many of today's drivers still wear the traditional bowler hat, bringing a touch of romance and a sense of nostalgia to the heart of Vienna.

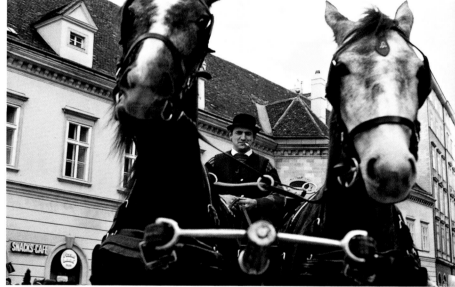

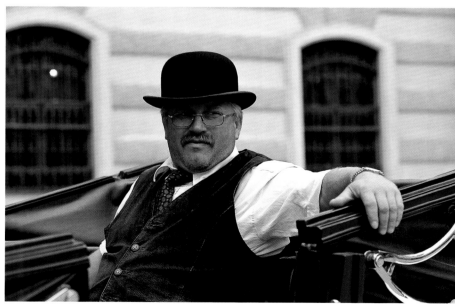

Right:
Naglergasse doesn't just have the best baroque facades in the centre of town; it also has a pleasing number of traditional cafés, pubs and restaurants where tired tourists can gather their strength for the next bout of sightseeing.

Far right:
This 16th century house was once a desirable residence "on the strand" (Am Gestade), built on a side arm of the Danube which used to pass this spot. The river has since been redirected but the medieval name remains.

Street cafés in Vienna have a long tradition going back to 1840 when the first tables, chairs and pot plants were placed enticingly on the pavement. No self-respecting coffee house would today be without its "outdoor living room".

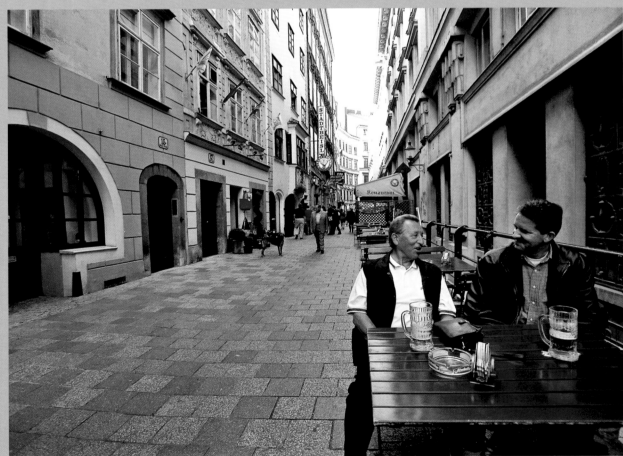

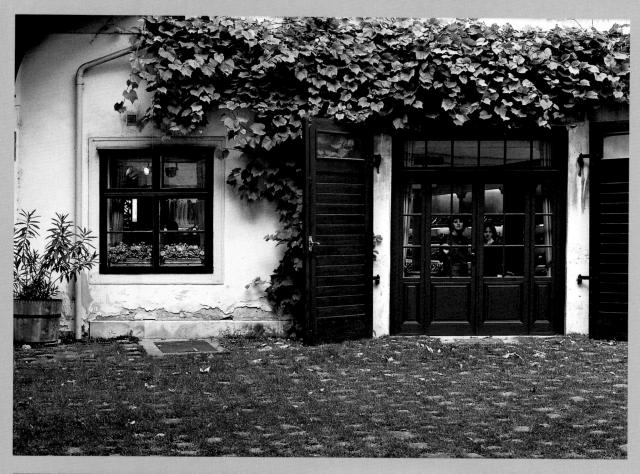

Just a few steps away from Vienna's congested streets there are a surprising number of green oases of calm and tranquillity, such as the Deutschordenhof on Singerstraße where Mozart once spent a few weeks in 1781.

A courtyard tucked away behind the Michaelerkirche on Kohlmarkt. This too has a musical connection; Joseph Haydn lived in an attic here for several years. Poet Pietro Metastasio also lived and died here.

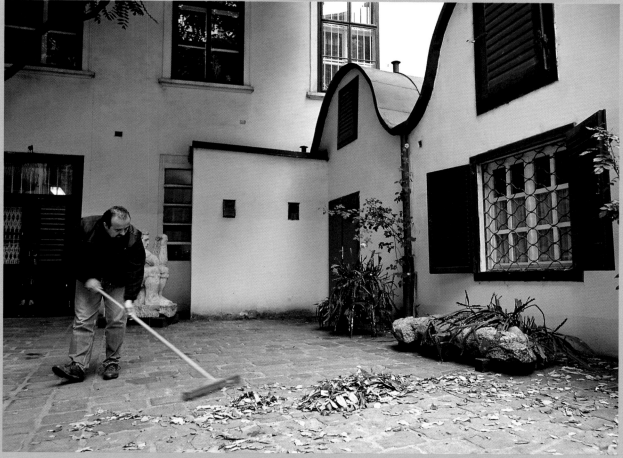

Above:
Originally a doctor, Arthur Schnitzler (1862–1931) later become known for his observations of Viennese society at the turn of the 19th century.

Above centre:
The work of Franz Werfel (1890–1945) centres on the struggle between his Jewish background and his strong leanings towards Catholicism. His best-known novels are "Verdi", "Die vierzig Tage des Musa Dagh" (The Forty Days of Musa Dagh) and "Das Lied von Bernadette" (The Song of Bernadette).

Above right:
In his novels textiles engineer Hermann Broch (1886–1951) traversed the boundaries of the traditional narrative in the search for new forms of literary expression.

"When I'm completely out of material I turn to the clock of St Stephen's. It's always got a little something tucked away in its clock mechanism. I visit it regularly, like you would an ageing aunt who you know is no longer quite all there but always has some sweets or other titbits hidden away in a cupboard." In an endearing but sarcastic tone Viennese critic Joseph Roth targets the temperamental cathedral clock which often stops, is too fast or too slow, doesn't keep time with the other steeple clock faces and so on and so forth. In a less accommodating frame of mind Karl Kraus clearly voices his contempt of Vienna when he says: "... the Viennese must be bad lyricists if they think that their puddings are sheer poetry which melts in the mouth."

When writers get going on Vienna, whether they live here permanently or are just passing through, both pencils and tongues are sharpened. Art historian Egon Friedell, for example, accuses the Viennese of being "unresponsive" and tersely remarks that there are people here who are too stupid to be the subject of prejudice. Georg Kreisler sighs: "Vienna would be so lovely without the Viennese, like a woman asleep. The city park would surely be much greener and the Danube would finally be so blue." Thomas Bernhard condemns it as "an enormous cemetery of crumbling, decaying curios". In comparison Swedish poet Per Daniel Amadeus Atterbom, who visited Vienna at the beginning of the 19th century, is almost harmless in his assessment of Vienna as "the capital of the dozy".

VIENNESE MELANCHOLY

Although equally disappointed with the Austrian capital, Theodor Adorno strikes a more positive note in 1967. For him, tarmacking the paths in

Above left:
He wrote "Everyman", plays, poems and opera libretti such as the "Rosenkavalier" and "Die Frau ohne Schatten" (The Woman Without a Shadow) which were set to music by Richard Strauß: Hugo von Hofmannsthal (1874–1929).

Above:
Karl Kraus (1874–1936) had a love-hate relationship with his native city, comparing life here to a book of badly executed cartoons "where the figures are characterised by rigidity".

Left:
The metropolis of Vienna has influenced German literature like none other and still today is the voice of contemporary writing. Here, Elfriede Gerstl reads from one of her latest publications.

Centre:
Johann Nestroy, Stefan Zweig, Robert Musil and Georg Trakl are a few of the many famous authors to come out of Vienna. Writer Doron Rabinovici is just one of the many to tread in their footsteps.

the Prater marks the end of Viennese melancholy. Catholic writer Reinhold Schneider, however, finds plenty to be morbid about in Vienna. He spent a few months here in 1957 and 1958, writing a philosophical diary entitled "Winter in Vienna". In it he claims: "The föhn wind, piercing bolts of lightening, nervous tension and an inconsolable feeling of dark premonition are inseparable from the melody of the waltz and the "Radetzky March". I escape to a small theatre time and again; the chandelier hovers above my head as black as the night, evil, dark, glowing eyes." Perhaps the dark premonition was all his own imagining; Schneider died one month after leaving the city.

In defiance of such doom and gloom one should mention priest to the Viennese court Ulrich Megerle, better known under his religious pseudonym Abraham a Sancta Clara. His fiery sermons were popular for their tempestuous language and feared for their brutal frankness. He once had the presumption to claim that the women of Vienna who had the audacity to follow the foolishness of fashion did not deserve to be touched with a barge pole. This time he had gone too far. He was forced to retract his remarks. The following Sunday he announced that he wished to amend his statement, claiming that such women didn't deserve to be touched with a barge pole; on the contrary: "They do deserve it!".

Journalist Alfred Polgar has the final word on the subject of Vienna. Sarcastic to the last, he writes: "Vienna will stay as it is – and that's about the worst thing you can say about this city."

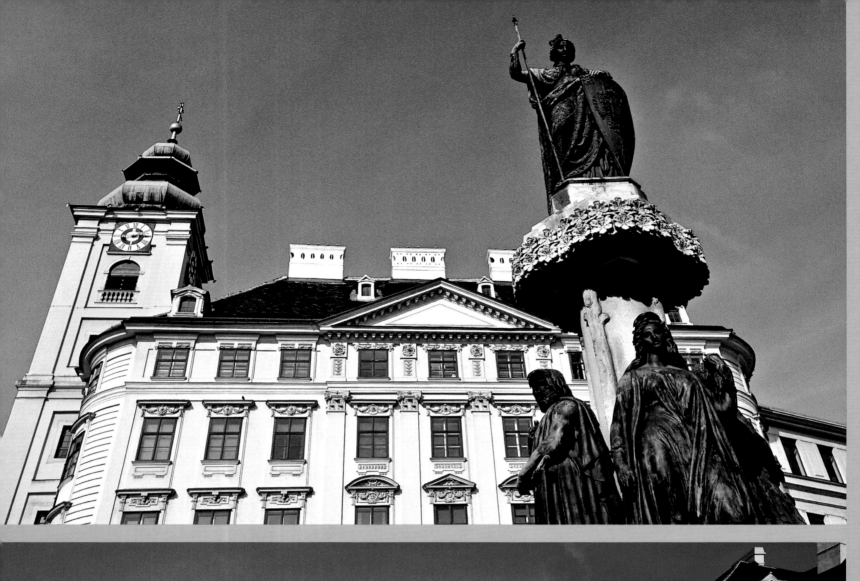

Left:

The Austria Fountain shown here was designed by Ludwig Schwanthaler. Behind it is Freyung Monastery founded by Irish-Scottish monks who were summoned to Vienna from Regensburg by Duke Heinrich Jasomirgott II in 1155. Their seminary was to be a safe house for refugees, hence the name "Freyung" which means "freedom".

The steeple of Maria am Gestade is an elaboration in Gothic. The church was begun in c.1330 and deconsecrated in 1786, after which it gradually fell into disrepair. Emperor Joseph II wanted to tear it down completely and build a pawnshop in its place; luckily, demolition proved too expensive and the church was spared. It was restored and reopened in 1812.

Etablissement Ronacher on Seilerstätte was Vienna's most dazzling music hall where Josephine Baker once performed. After the Burg-theater had been heavily damaged during the Second World War Ronacher provided an alternative venue. It was later a television studio before finally being reopened as a show theatre.

Left:

Vienna's largest enclosed square, Am Hof, was once the site of a Roman fortress. During the 12th century the Babenbergs built a castle here. On the left in the background is the old public arsenal from the 16th century with a golden ball surmounting its front gable.

Detail of the facade of what was once the Bohemian Royal Chancellery. It was from here that the Habs-burgs once ruled Bohemia. Today the building is used by the Austrian courts.

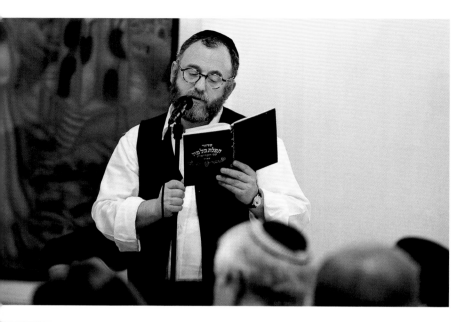

Top left:
The Jewish community in Vienna enjoys a rich religious, cultural and social life. Chief Rabbi Paul Chaim is shown here reciting at a festival at the community centre.

Centre left:
The Stadttempel is the oldest remaining synagogue in Vienna. Biedermeier architect Joseph Kornhäusl hid it away behind a block of flats as at the time of its construction non-Catholic houses of worship were not allowed to be recognised as such. This saved the synagogue during the Third Reich.

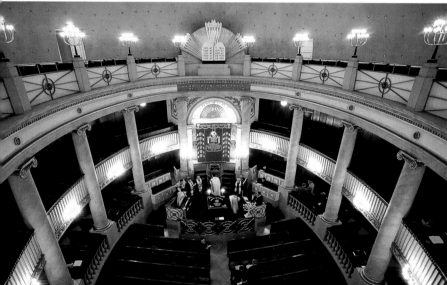

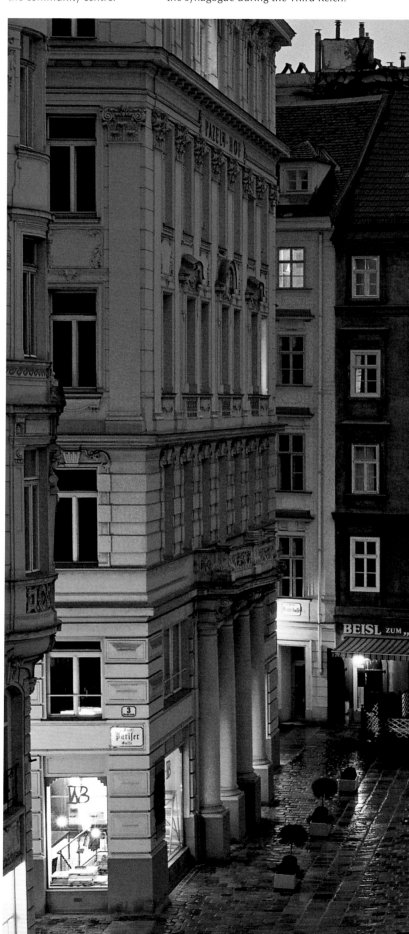

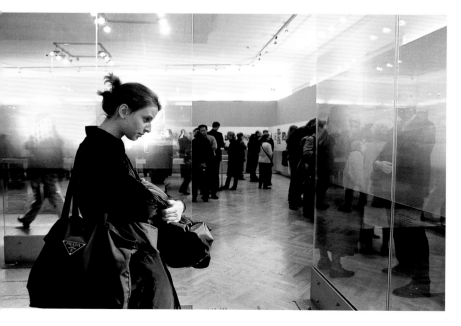

Bottom left:

Bottom left:
The Jewish Museum charts the history of the Jews in Vienna from the first medieval communities and ghettos to their expulsion and finally brutal eradication by the Nazis. It also documents the blossoming of Jewish culture in the 19th century and the day-to-day concerns of the present thriving Jewish community.

Below:
Judenplatz is dominated by Rachel Whiteread's Holocaust Memorial. It represents a library turned inside out, commemorating the 65,000 Viennese Jews who were murdered in the death camps. This is where the largest synagogue north of the Alps once stood, destroyed in 1421.

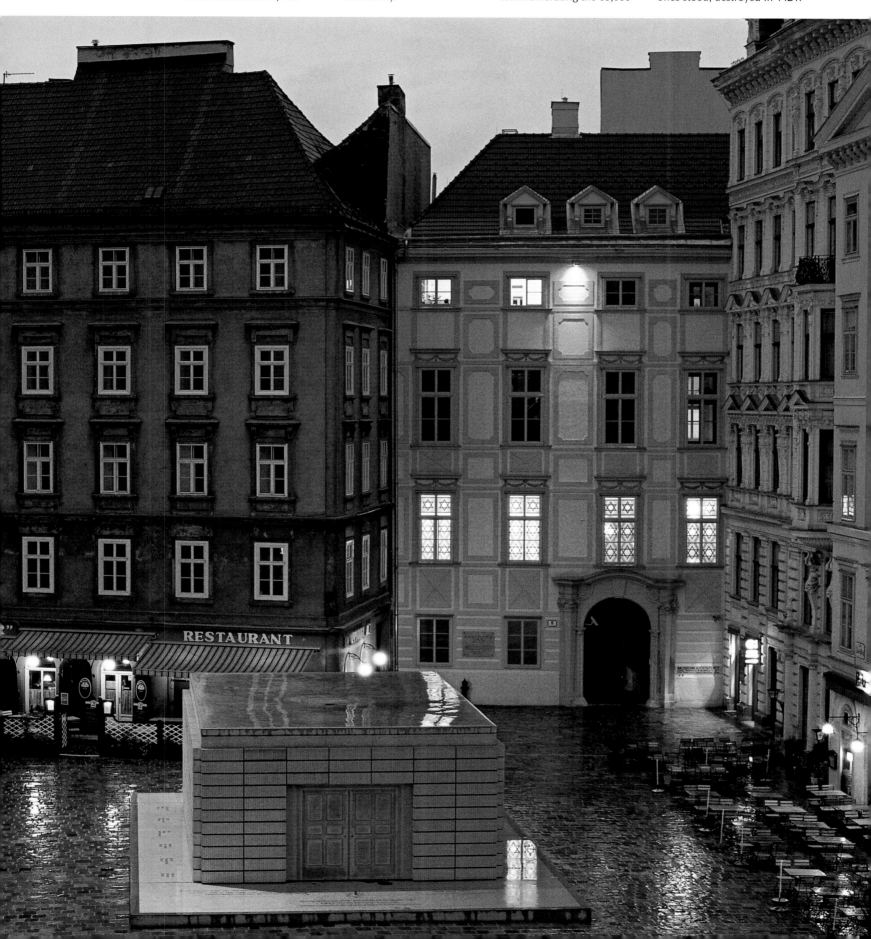

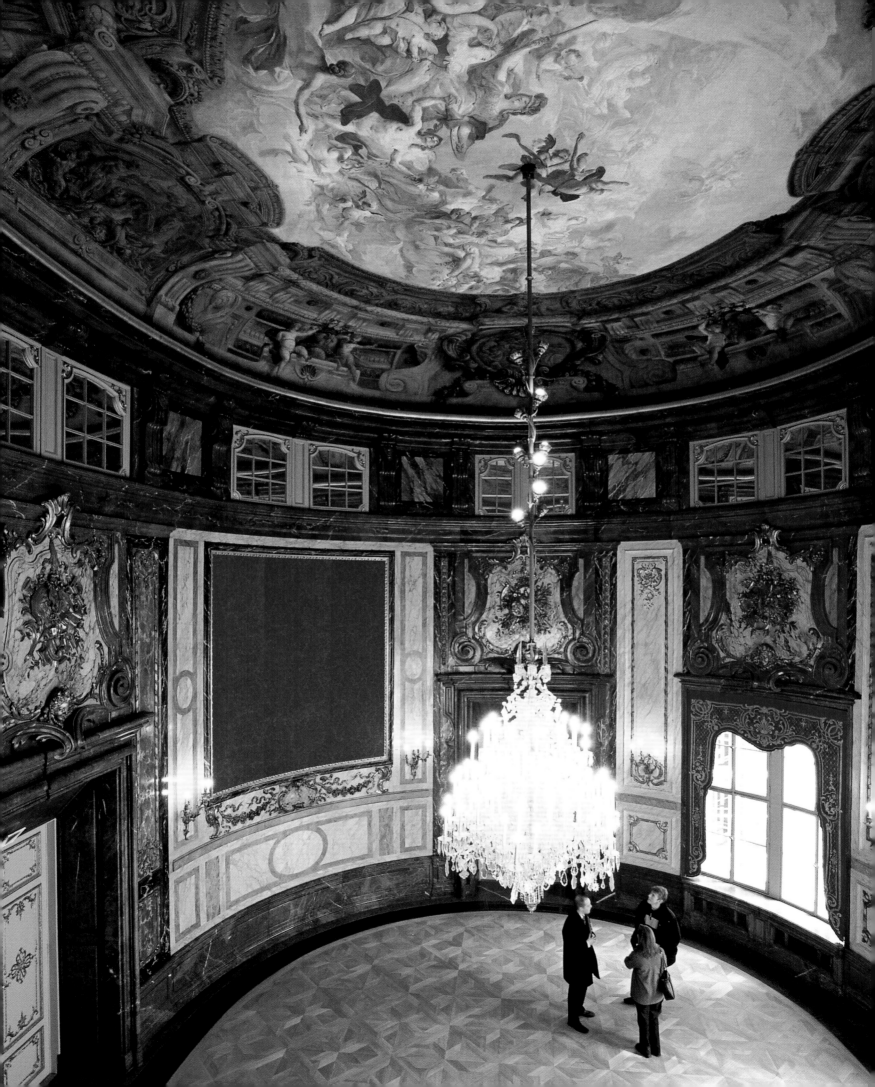

Palais Daun-Kinsky was built between 1713 and 1716 by Johann Lukas von Hildebrandt and is his second most magnificent secular building after Schloss Belvedere. The palace was commissioned by the father of Maria Theresa's field marshal Leopold Joseph Daun who rides alongside the enormous Viennese statue of the empress. The building was owned by the Kinsky counts from 1790 to 1986 and was subsequently extensively restored. In the oval ballroom above the entrance (left page), which is often used for concerts, the ceiling is painted with allegorical frescos by Carlo Carlone. The walls of the room are panelled with marble. Even the Dutch stove in the corner of the Herrensalon is a sumptuous work of art.

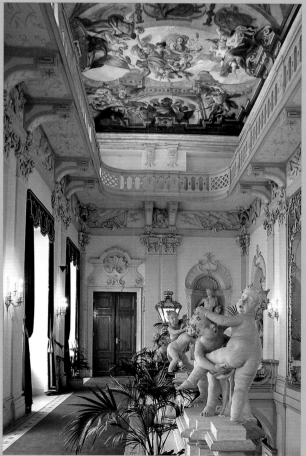

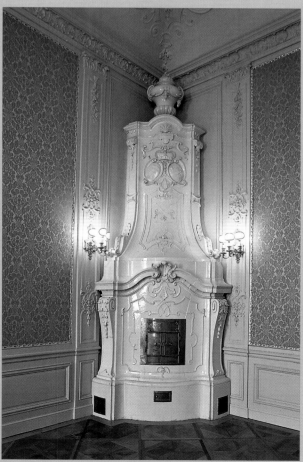

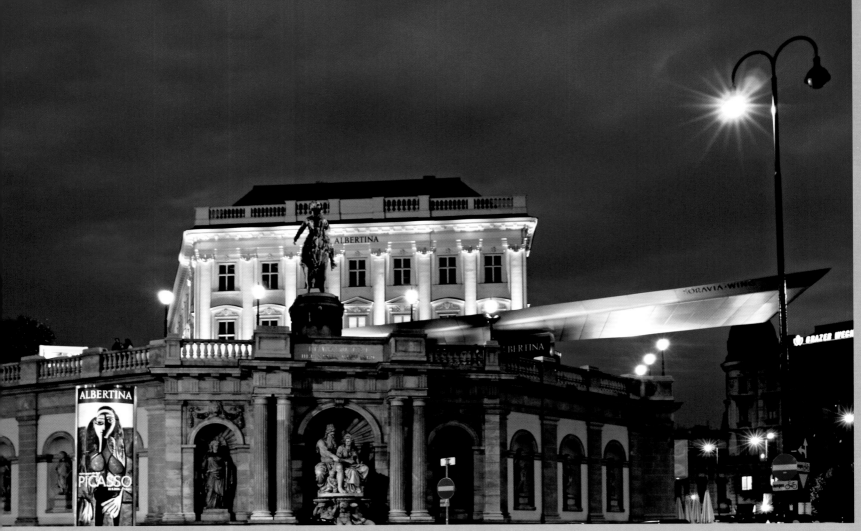

Above:
The Albertina in the old palace of Archduke Albrecht houses one of the biggest major collections of graphic art in the world. It contains ca. 50,000 drawings and one million printed graphics, including works by Michelangelo, Raffael, Dürer, Schiele, Klimt, Warhol and others. The Albertina also has photographs, architecture and posters on display.

Right:
The Habsburg state rooms in the Albertina were installed by the founder of the Albertina, Duke Albert of Saxony-Teschen, between 1801 and 1807. The grand terrace outside the balcony room offers magnificent views of the palace grounds, once the private gardens of the emperor and his family.

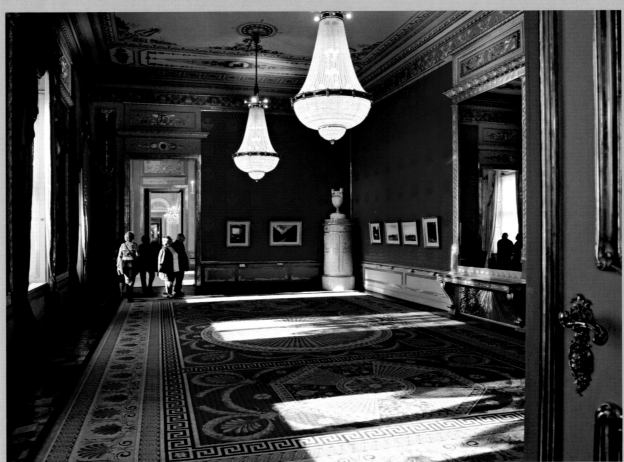

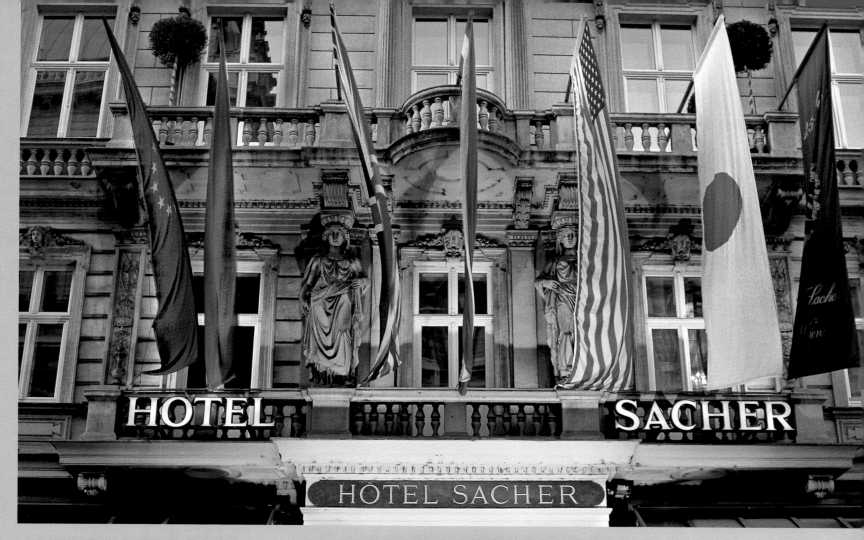

Above:
Hotel Sacher is a Viennese institution. Opened in 1876 as Hôtel de l'Opéra, it quickly spiralled to fame with its famous chocolate Sachertorte, 270,000 of which are made and exported all over the world each year.

Left:
You don't have to worry about finding a space when you roll up outside Hotel Sacher; the hotel has a professional attendant who'll park your car for you.

Zum Schwarzen Kameel on Bognergasse is named after its founder Johann Baptist Cameel who in 1618 had a spice emporium here. This has since become a traditional restaurant serving outstanding Viennese cuisine. Beethoven, Schubert, Brahms and Johann Strauß all dined here. The Jugendstil interior from 1901 makes the building one of the most beautiful restaurants in the whole of Vienna (top). The Kameel also has a mouth-watering delicatessen and wine merchant's (bottom).

Architect Adolf Loos from Brno in the Czech Republic spent three years in America in the late 19th century before settling in Vienna. He spoke out against Jugendstil and the Wiener Werkstätte, his more progressive designs greatly influencing architectural developments in the 20th century. His 1908 interior at the American or Loos Bar clearly looks towards the future.

Below:
The old Babenberg Passage underpass on the ring road has been turned into a popular disco. Passage's unusual location and various events often attract famous names to its humming bar.

Below and below right:
Culinary Viennese delights. The "Wiener Schnitzel" served at Figlmüller's is absolutely legendary and so large that it seems to spill off the plate. The pork is wafer thin so that the pores close rapidly when fried, keeping the meat juicy and tender. The term "Wiener Schnitzel" was first used in cooking in c.1900. Prior to this date thin pork steaks covered in breadcrumbs were a speciality of the Weinviertel where they were served at farm weddings.

Right page:
The Steirereck restaurant in the Stadtpark is one of Vienna's top eating establishments and revered throughout the whole of Austria. The chef de cuisine is Heinz Reitbauer who is aided in his successful endeavours by an entire army of young trainees.

Weibel's Wirtshaus on Kumpfgasse near St Stephen's Cathedral is another gastronomic institution. In summer their top-quality wines are also served outside in the obligatory restaurant garden.

SECOND HOME OF THE INTELLECTUAL –
THE COFFEE HOUSE

Above:
Fashions come and go but the waiters – ever distinguished, discreet and polite – at Bräunerhof on Stallburggasse and other such establishments of renown haven't changed a bit.

Centre:
Vienna's coffee houses all vie for the unofficial title of Most Famous Coffee House in the World. Demel on Kohlmarkt is certainly in the top ten.

The term "fin de siècle" is used to describe the bourgeois in society, art and literature at the turn of the 19th century. The Viennese coffee house was at the centre of this, the perfect embodiment of the mood of the age. Much more than humble cafés where coffee was drunk and pastries were consumed, the coffee house was the second home of the intellectual where scholars, artists and politicians convened, hotly debating the issues of the day, dreamily watching the world go by or composing one of their many tracts.

Joseph Roth was one such candidate who liked to write his novels firmly ensconced in a coffee house armchair. In "Kapuzinergruft" his protagonist conjures up the atmosphere: "It must have been about seven o'clock in the morning when we got to Café Magerl. The first baker's boys were arriving, as white as snow and smelling of crisp rolls, poppy seed pastries and salt sticks. The first fresh coffee, virgin and aromatic, bore the scent of a second morning." The café in question no longer exists. Other traditional establishments are still going strong, however, or have been reopened. Demel, Landtmann, Bräunerhof, Central, Dommayer, Hawelka and Sperl have all managed to retain something of the "fin de siècle" about them.

The first "coffee roaster" is generally said to be Georg Kolschitzky, an imperial spy during the second Turkish siege of Vienna. The legend goes that in 1683 he was given sacks of strange brown beans (coffee) abandoned by the sultan's retrea-

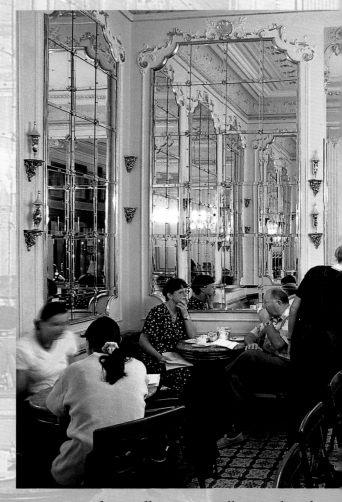

ting army. In fact, coffee was actually introduced to the Viennese by two men from Armenia, long before Kolschitzky's éclat.

Only the uninitiated order a simple coffee in Vienna. Drinking coffee is an art here. There is the large or small "Schwarzer", mocha without milk; with milk it's a "Brauner" (brown coffee). Café au lait or milky coffee is a "Melange", sometimes topped with whipped cream and sprinkled with cinnamon or cocoa. A "Schwarzer" in a glass mug with rum is a "Fiaker"; with cream the same

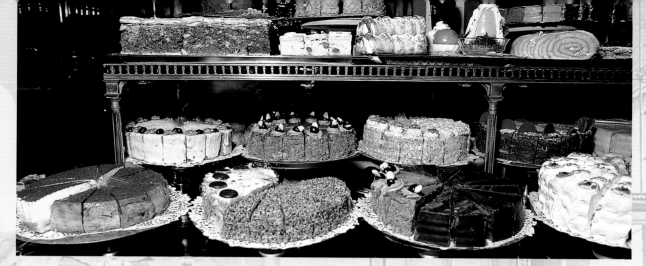

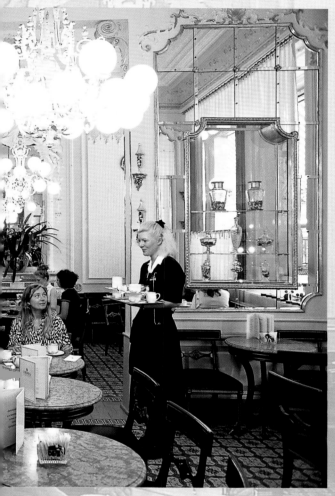

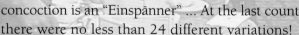

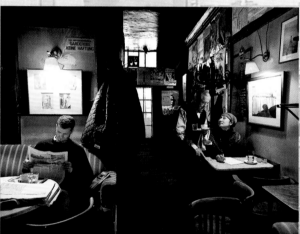

concoction is an "Einspänner" ... At the last count there were no less than 24 different variations!

Coffee is traditionally accompanied by one of Vienna's many "Mehlspeisen", maybe an apple strudel, yeast "Buchteln" buns or "Palatschinken" (a thin, filled, sweet pancake). If you want the full monty – "Sachertorte" at Hotel Sacher – be prepared for a long wait ("You will be seated!") and high prices. To pass the time you can learn about how the rich chocolate gateau was first created. In 1832 Count von Metternich commissioned his chef de cuisine to make him a delicious dessert. The master cook suddenly fell ill and the royal order was passed down to his apprentice, one Franz Sacher. "The rest is history", claims Sacher's glossy brochure. "Today our sweet secret is still made using the original recipe from 1832 and exported to almost every country in the world."

To close, the poet Arthur Schnitzler offers a fitting summary of the Viennese coffee house: "The waiter is forgetful, the cashier ugly, the walls grey, the lighting poor – that's what I like about it."

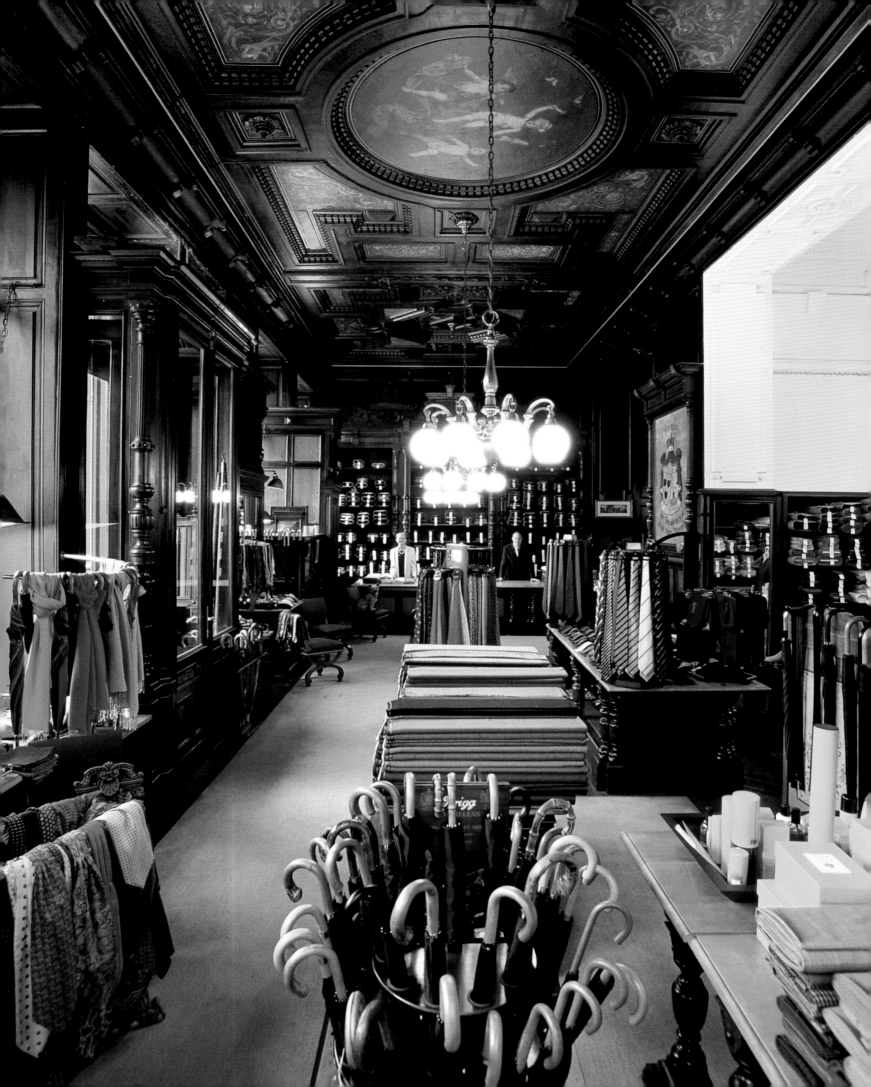

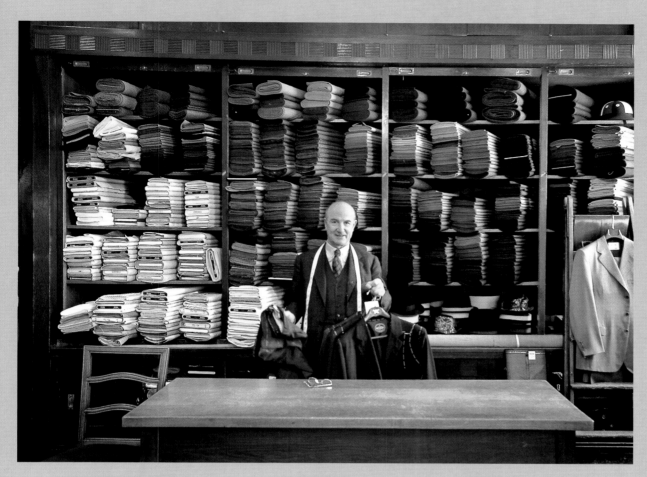

Left page:
You can literally shop like an emperor (or empress) at Wilhelm Jungmann's store on Albertinaplatz, founded in 1866. This noble purveyor of items of silk and wool was just one of the many official suppliers to the imperial and royal family.

Knize on Graben, once the royal tailor, has retained its original Adolf Loos interior from 1910 in its entirety.

The House of Habsburg and other well-heeled members of the aristocracy purchased their tailor-made shoes and riding boots from court shoemaker Rudolf Scheer & Söhne on Bräunerstraße.

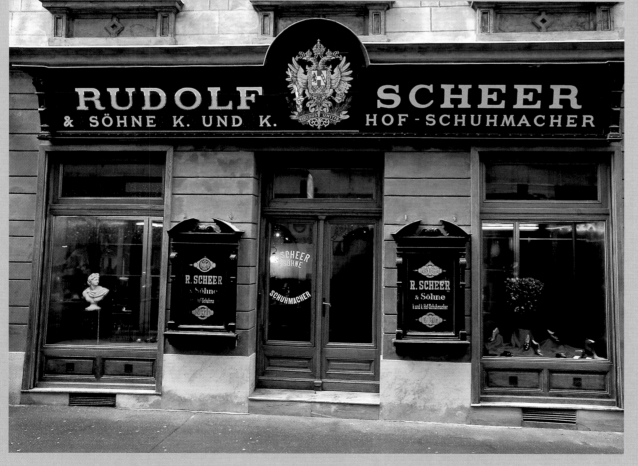

RUDOLF SCHEER
& SÖHNE K. UND K. HOF-SCHUHMACHER

Only the best are allowed to give themselves the epithet "K.u.K. Hoflieferant" (purveyors to the imperial and royal court). Many of these elegant stores have all the flair of a bygone age; even the odd member of the royal family is still there to keep an eye on the sales personnel, albeit in image alone. Despite the air of nostalgia these hallowed halls are certainly not just museums; still fully functional, they offer visitors to Vienna some of the most exclusive shopping in town.

Picture framer and gilder extraordinaire C. Bühlmayer on Michaelerplatz, for example has an entire range of beautiful and exquisite goods, professionally marketed by proprietor Dr Michael Haider (below left and bottom right page).

For the best in chandeliers J. & L. Lobmeyr's is the place to go (below right). And antiques dealer Reinhold Hofstätter may not actually be a court purveyor but he certainly has plenty of choice artefacts for sale at his shop (top right page).

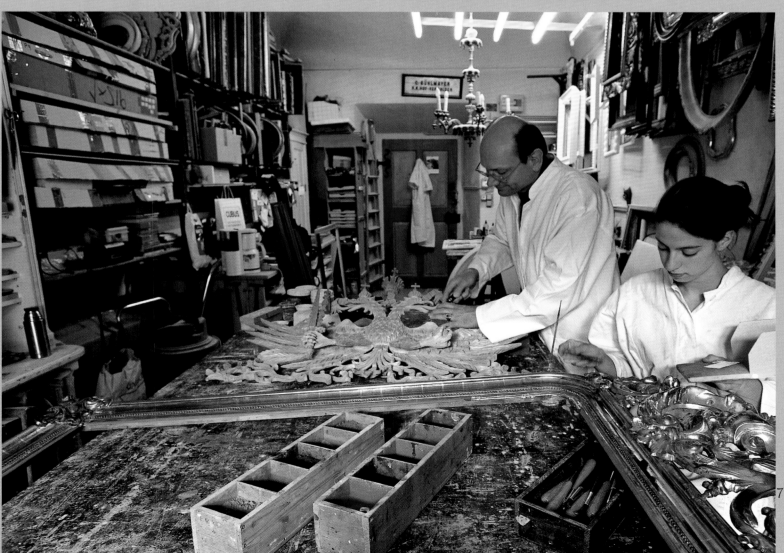

75

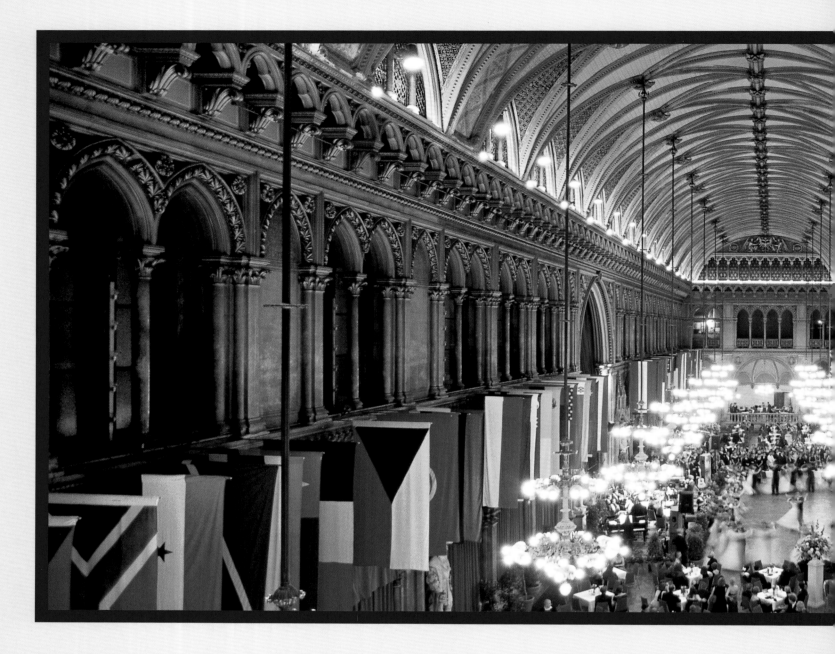

PALACES AND PARKS – THE RINGSTRASSE

For centuries the heart of Vienna was constricted by the forbidding city defences. To great sighs of general relief in 1857 the ramparts and bastions were torn down to make way for the Ringstraße, an avenue of imperial proportions lined with monumental edifices, royal palaces and lush parks. The Stadtpark, laid out as an English landscaped garden in 1862, is a haven of peace and quiet in the middle of town through which the River Wien runs, its source in the nearby Vienna Woods. Statues dotted about the grass pay homage to the famous of Vienna; Johann Strauß fiddles and Franz Schubert composes alongside other men of renown, Robert Stolz, Anton Bruckner and Sebastian Kneipp among them.

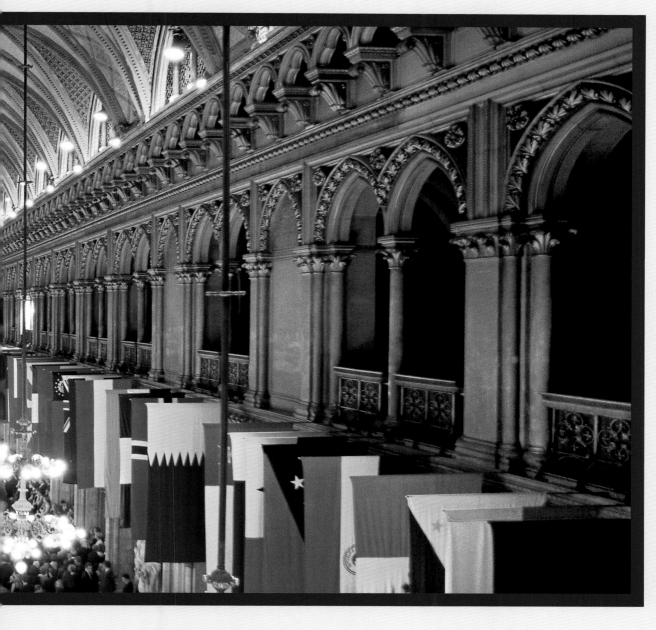

The grand ballroom at the Rathaus or town hall is a glittering venue for exhibitions, award ceremonies, concerts and celebrations on a huge scale, such as the famous Jungbürgerball. Friedrich von Schmidt, who built the Rathaus, planned the room down to the last detail – from the sparkling chandeliers to the ornamental mountings on the doors. In 1999 the ballroom was painstakingly renovated. The glass windows which had been shattered during the Second World War were reconstructed with as much care and attention as the magnificent oak floor, restoring one of the most marvellous Viennese interiors of the late 19th century to its former glory.

A few streets away lies the elongated Schwarzenbergplatz, beyond which, according to a bon mot delivered by Count von Metternich, the Balkans begin. Rennweg is supposedly the place where East meets West in a city where for centuries peoples and cultures from the Orient and the Occident have come together in times of war and peace.

Following the Ring clockwise you hit upon two veritable temples of the muse: the Musikvereinsgebäude (the Society of Friends of Music building), built by Theophil Hansen, and the Künstlerhaus (artists' house). The New Year's Day concert given by the Vienna Philharmonic each year is broadcast from the ballroom of the former, one of the best concert halls in the world. The Künstlerhaus was where the artists of Vienna once convened and exhibited their work and is still owned by the original society today. It's now used as a forum for art aficionados of all disciplines.

Not far from here is the Karlskirche, the second major place of worship in Vienna after St Stephen's Cathedral. When in 1713 the bubonic plague ravaged Vienna yet again, costing 8,000 lives, Emperor Charles VI pledged to erect a church if the saint it was dedicated to – St Charles Borromeo – put an end to the dying and suffering. The magnificent building, with its green cupola

Right:
The Musikvereinsgebäude is not only the seat of the Society of Friends of Music and an international concert venue. It's also home to the Vienna Philharmonic, the Vienna Male Voice Choir, music publisher Universal Edition, famous piano manufacturer Bösendorfer and violinmaker to the Vienna Philharmonic Otmar Lang.

Above:
Johann Andreas von Liebenberg performed great services during the year of the plague in Vienna and was made mayor of the city for his pains during the second Turkish siege of 1680–1683. In 1890 a column was erected in his honour opposite the university, topped by this gilt goddess of victory.

flanked by victory pillars, was constructed between 1716 and 1739 by Johann Bernhard Fischer von Erlach and his son Joseph Emanuel.

Opposite the Hofburg are the museums of art and natural history and in the Messepalast the new museum quarter opened in 2001, venue for exhibitions and home to several museums ranging from the Leopold collection of masterpieces of modern Austrian art to a museum for children.

In the Kunsthistorisches Museum (Museum of Art History) are the countless art treasures collected by the Habsburgs throughout the centuries, spanning a time scale from Ancient Egypt to the end of the 18th century. Breughel, Dürer, Raphael, Rembrandt, Rubens, Tintoretto, Vermeer: everybody who's anybody in the history of art is featured here. The Naturhistorisches Museum (Museum of Natural History) has made it into the world's top ten of museums for its modern presentation. One example of this is a video of freshwater fish as

you've never seen them before. Graceful and elegant, they swim apparently in perfect, coordinated time to the dulcet tones of a Viennese waltz. The spectrum of exhibits ranges from fossils to stuffed extinct animals, from dinosaur skeletons to the famous Venus of Willendorf, a tiny stone figure thought to be ca. 25,000 years old whose purpose is still a bone of contention to the archaeological community. The splendid café under the museum dome is a good place to round off a visit, savouring one of Vienna's many different coffees. You'll be in good company; the largest statue in town watching over the twin museums is of Empress Maria Theresa.

One of the high points of 19th-century Viennese town planning is the ensemble of the parliament, town hall and university buildings erected between 1872/73 and 1883. The architect behind Vienna's seat of government, Dane Theophil Hansen, based his designs on those of Ancient Greece in deference to the birthplace of the

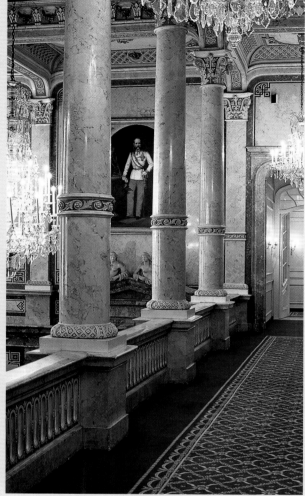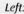

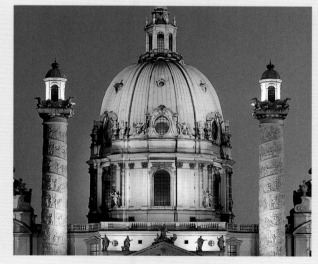

Left:
Hotel Imperial on Kärntner Ring opposite the opera house was originally built as a palace for the duke of Württemberg. Less than ten years after its completion in 1865 the palace was turned into a hotel; the duke had by then lost interest in his regal dwelling, with Theophil Hansen's new Musikvereinsgebäude now blocking his view of the River Wien.

Centre:
The Karlskirche, Vienna's main baroque church, was built in honour of the patron saint of the bubonic plague, St Charles Borromeo, by father and son Fischer von Erlach in the 18th century. The twin pillars flanking the exterior are modelled on the Trojan Pillar of Rome and decorated with spiral reliefs depicting the life and work of St Charles.

Lit up at night, it bursts with the self-confidence of the metropolis. And as the thirst for knowledge was the driving force behind the Renaissance, it was on this period that Heinrich Ferstel decided to model his university. These three buildings surround the Rathauspark, with the Burgtheater making up the complement on the far side of the Ringstraße.

The neo-Gothic Votivkirche (Votive Church) behind the university was built for more personal reasons. In 1853 Emperor Francis Joseph I survived an attempted stabbing. His brother Ferdinand Maximilian – later the emperor of Mexico who himself was murdered in 1867 – promptly initiated a fund-raising campaign in thanks for Francis Joseph's recovery. Money was sent in from as far afield as Syria and Egypt but enthusiasm for the project soon waned. The church, planned by Heinrich Ferstel, was finally completed to coincide with the silver wedding of the imperial couple in 1879 – 23 years after it was first begun.

democratic ideal. The facade is a splendid mock Greek temple, with the Pallas Athena fountain in front of it a celebration of the goddess of wisdom. Master builder of the cathedral Friedrich Schmidt fashioned his town hall or Rathaus in neo-Gothic to represent the pinnacle of power reached by the bourgeoisie during the high Middle Ages.

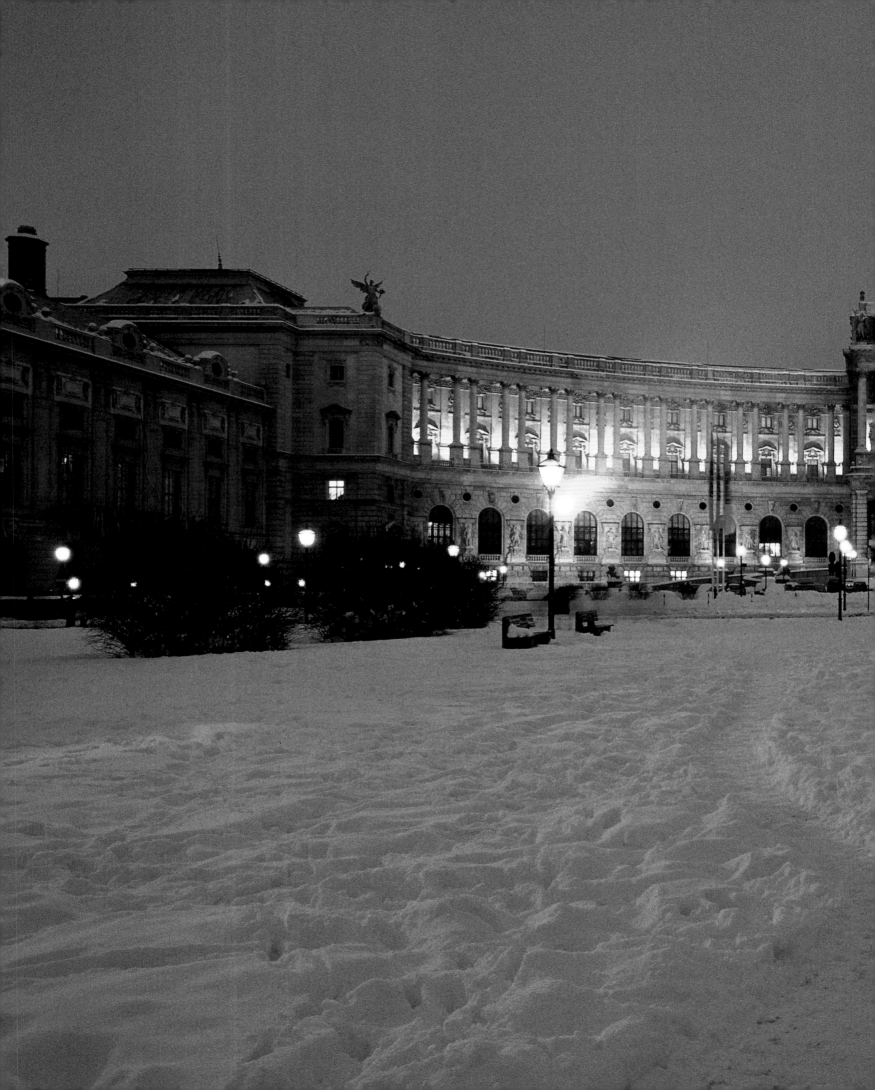

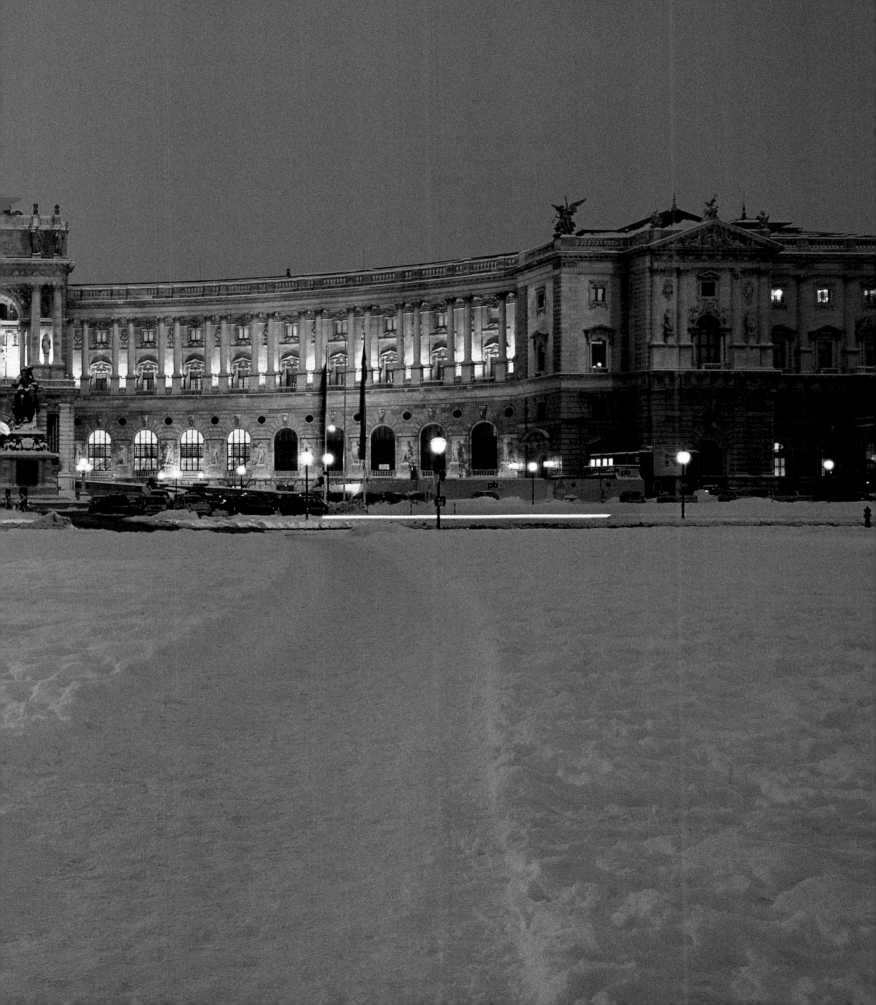

Page 80/81:
Vienna in winter is not to be missed, with snow not infrequently dusting the sights with a thin covering of icing sugar. Here Heldenplatz and the Neue Hofburg under a blanket of white.

Right:
The Schatzkammer (Imperial Treasury) at the Hofburg safeguards sacred and secular artefacts spanning over one thousand years of European history. No less than 21 rooms are packed with precious exhibits, from the insignia of the realm and crown jewels to imperial gowns to cult objects and curiosities, among them the cloak made for Emperor Francis I of Austria in 1830 (above left), the crown of the Kingdom of Germany in the Holy Roman Empire from the 10th century (above right) and the crown, orb and sceptre of Emperor Rudolph II (1552–1612), made in Prague at the beginning of the 17th century and used at the coronation of all of Austria's emperors from 1804 to 1918 (below).

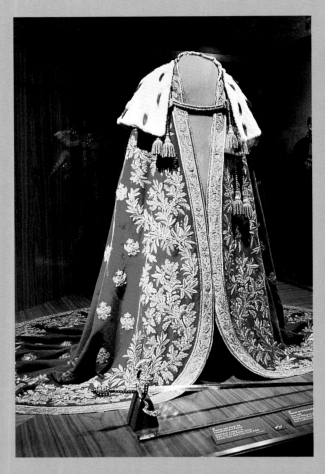

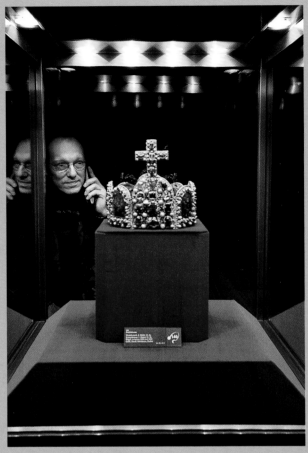

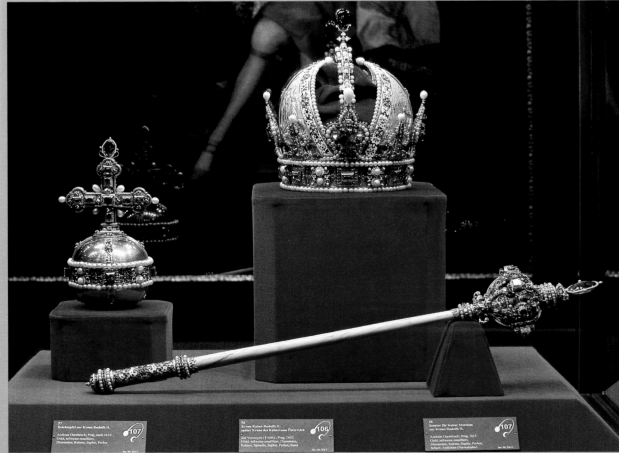

Right page:
The monarchy was already nearing its end when Ludwig Baumann designed the stairs for the Neue Burg. The photo shows the right-hand staircase leading up to the Museum of Art History, Ephesos Museum and armoury.

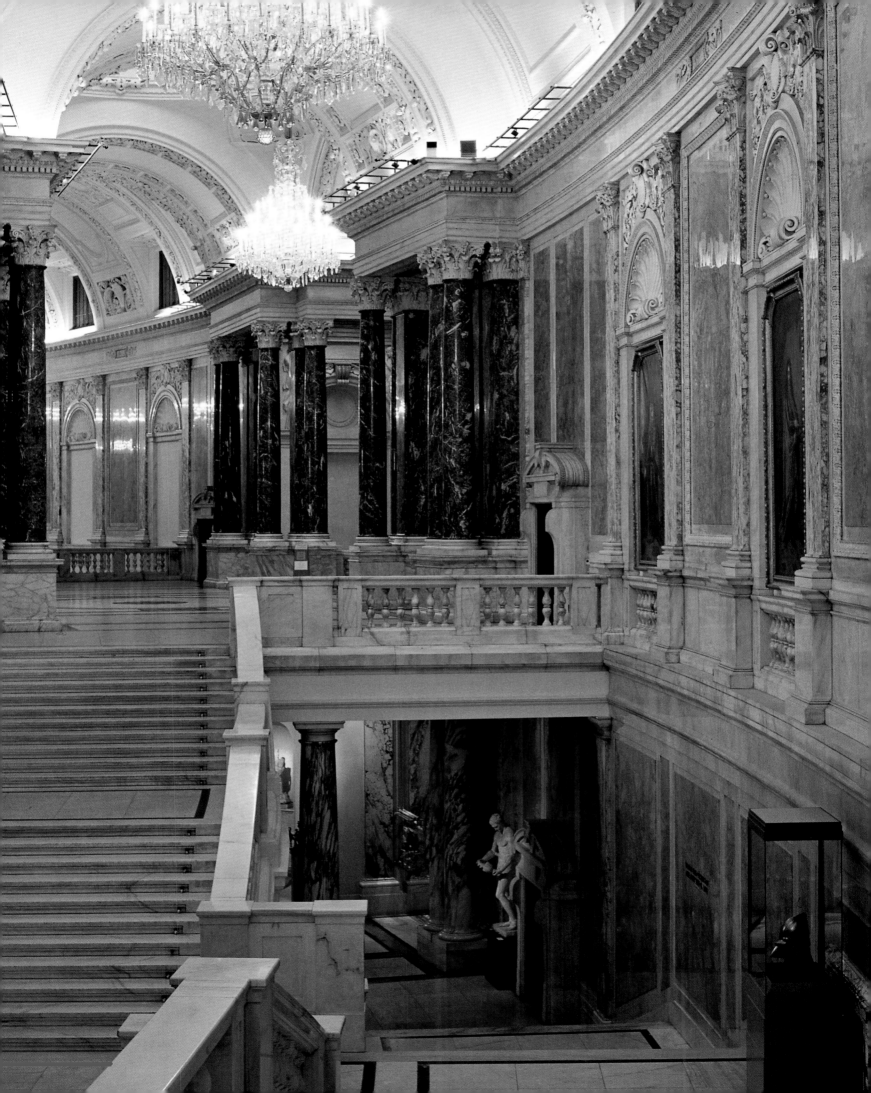

One absolute highlight of any tour of the Hofburg is the dining room which was used for gala dinners with a modest number of select guests. The table is laid with the finest porcelain, silver and glass from the court's huge store of top-class table-ware.

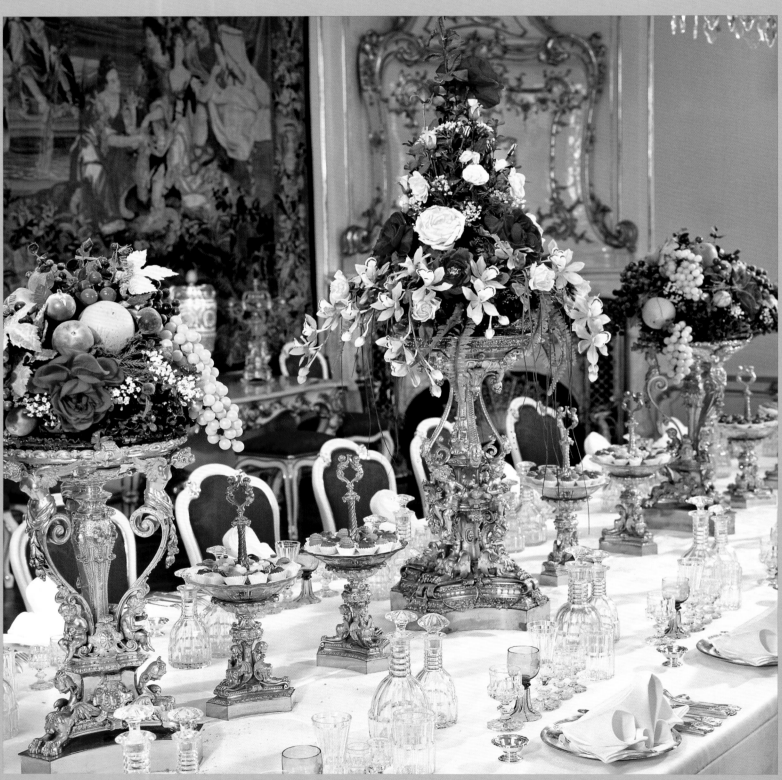

Beyond the empress's private lounge and bedchamber lies the dressing room-cum-gym where the empress spent several hours a day attending to her hair. Now restored, the bars at the back of the room were where Sissi regularly worked out to keep her minuscule figure in shape.

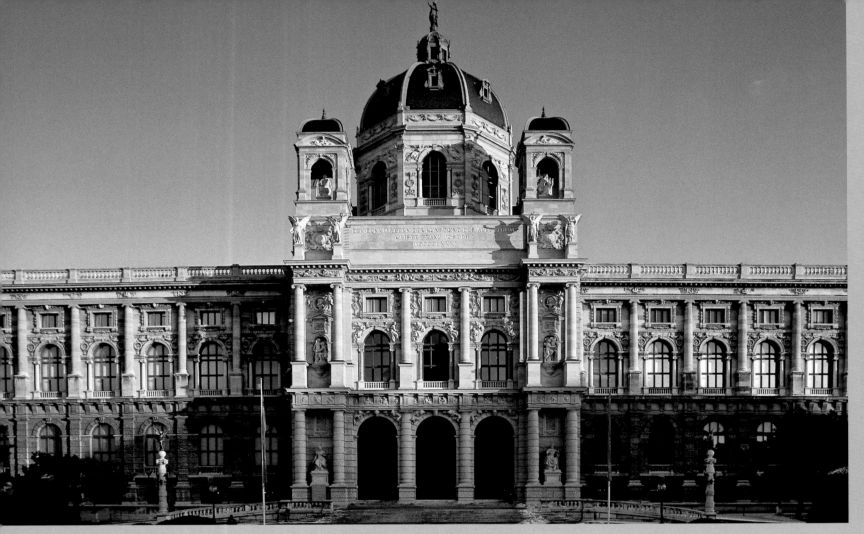

Above:
The Museum of Art History opened on Maria-Theresien-Platz in 1891 draws over one-and-a-half million visitors from all over the world each year. Both this and the Museum of Natural History opposite are the work of Gottfried Semper, with interiors by Karl Hasenauer. The huge dome is crowned by a statue of Pallas Athena.

Right:
The stairs lead up to the splendid domed hall which opens up onto the vestibule below. The upper storey is now used as a café and museum shop.

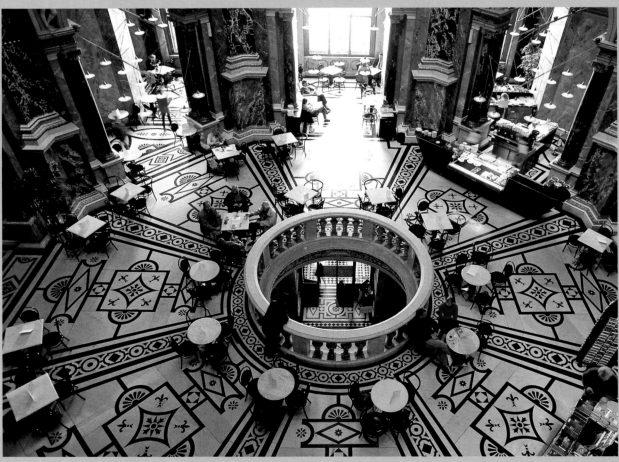

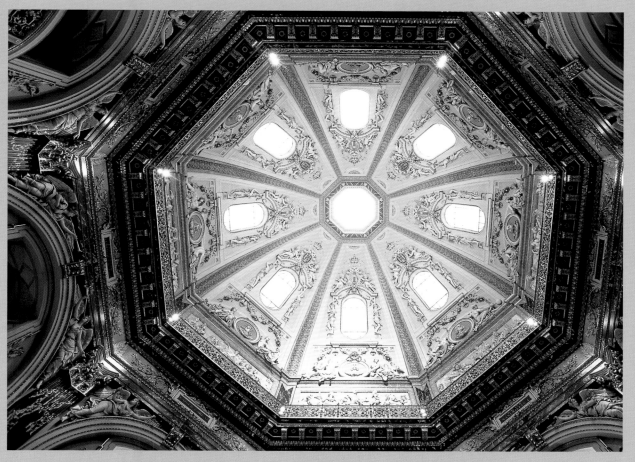

Left:
The dome of the entrance hall of Vienna's Museum of Art History. The black-and-white marble floor mirrors the octagonal panels of the cupola.

Below:
The museum art gallery reflects the tastes of the Habsburgs who were responsible for much of the collection. They were great lovers of the Dutch masters, of the Venetians and of Dürer and Rubens, compiling what is now one of the largest Rubens collections in the world.

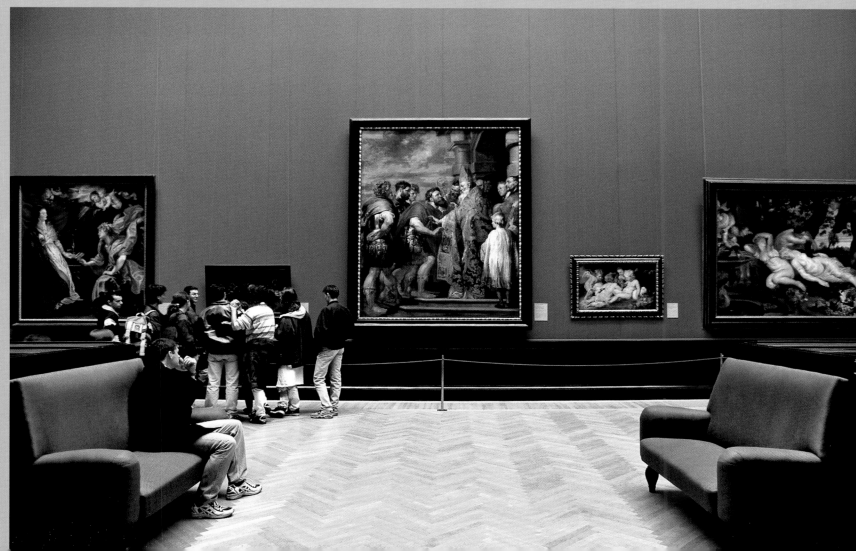

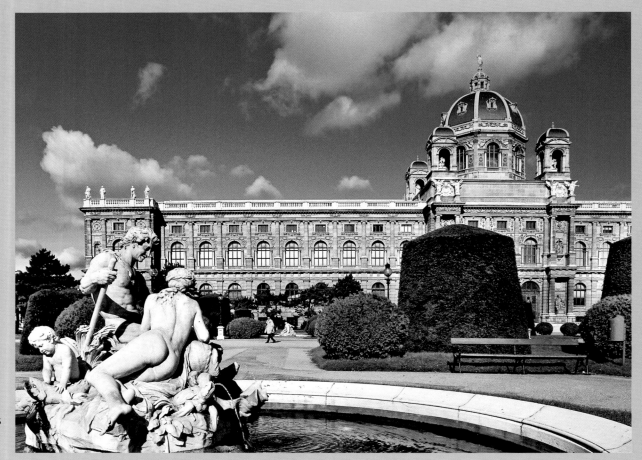

The simply enormous Museum of Natural History with its Triton Fountain boasts one of the largest scientific collections in Europe.

The exhibition halls at the Museum of Natural History are filled with meteorites and minerals, all kinds of fossils, stuffed animals from all five continents and no less than six million insects. The biggest attractions – in all senses of the word – are, however, the dinosaurs.

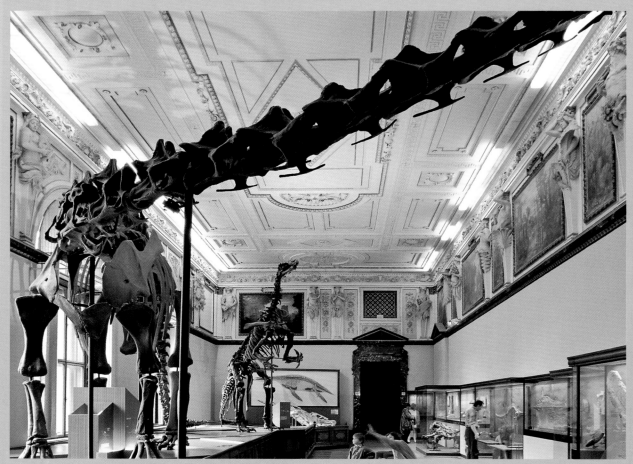

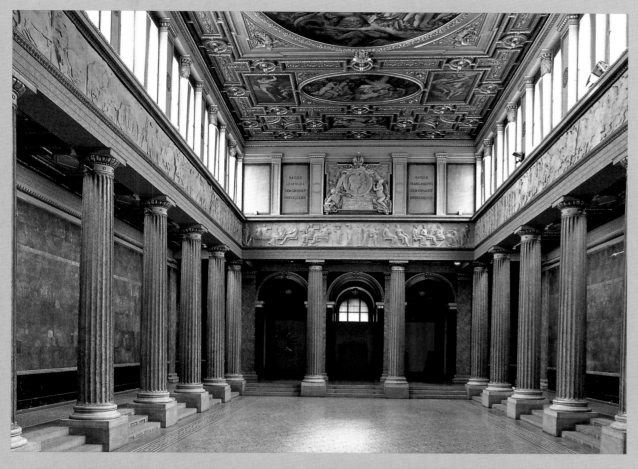

The Akademie der Bildenden Künste (Academy of Fine Arts) is a veritable temple, built in the style of the Italian Renaissance by Theophil von Hansen in the late 19th century. The academy's art gallery enjoys international acclaim and features the best of western painting from six centuries.

Maria-Theresien-Platz between the art and natural history museums is dominated by a giant statue of the empress. The fountains to either side of the monument are no less aesthetically pleasing, designed by Viktor Tilgner.

Below:
MuseumsQuartier Wien has set up shop in what was initially a royal stables and later an exhibition centre. In the 1990s the site was readapted to house a number of museums. MUMOK or the Museum moderner Kunst, for example, is just one of them and Austria's largest museum of modern and contemporary art. The photo shows the main building and lifts.

Right:
The simple atrium of the Leopold Museum at the MuseumsQuartier forms the centrepiece of the museum.

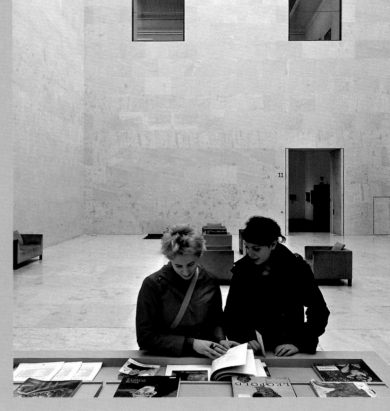

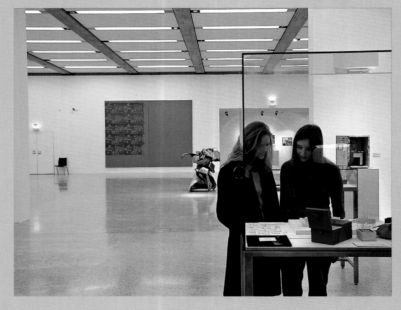

Above:
Level 3 of MUMOK which features the museum's collection of Pop Art and Photorealism, Fluxus and Nouveau Réalisme and Viennese Actionism.

Above right:
Promising young artists are taught at the art academy on Schillerplatz.

Top right page:
Together with the Leopold Museum and Kunsthalle Wien, the grey basalt cube of the MUMOK is one of the main architectural components of the Museums-Quartier Wien.

Right:
Gustav Klimt's "Der Tod und das Leben" (Death and Life). The Leopold Museum is dedicated to the artists of the Vienna Secession, the Viennese Modern Movement and Austrian Expressionism. It holds the world's largest collection of works by Egon Schiele and also many top pieces by Gustav Klimt, Oskar Kokoschka and others.

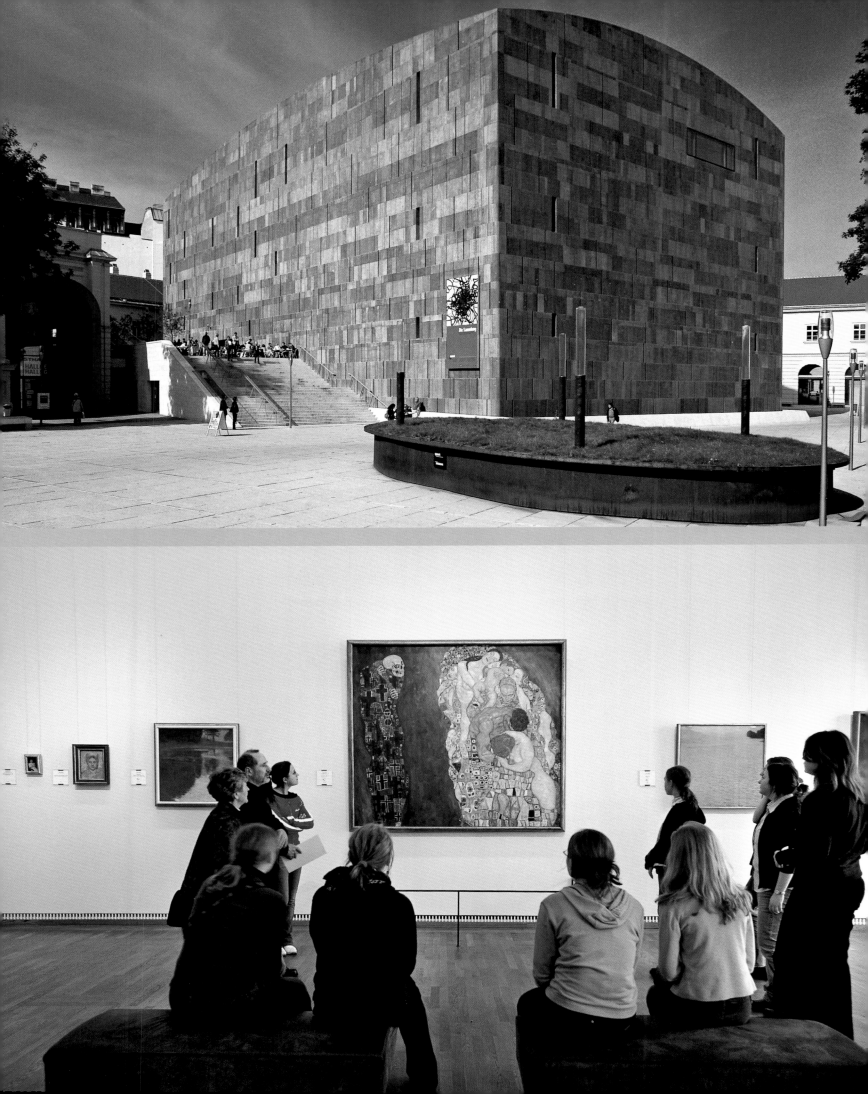

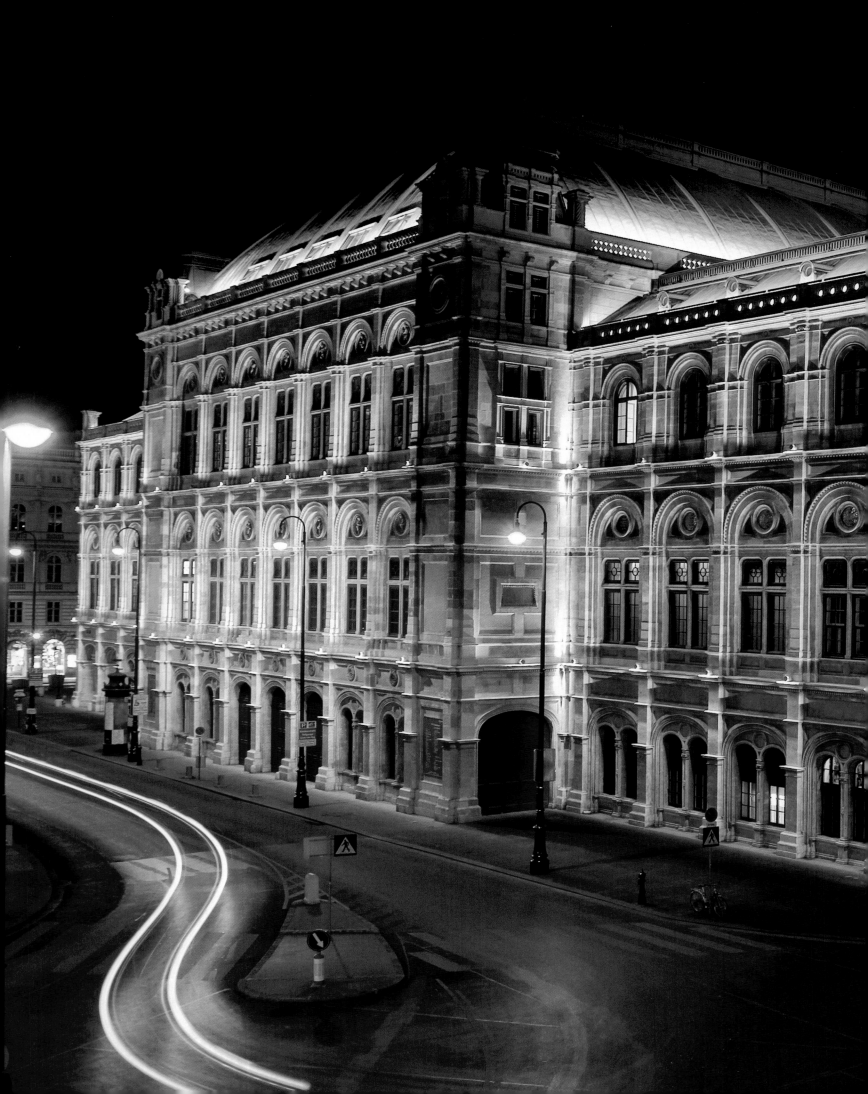

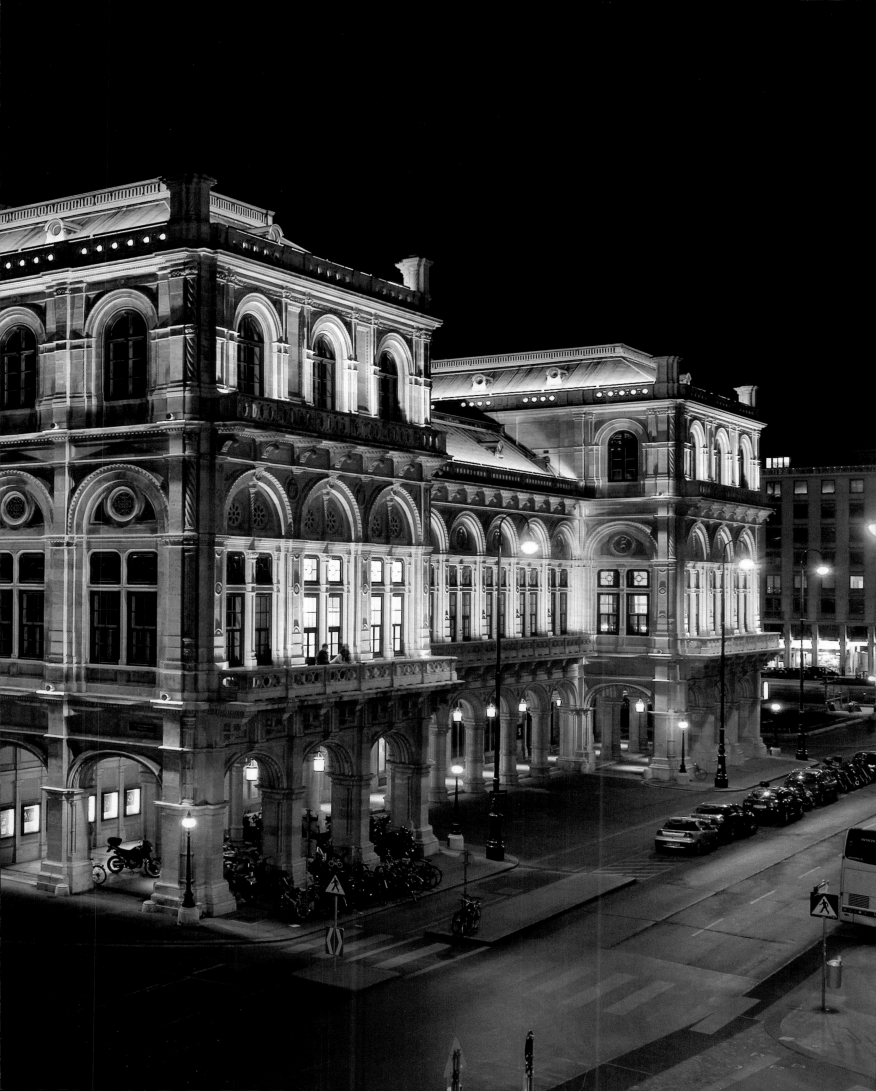

Page 92/93:
The Staatsoper or state opera house is the cultural nucleus of Vienna, built in the 1860s by August von Siccardsburg and Eduard von der Nüll in the style of the Renaissance. Mozart's "Don Giovanni" was performed at the grand opening ceremony on May 15, 1869. The opera was destroyed during the Second World War and reopened in 1955.

A night at the Viennese opera is an unforgettable and heavenly experience. And should "Boris Godunov" in Russian become a little too taxing, each seat has a tiny screen which provides a simultaneous translation of the libretto in German or English.

The resplendent staircases at the Burgtheater are a fitting overture to the delights in store on stage. Designed by brothers Gustav and Ernst Klimt and Franz Matsch, Emperor Francis Joseph was so taken with the staircase frescos that he awarded the artists the coveted Goldenes Verdienstkreuz, Austria's highest decoration for services to the country.

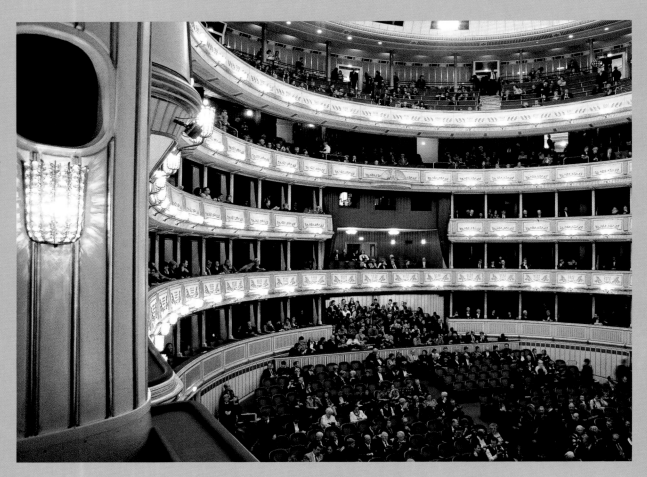

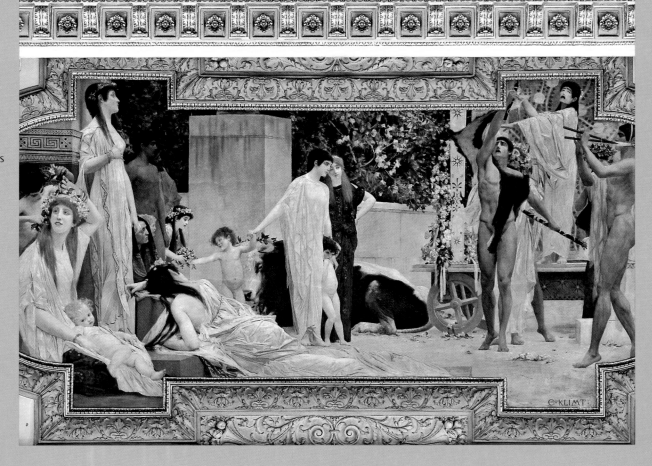

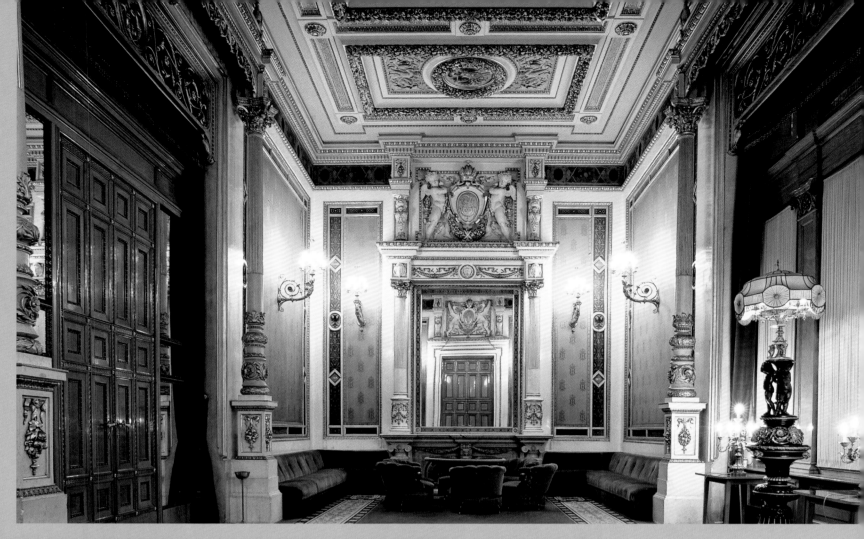

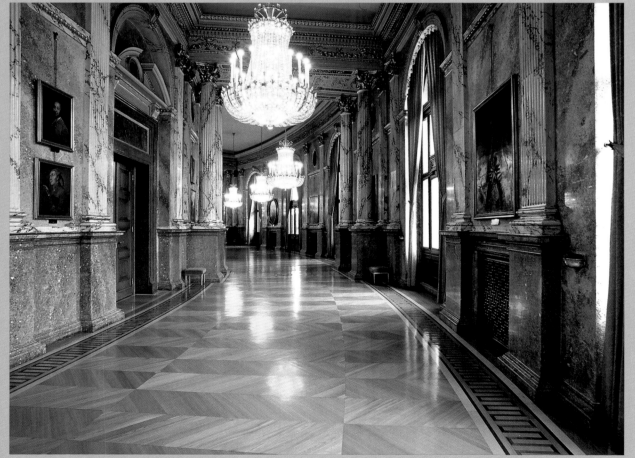

Above:
This sumptuous royal box at the Staatsoper was once reserved for members of the imperial family only; today anybody can take refreshments in the opera's illustrious Teesalon. Built in 1869, it's one of the few rooms to have survived the air raids of the Second World War in its original state.

Left:
Meandering along the foyer of the Burgtheater during the interval is as much part of a trip to the theatre as the performance itself. The roomy corridor is also used for readings, discussions, exhibitions and television recordings.

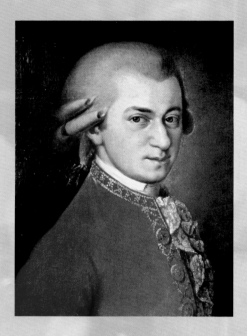

Above:
Wolfgang Amadeus Mozart as painted posthumously by artist Barbara Krafft who met the composer during his lifetime. Although Vienna was his fixed abode for just the last six years of his life, Mozart is lauded as the city's greatest musical genius.

Right:
Ludwig van Beethoven had 60 different places of residence in and around Vienna. At the Pasqualati Haus (where he composed the opera "Fidelio") one of the more unusual exhibits is a lock of the great musician's hair.

Vienna is a veritable musical metropolis once patronised by composers such as Mozart, Beethoven, Schubert, Strauß, Brahms, Bruckner, Mahler and Schönberg, to name but a few. Their works are an invaluable contribution to our cultural heritage, with pieces such as "The Magic Flute" and "The Blue Danube" bringing enjoyment and entertainment to all four corners of the globe.

The works of the masters are regularly performed by a number of legendary Viennese institutions. The Wiener Sängerknaben or Vienna Boys' Choir is just one of them, dating back to 1498 when Emperor Maximilian I ordered that six boys join his ensemble of court musicians. Today there are about one hundred young men between 10 and 14 making up four choirs who sing mass each Sunday in the Hofburg chapel. In the 1930s the choir began giving concerts outside Vienna to raise funds. The venture proved so successful that the performances were continued, with the boys in their sailor suits now travelling far afield to delight audiences all over the world.

Another of Vienna's permanent musical fixtures, transmitted worldwide on radio and TV, is the New Year's Day concert performed by the incomparable Vienna Philharmonic. This independent association of court musicians was founded in 1842 on the initiative of composer Otto Nicolai. Today only the best are allowed to join and must be members of the Vienna State Opera. Women were only admitted in 1997. Fixed venues in Vienna are the Musikvereinsgebäude and the Staatsoper – plus all major international concert halls abroad.

Music is extremely important to the Viennese, as journalist Jörg Mauthe once observed. At the New Year's Strauß concert in 1945 all present were racked by cold and hunger – both the audience and the performers – with the temperature in the

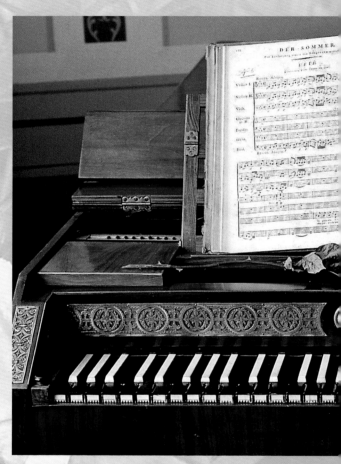

ROPOLIS

Left:
The Arnold Schönberg Center on Schwarzenbergplatz houses the legacy of the great twelve-tone composer. His study has been carefully reconstructed using original artefacts from his days in Mödling near Vienna, Berlin and California.

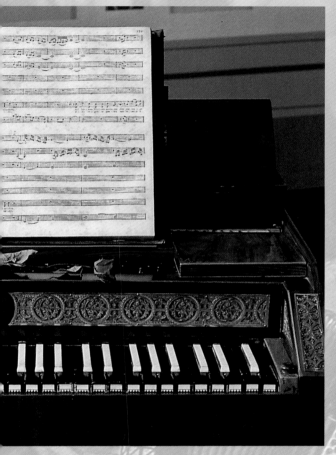

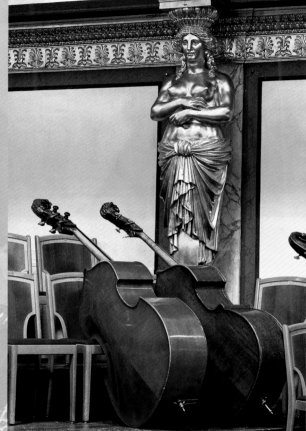

Above:
Austrian folk music ("Heurigen-Musik") at the Beethoven Haus in Heiligenstadt where Beethoven spent much of 1817. Heiligenstadt was once a spa where the composer hoped – in vain – to find a cure for his deafness.

Left:
Detail of the Goldener Saal at the Musikvereinsgebäude. One of the gilt caryatids watches over the double basses while the players take a well-earned break. The hall is where the famous New Year's Day concert is broadcast from every year.

Centre:
On Haydngasse stands the house where Joseph Haydn spent the last twelve years of his life. This is where the oldest representative of Viennese Classicism composed his famous works "The Creation" and "The Four Seasons".

concert hall at the Musikvereinsgebäude below freezing. After just a few bars of the Strauß waltz "G'schichten aus dem Wienerwald" the orchestra lowered their instruments, tears streaming down their faces. Everybody was crying for joy, the musicians, the conductor and members of the public. In the suffering and devastation of war, writes Mauthe, these beautiful harmonies gave the Viennese new-found hope.

Viennese music is not all Mozart and Strauß. There are countless "Lieder" extolling the virtues of the city and of wine, women and song, some of them frivolous, some satirical and some traditionally morbid and preoccupied with death. There is also "Schrammelmusik", Viennese folk music named after two brothers, Johann and Josef Schrammel, who in 1880 formed a quartet of two violins, a clarinet and a guitar and began performing in the pubs of the city suburbs.

Another famous Viennese musician is Georg Kreisler, a singer-songwriter with a biting wit who once shocked the republic to such an extent that his lyrics were banned on the radio. Today Kreisler is one of Vienna's modern classics whose most popular ditties sing of poisoning pigeons in the park and other such cynical niceties …

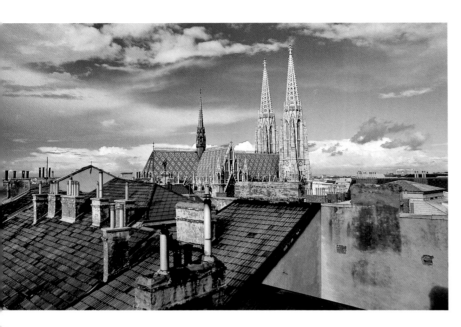

Come rain or shine, there's always plenty to see in Vienna. There's the Votivkirche (Votive Church) with its filigree Gothic Revival steeples (top left), the impressive Hofburg with its mighty gatehouse (centre left), the Museum of Art History with its rooftop statues of famous artists (bottom left) and the town hall with its lofty iron vanguard of Vienna watching over the city from the top of the tower (below).

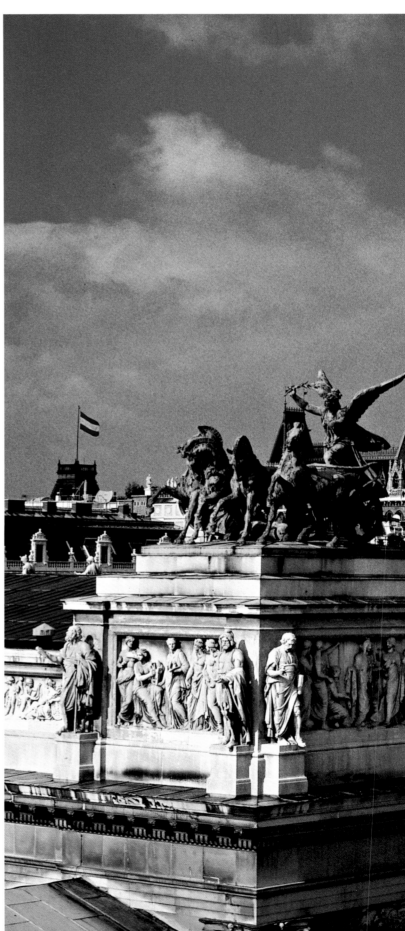

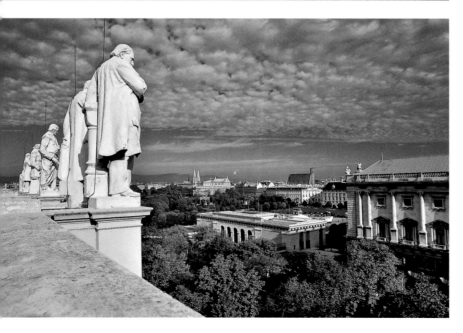

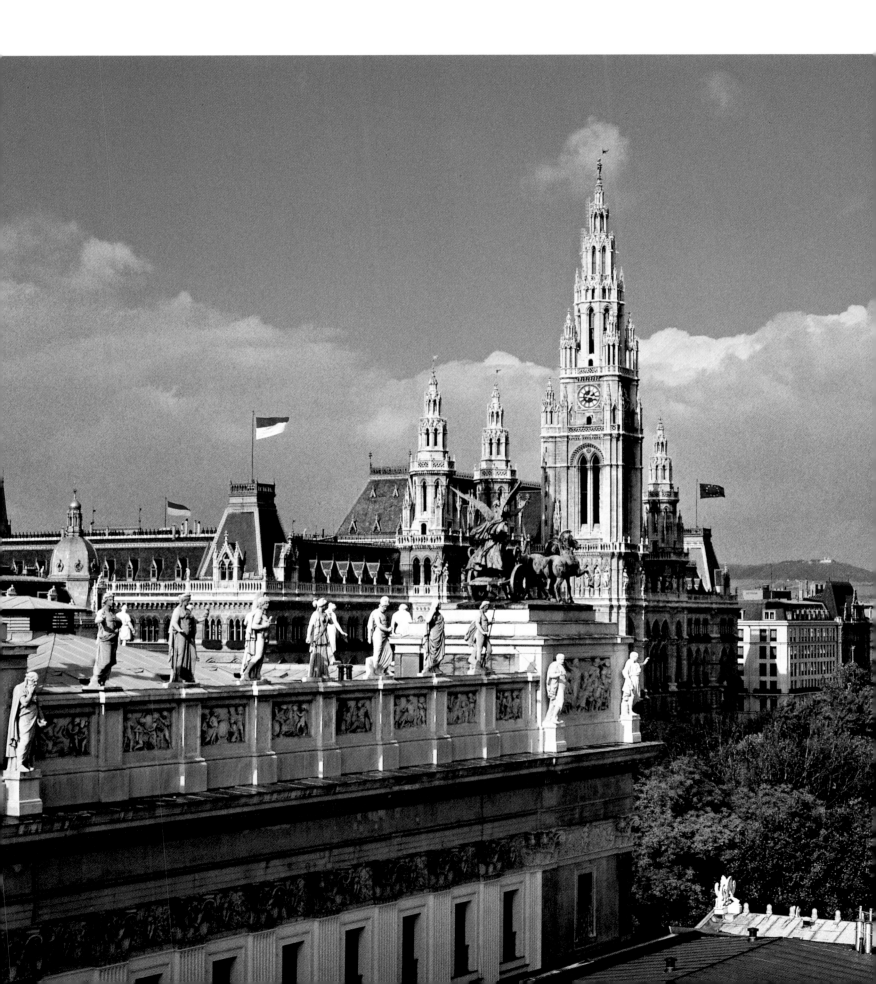

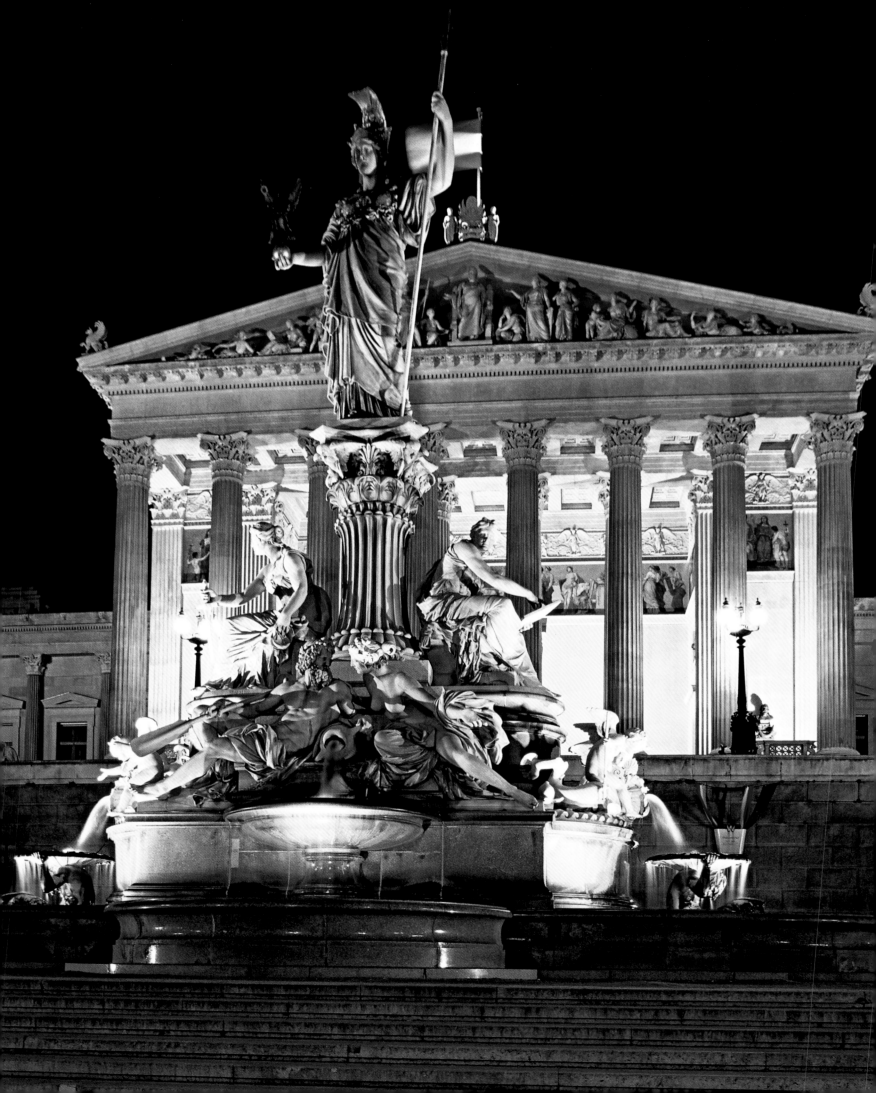

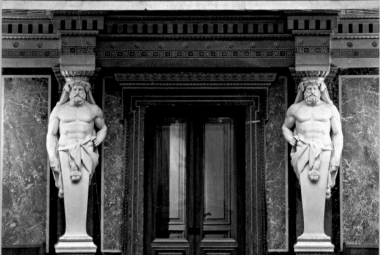

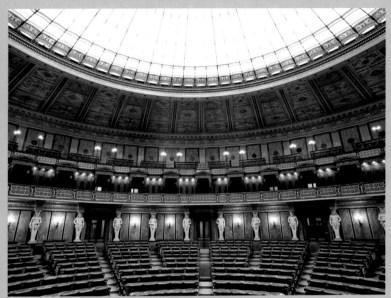

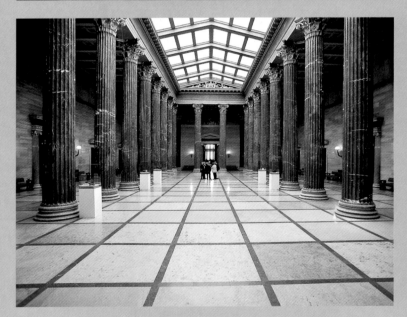

Left page:
Although one operetta aria maintains that Vienna is only beautiful at night, this would be doing the parliament building an injustice, impressive whatever the time of day. Built to resemble a Greek temple, who better than the Greek goddess of war and practical reason to adorn parliament's Athena Fountain?

Above:
The central door of the atrium opens out onto a long corridor with 24 Corinthian pillars propping up the coffered ceiling and glass roof. The floor is laid with marble slabs.

Above:
A door handle in the shape of a snake on the main floor of the parliament building.

Like something out of a
fairytale, in the run up to
Christmas Rathausplatz and
the adjoining park are illu-
minated by the bright fairy
lights of the Viennese Christ-
mas Fair which has been
held for almost 700 years.

Walking up the red carpeted staircase of the
Rathaus is enough to make even the lowliest
visitor feel important! Stone from all over the
Austro-Hungarian empire went into creating
this and the rest of the nothing less than
magnificent town hall.

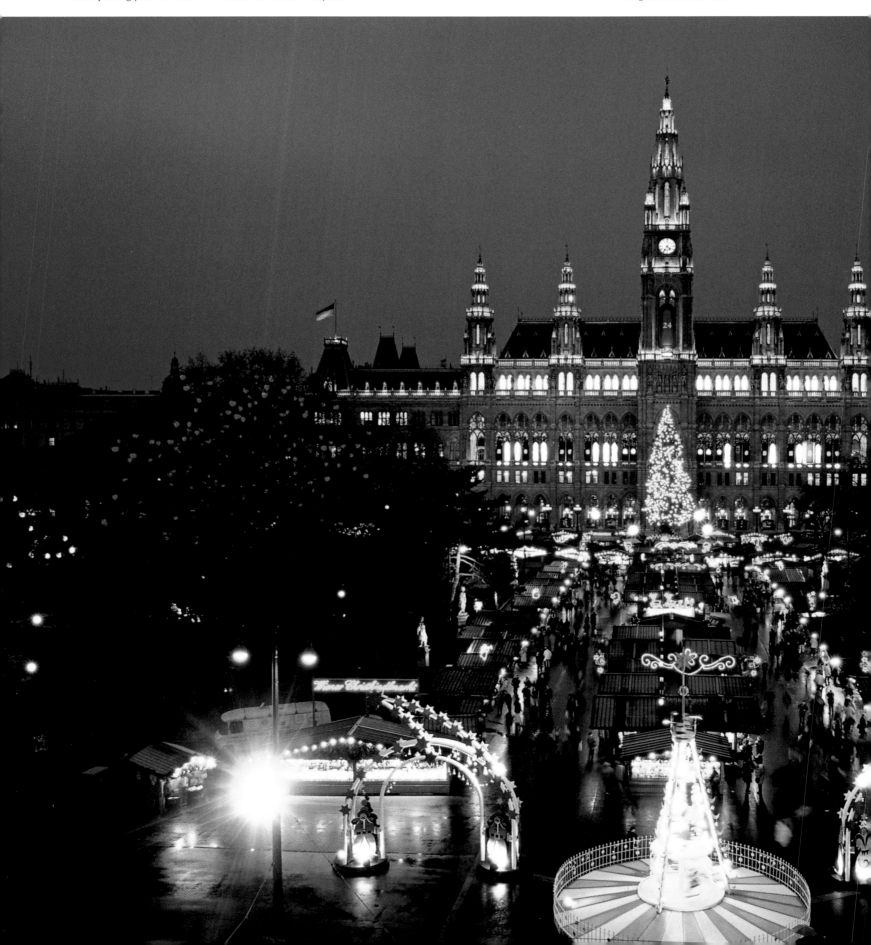

Centre right:

Centre right:
Rathausplatz is a hive of activity all year round, providing a spectacular backdrop for open-air events of all kinds, from plays and concerts to the circus and film festival in summer to ice-skating in winter.

Bottom right:
Each May Rathausplatz sees the grand opening of the Wiener Festwochen when the glorious sound of music from pop to the Philharmonic fills the air.

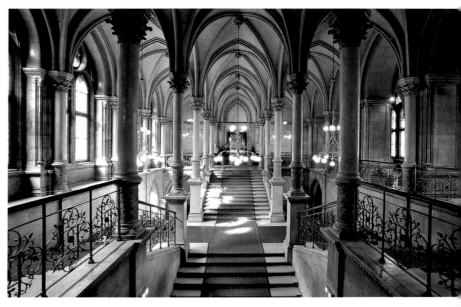

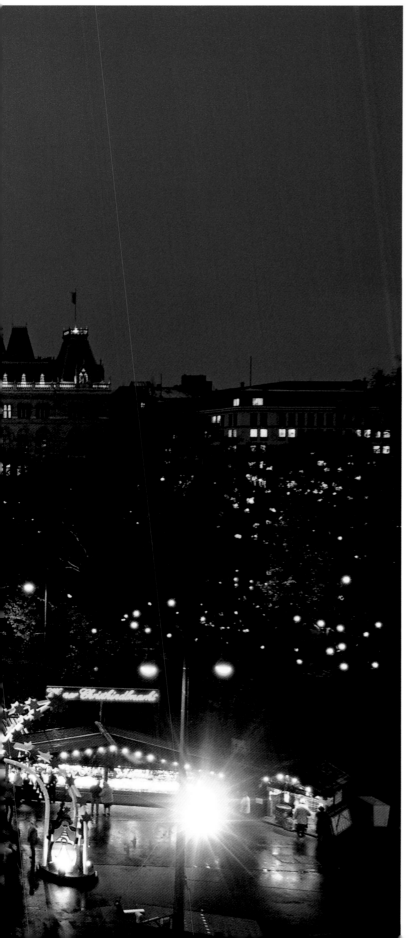

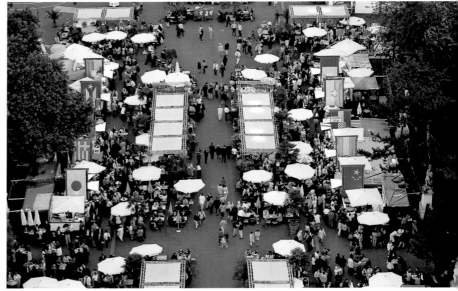

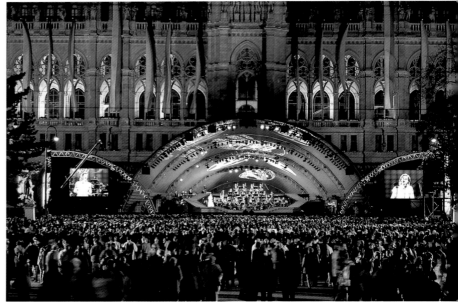

Right:
Once a palace for nobles, now a luxury hotel fit for a king – or the likes of Richard Wagner and Plácido Domingo, both of whom have stayed here. Outside Palais Württemberg, now the Hotel Imperial on Kärntner Ring, the resident chauffeur awaits his next motorised guests.

Below:
Gourmet restaurant Korso at Hotel Bristol opposite the Staatsoper is famous for both its stylish interior and award-winning cuisine.

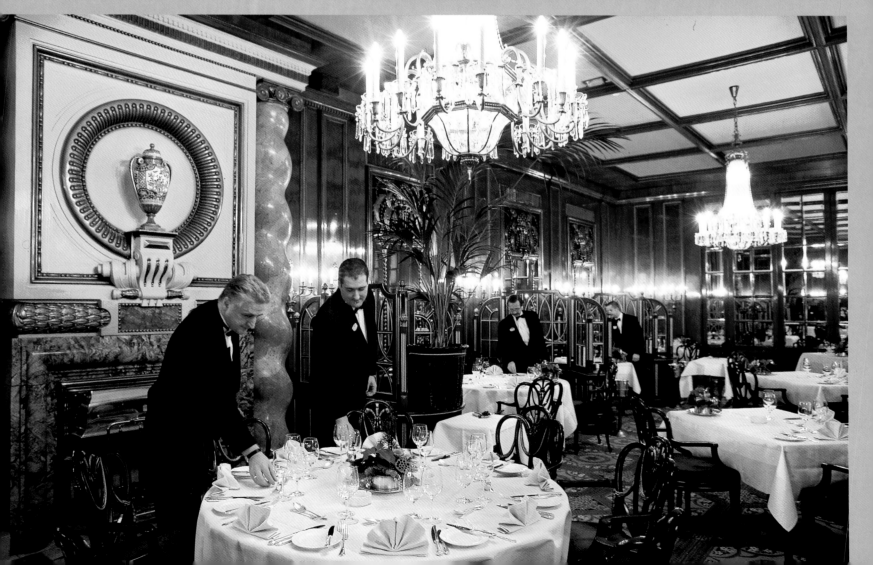

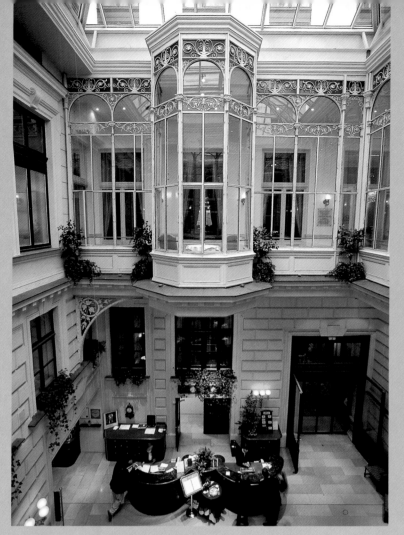

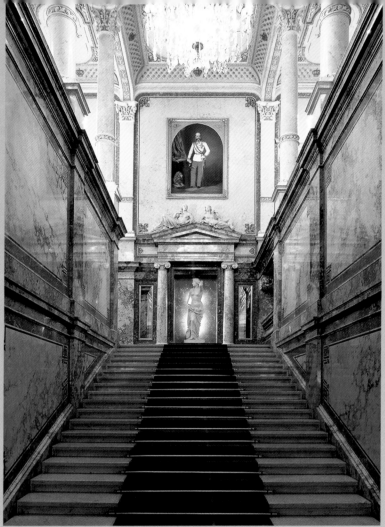

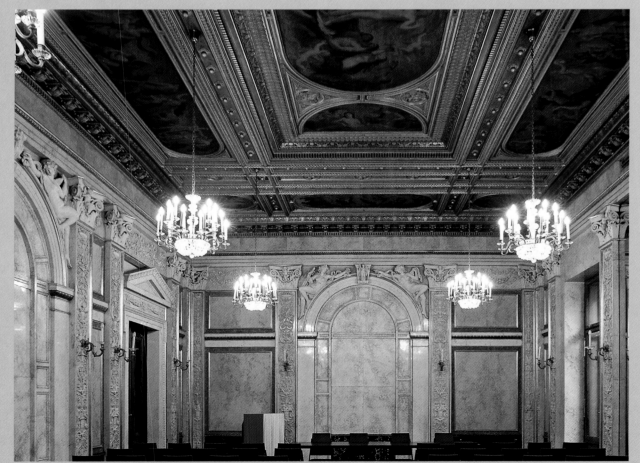

Above left:
Palais Leitenberger on Park-ring, part of the Ringstraße, is also now a hotel, named after the man who had it built, landowner, factory proprietor and keen patron of the arts Baron Friedrich Franz Josef Leitenberger. Guests are welcomed at reception in the wonderful covered inner courtyard.

Above:
The majestic staircase of the present Hotel Imperial (formerly Palais Württemberg).

Left:
The old ballroom at Palais Epstein between parliament and the Museum of Natural History, built by Theophil Hansen in the style of the Italian Renaissance in the 1870s.

Below:
The Votive Church at dusk, the most significant example of Gothic Revival church architecture in the world. Its filigree towers are 99 metres (325 feet) tall.

Below right:
The vaulted ceiling of the nave of the Votive Church. The church is a popular venue for concerts of sacred music.

Right:
The palm house in the Burggarten, the private imperial gardens commissioned by Francis I in c.1818 and opened to the public in 1919. The enormous glasshouse from 1901 is now a café and tropical butterfly house.

Far right:
Palais Todesco on Kärntner Straße opposite the opera is where Johann Strauß met his first wife, at that time the owner's partner. The palace was built in the 1860s by Ludwig Förster and Theophil Hansen.

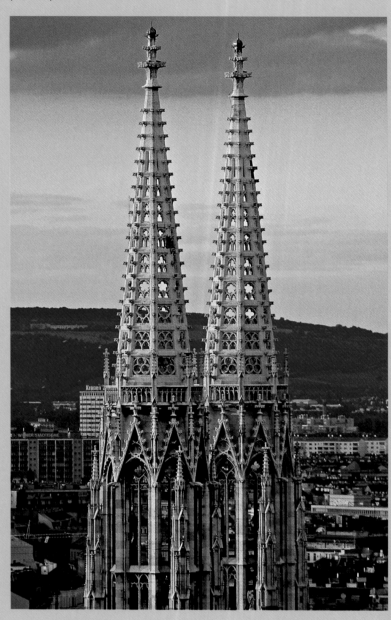

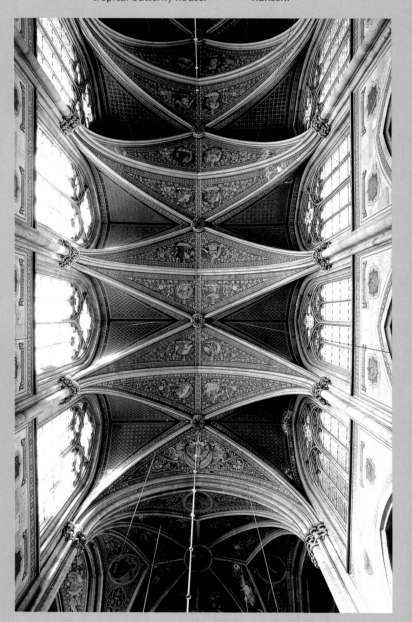

Right:
Time has stood still at the elegant Café Landtmann on Karl-Lueger-Ring next to the Burgtheater. The guest book is full of famous names, among them Marlene Dietrich, Thomas Mann and Gary Cooper.

Far right:
The grand ballroom of what was once the stock exchange is now a major venue for concerts and society gatherings. The emperor himself keeps a careful eye on the proceedings.

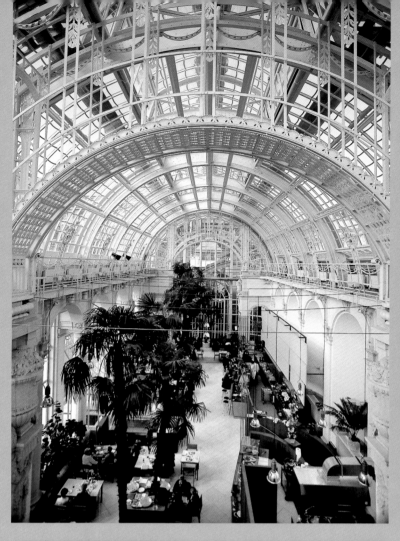

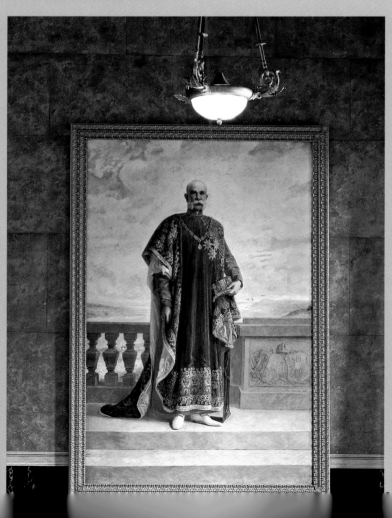

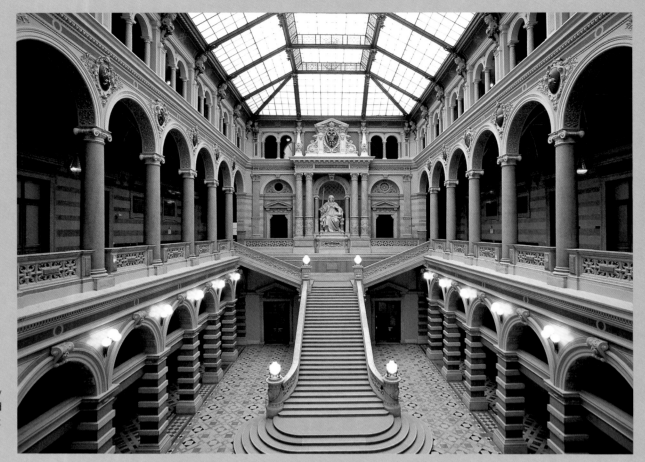

Right:
The main hall of the Palace of Justice on Schmerlingplatz. Built between 1875 and 1881, various courts of the land once held office here. It was set alight during the July Revolt of 1927 and acted as Allied headquarters in the aftermath of the war from 1945 to 1955.

Below:
The great hall at the university where doctorates are awarded under the flags of the republic of Austria and the city of Vienna.

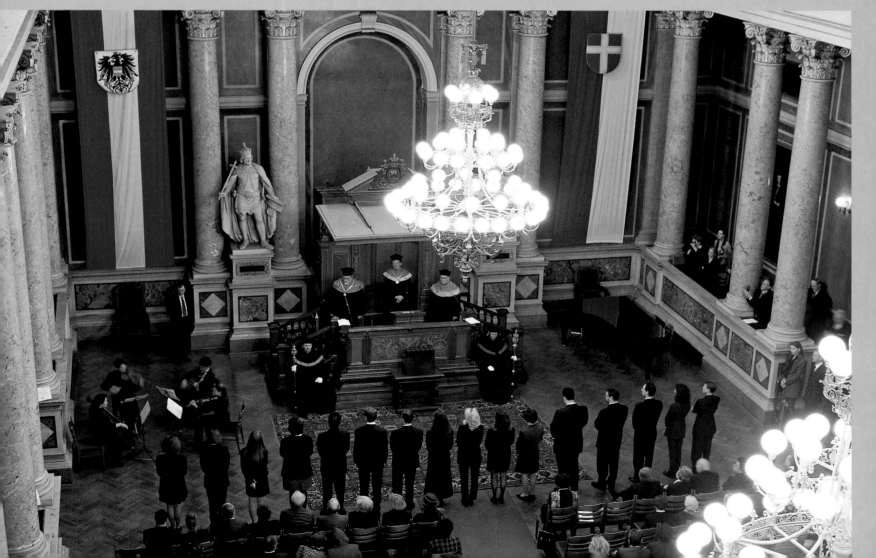

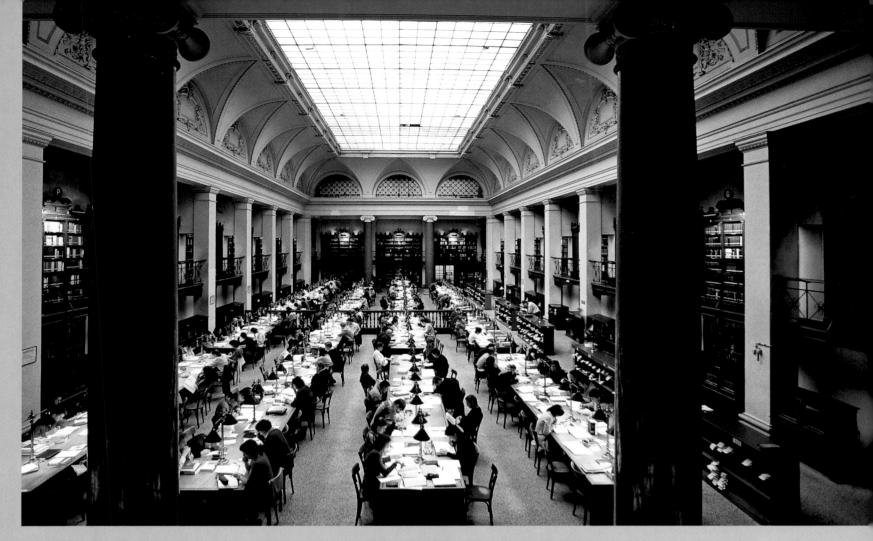

Above:
The university library reading room has retained much of its original decor from 1884.

Left:
In 1902 Gustav Klimt painted a set of allegorical faculty murals for the great hall of Vienna University. His work created a scandal, with many of the professors outraged at Klimt's wispy portrayals of Philosophy, Medicine and Jurisprudence who they claimed "floated aimlessly" around the room.

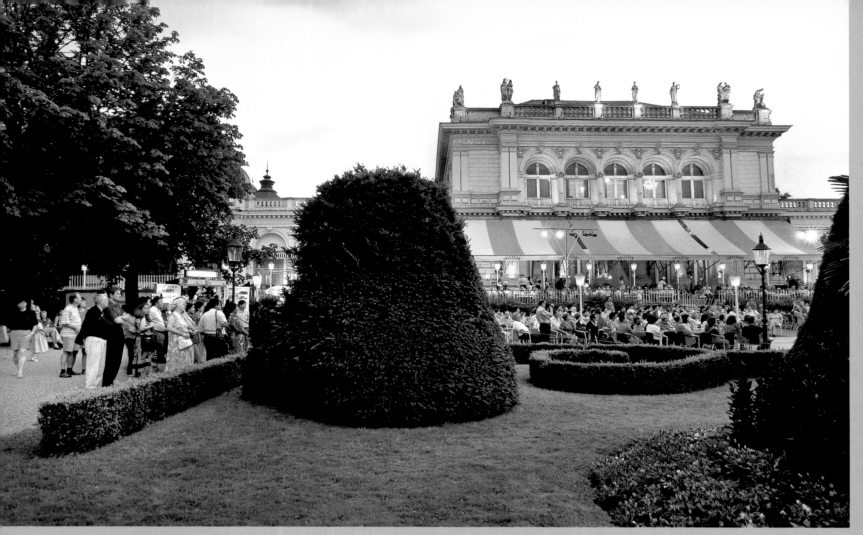

Above:
Close to the statue of Johann Strauß in the Stadtpark is the Kursalon, Vienna's chic spa rooms. Completed in 1867, coincidentally the year in which "The Blue Danube" was first performed, the salon is still where balls, operettas and waltzes are held.

Right:
Autumn in the Volksgarten, the public park opened in 1823 for the emperor's loyal subjects. The adjacent imperial gardens were then still very much in private use.

Above:
Playing some Strauß in the Stadtpark. The assembly rooms were initially not particularly well frequented, devoted in their entirety to water treatments which didn't prove too popular. To boot, concerts and other forms of entertainment were banned. This soon changed, however, with the first Strauß concert being performed a year after the opening – resulting in a larger clientele.

Left:
Roses in bloom in the Volksgarten. The garden's coffee house was where Joseph Lanner and Johann Strauß the Elder once played.

111

CITY LANDMARKS —
THE PRATER
AND DONAUTURM

One of the city's most famous landmarks is not an imperial palace or majestic church, as one might expect, but a piece of ironwork, an amalgam of metal: a giant Ferris wheel constructed by English engineer Walter Basset. In operation since 1897, it affords its cosmopolitan clientele marvellous views out across the roofs of Vienna and the park in which it gently rotates, the Prater.

Until the Danube was regulated this stretch of woods and fields was meadowland and the private property of the emperor who rode and hunted here. In 1766 Emperor Joseph II granted access to the public "at all times of the year and

Schloss Schönbrun, the baroque palace was built in 1696 and furnished as a summer residence for Empress Maria Theresa in the mid-18th century. The Congress of Vienna was held here in 1814/1815.

all hours of the day". His subjects descended on their new pleasure grounds in droves and to this day the Prater is a popular haunt of the Viennese and their guests. The long main avenue leads to the Lusthaus, once the emperor's hunting lodge and now a restaurant. There are sports facilities, open-air swimming pools, a planetarium and even a chapel dedicated to St Mary "in the green". In spring the expansive park is a sea of chestnut blossom. At the Wurstelprater funfair beneath the huge big wheel the scene is one of jolly festivity all year round, the screams of delighted punters and the smell of candy floss filling the air, with beer tents for the adults and rides and even a miniature railway for the kids.

The Ferris wheel was unrivalled up until the advent of Vienna's International Garden Show in 1964. A new landmark had been erected which at 252 metres (827 feet) dwarfed its counterpart; the new Donauturm even boasted a revolving restaurant 170 metres (558 feet) up. The gardens were later turned into the Donaupark as a place for the city-weary to relax and recuperate.

Vienna has many faces, the most aristocratic of which is worn by the two palaces of Schloss Belvedere. They were built by Prince Eugene of Savoy (1663 – 1736), diplomat and victorious hero in the battle with the Turks and the French. Servant to no less than three emperors, Eugene

was not only an outstanding statesman but also a passionate lover of the arts which he promoted as both patron and collector. Belvedere is an expression of his social standing and irrepressible "joie de vivre" and an absolute pearl of the baroque. The lower palace (Unteres Belvedere) was erected between 1714 and 1716, the upper building (Oberes Belvedere) from 1720 to 1723, both under the supervision of architect Lukas von Hildebrandt. Between them lies an expanse of elegantly terraced parkland half a kilometre long. Oberes Belvedere was a symbol of princely prestige and is now home to Austria's national gallery of 19th- and 20th-century art. The collection includes Gustav Klimts "The Kiss" and various other masterpieces of the age by Egon Schiele and Munch, to name but a few. It was here that in 1955 Austria signed its state treaty with the Allies in which the country was again granted sovereignty. Unteres Belvedere was a regal summer residence and is today a museum of the baroque, with artwork from the Middle Ages on display at the neighbouring orangery.

This pomp is only surpassed by Schloss Schönbrunn, formerly the summer residence of Austria's royal rulers. Its history is long and turbulent. During the 14th century this was the site of a mill belonging to the monastery at Klosterneuburg and later a manor house which Emperor Maximilian II bought in 1559 as a summer home. In 1619 Emperor Matthias is said to have discovered a natural spring nearby, the "schöner Brunnen" which was to give the palace its name. In 1683 the building was destroyed by the Turks. A new complex was designed by Johann Bernhard Fischer von Erlach and modelled on Versailles; the great expense of war meant that the palace got no further than the planning stage. A simpler version of the new imperial seat was erected between 1695 and 1711. It soon became the favourite abode of Empress Maria Theresa who had it more comfortably furbished by Nicolaus Pacassi between 1744 and 1749. She lived here with her husband and 16 children. In 1805, 1806 and again in 1809 Schloss Schönbrunn served as

the outskirts of the city. The wine tavern is another composite part of Vienna's diverse culture. "Heuriger" is both the new wine from the last harvest and the tavern in which this wine is served. Sprigs of pine hung up above the door indicate that the establishment is open for business. And when the cheerful sound of fiddles, guitars and accordions can be heard within, then the visitor has finally found that desirable atmosphere of cosiness and wellbeing every guidebook warmly recommends: genuine Viennese "Gemütlichkeit".

Below:
A couple of friends enjoying a refreshing glass of wine at the Sirbu "Heuriger" on Kahlenberg. Many of Vienna's wine taverns are out in the leafy suburbs, making a trip out to savour excellent local vintages one of summer's greatest pleasures.

Napoleon's headquarters during his occupation of Vienna. In 1814 and 1815 the Congress of Vienna staged a series of grand balls here. Emperor Francis Joseph I was born here in 1830 and died at the same place in 1916. His successor Charles I announced his abdication at Schönbrunn in 1918.

Suffering heavy damage during the Second World War, the palace was restored and reopened in 1948. Its over 1,400 rooms once included 139 kitchens alone. Today ca. 50 of the rooms are open to the public, a mirror of the life and times of the great imperial aristocracy. Other points of interest are the Wagenburg with its collection of historic coaches, the surrounding gardens with the palm house and zoo and the Gloriette, a colonnaded monument built on a hill above the palace. Schloss Schönbrunn was made a World Heritage Site in 1996. Not far from Schönbrunn the gentle slopes of the Vienna Woods are planted with neat rows of vines which creep down to

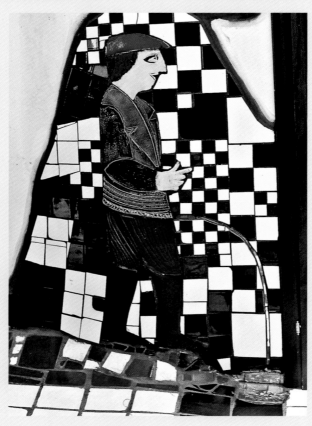

Left:
An unmistakable Hundertwasser mosaic on the corner of the KunstHausWien on Untere Weißgerberstraße.

115

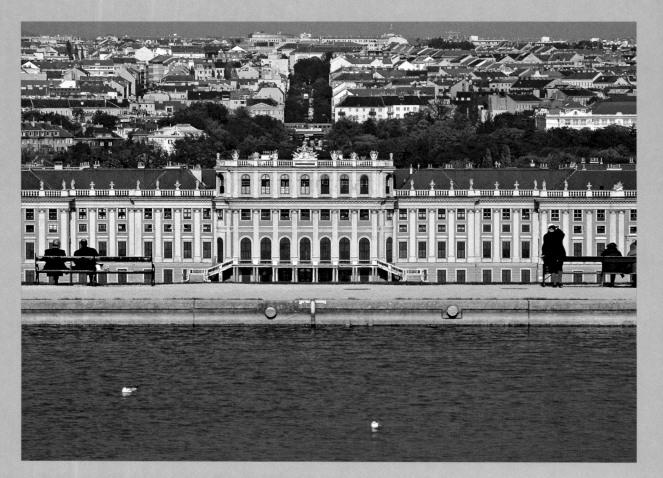

Schloss Schönbrunn seen from the Gloriette, with the roofs and treetops of downtown Vienna beyond.

The palace and gardens at Schönbrunn were made a UNESCO World Heritage Site in 1996. Almost two square kilometres (500 acres) in size, the park is landscaped in the typical style of the French baroque.

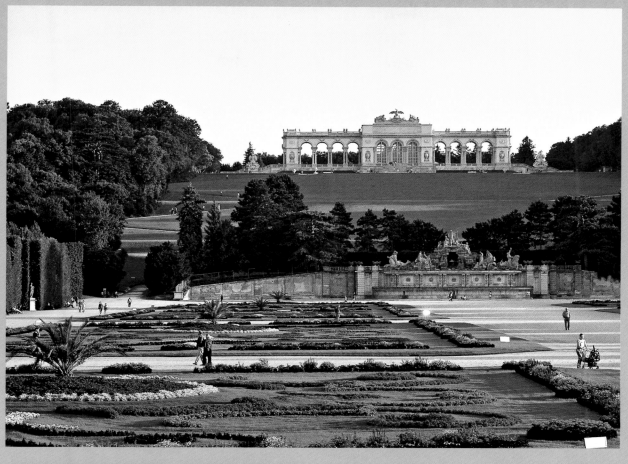

Left:
The monumental Gloriette at Schloss Schönbrunn affords marvellous views of the surrounding hills, fields and forest – and of the colourful summer bedding of the palace parterre.

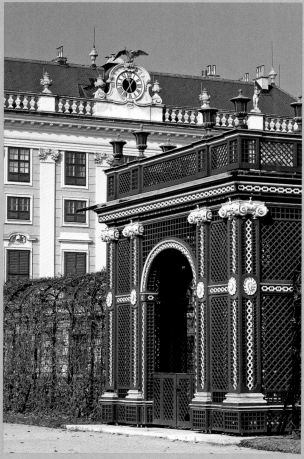

Far left:
Mythological statues hide in niches in the hedges which divide the park at Schloss Schönbrunn into a number of outdoor rooms.

Left:
An imperial pergola east of the palace at Schönbrunn. The gardens are a successful melange of natural parkland and regimental flower beds dotted with architectural statues and follies.

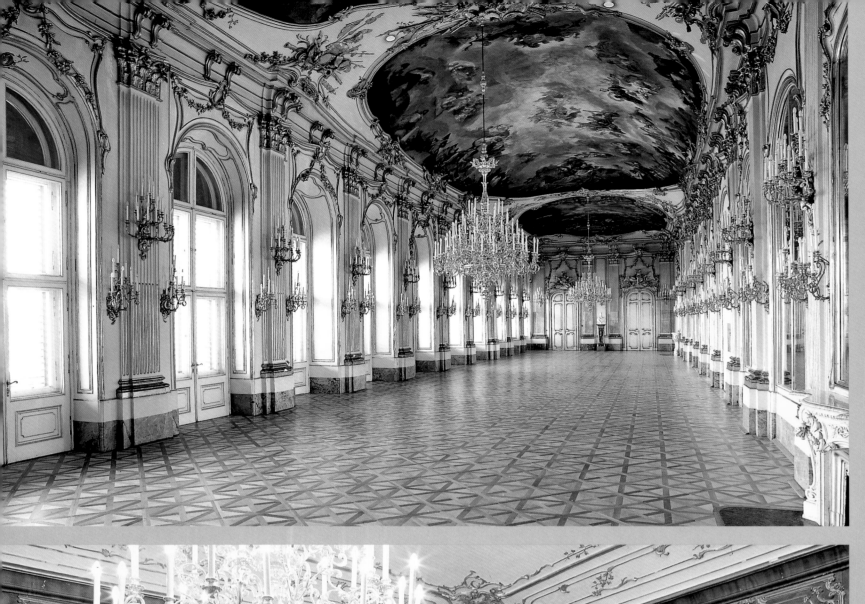

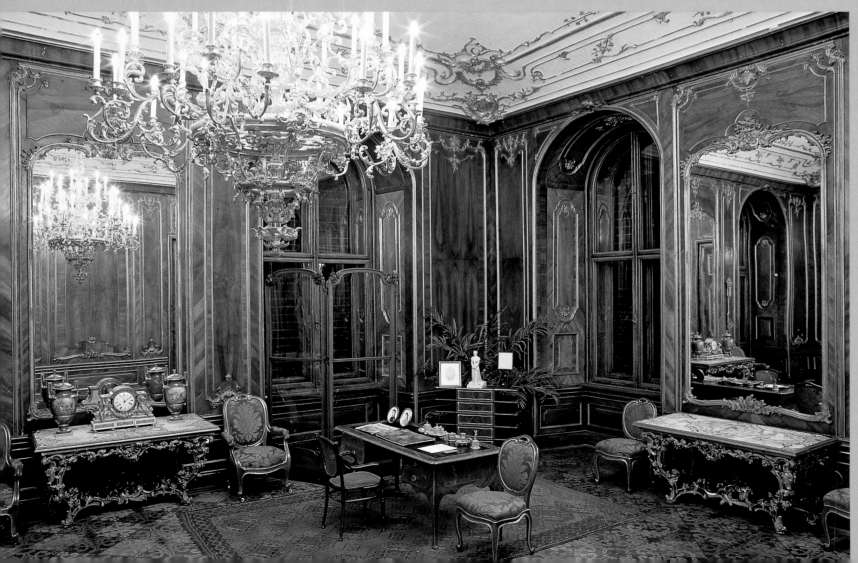

Left:
The Long Gallery, 43 metres (141 feet) long and 10 metres (33 feet) high, is the most sumptuous room at Schloss Schönbrunn and was where acts of state and lavish ceremonies were performed. The ceiling frescos depict Empress Maria Theresa and her husband Francis Stephen of Lorraine.

Below left:
In her dressing room with its walnut dressing table and desk Empress Elisabeth devoted hours a day to her appearance.

Below:
The Imperial Bedroom of Emperor Francis Joseph and Empress Elisabeth. The jacaranda wardrobes (not visible here) were a wedding present from Vienna's guild of carpenters. The emperor was a carpenter himself; Habsburg tradition required each member of the family to learn a skilled trade.

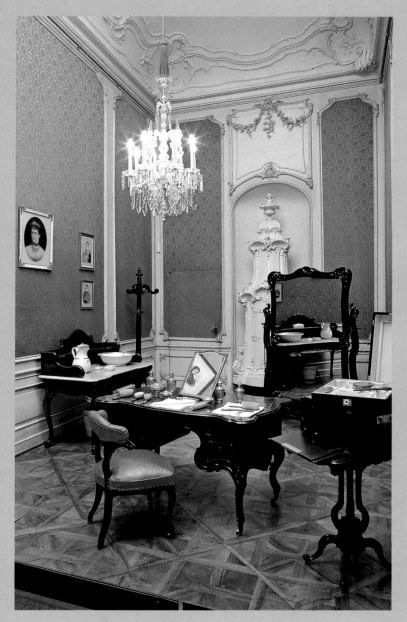

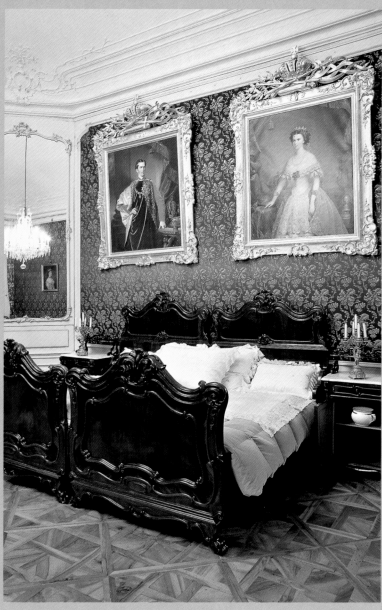

Left:
The palace has about 1,400 rooms, 40 of which are open to the public. Here in the Walnut Room Emperor Francis Joseph used to receive guests waiting for an audience with the monarch in the adjacent Billiard Room.

THE UNFORGOTTEN EMPRESS –
SISSI

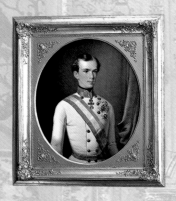
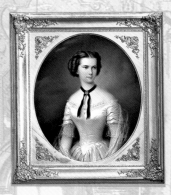

Above:
Portraits painted on the occasion of Francis Joseph's engagement to Elisabeth. His future bride was later to write: "Marriage is a senseless institution. As a child of fifteen one is sold and swears an oath which one does not understand, only to regret this for 30 years or longer and not be able to go back on it."

Centre:
After years at court the carefree young Elisabeth had become a reluctant monarch who longed for escape. Her sarcophagus in the vaults of the Capuchin Church, always respectfully adorned with flowers, is probably the last place she would have wanted to be laid to rest.

Right:
The face of the empress is a marketing goldmine, with her fine features found adorning t-shirts, mugs, calendars and even chocolates.

Dead for over a hundred years, fresh flowers are still laid on her tomb in the vaults of the Kapuzinerkirche. Empress Elisabeth of Austria has never ceased to fascinate her admirers. Her biography reads like a kitsch fairy tale, the stuff Hollywood films are made of, darkened by drama and tragedy.

Amalie Eugenie Elisabeth was born in Munich on Christmas Eve 1837, the second daughter of Duke Max of Bavaria and his ambitious wife Ludovika. In 1853 Elisabeth's older sister Helene was due to be engaged to the Austrian emperor Francis Joseph. The young monarch, however, just 23, fell instead for the 15-year-old Sissi. The couple were married in Vienna in April 1854.

Ludovika's sister Sophie, the emperor's mother, ran her imperial court with regimental discipline; Sissi abhorred royal protocol and obeyed under protest. In March 1855 she gave birth to her first child, daughter Sophie, who died at the age of two. In 1856 she had a second daughter, Gisela, and in 1858 produced heir to the throne Rudolph.

Sissi was heralded as one of the most beautiful women of her day and age. Her hair came down to her ankles; it took three hours a day to style and its weight gave her headaches. Her teeth were bad, causing her to keep her mouth closed, speak infrequently and mumble. 1.72 metres tall (5' 6"), she weighed just 50 kilos (8 stone), often surviving on a diet of beef stock and lemon juice. She was an accomplished horsewoman, worked out in her own gym and spent long hours out walking.

UNREST, MELANCHOLY AND DESIROUS OF DEATH

She avoided public appearances as she did her husband; she preferred instead to write poetry, learn languages and while away the hours with her beloved dogs and parrots. She suffered from depression and anorexia and contracted a chronic lung condition. In the winter of 1860, when she discovered that the emperor had had a num-

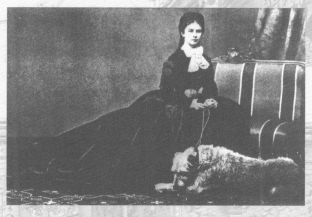

Left:
This photo of the empress at the age of about 30 shows a woman bursting with confidence. At her feet lies her loyal companion Shadow, an Irish Airedale who followed her wherever she went.

1837 – 1898

Above:
Elisabeth's assassination dominated front pages all over the world. Countless illustrated newspapers and magazines featured artists' impressions of her dramatic demise. Biographer Brigitte Hamann remarks that the murder "gave the world-weary, seriously depressed empress the painless death she longed for."

Above left:
This monument to Empress Elisabeth from 1907 stands in the Volksgarten. It shows her as she would probably liked to have been remembered – as a strong and beautiful young woman.

ber of love affairs, she left court and spent the following two years travelling in Madeira, Venice and Corfu where she had a palace built. Travelling became her life; in later years she avoided Vienna whenever she could.

Elisabeth's sole political interest was Hungary which since 1848 had strived for independence from Austria. She learned Hungarian and was instrumental in bringing about the Compromise between Vienna and Budapest. This created a dual monarchy with two capitals of equal status and in 1867 Francis Joseph and Elisabeth were crowned king and queen of Hungary. Ten months

later her daughter Marie Valerie was born whom Elisabeth loved dearly and insisted on raising herself.

In 1889 her son Crown Prince Rudolph and his lover Mary Vetsera committed suicide. The empress spent her last years travelling, mostly in-cognito, plagued by unrest and melancholy and desirous of death. On leaving her hotel on September 10 1898 anarchist Luigi Lucheni stabbed a file into her heart. Her sad life was over, summed up perhaps by the following line from one of her own poems: "Not a single soul ever understood me."

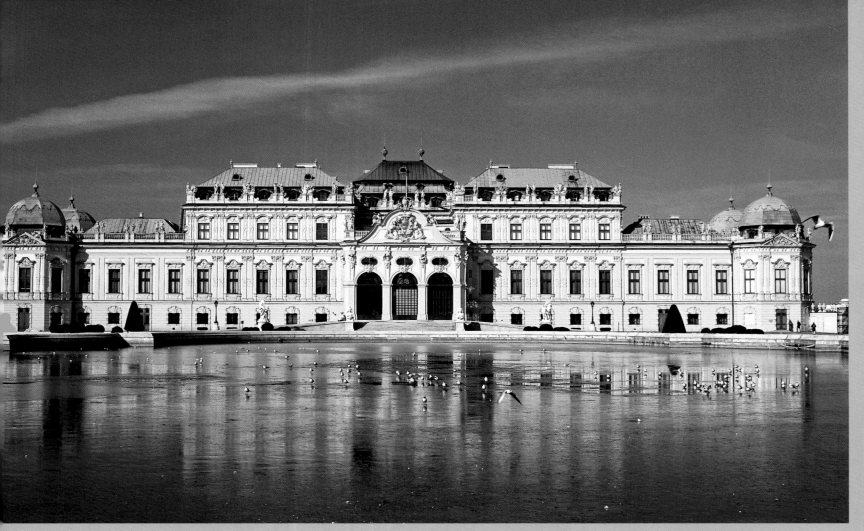

Above:
Oberes Belvedere is a master-piece by Lukas von Hilde-brandt, built in 1721/1722 for Prince Eugene of Savoy as a symbol of princely prestige. Standing on a slight incline, the original plans were for a Gloriette similar to the one at Schloss Schönbrunn.

Right:
Oberes Belvedere now houses the Österreichische Galerie containing works of art from the 19th and 20th centuries by artists who include Klimt, Kokoschka and Egon Schiele (shown here).

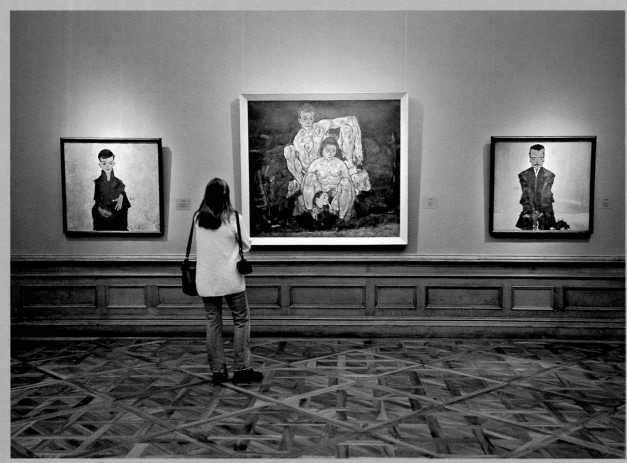

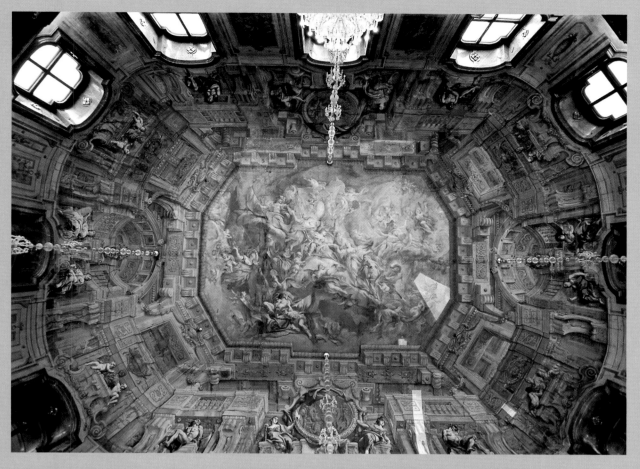

The ceiling fresco in the central hall of red marble at Oberes Belvedere is the work of Carlo Carlone and contains an "allegory of fame" to Prince Eugene.

It was in this marble hall that on May 15, 1955, the state treaty was signed in which Austria was again granted sovereignty. After much negotiation Foreign Secretary Leopold Figl was able to walk out onto the balcony and wave the treaty before a jubilant public, crying: "Austria is free!"

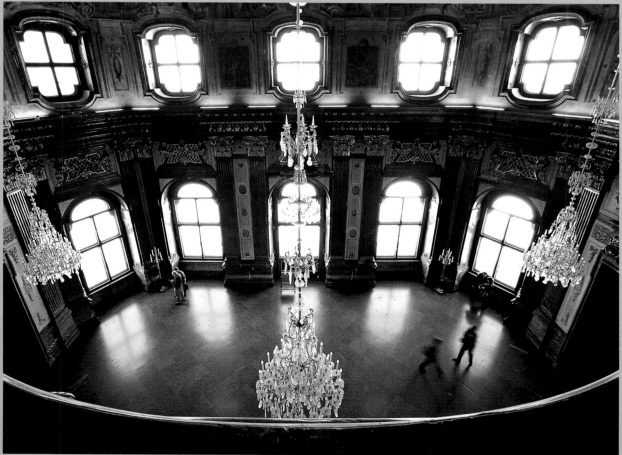

Below:
Unteres Belvedere was Prince Eugene's summer residence. It now holds a museum devoted to the baroque period in Austria. The palace's Golden Cabinet or Hall of Mirrors contains a splendid monument to the prince: Balthasar Permoser's "Apotheosis of Prince Eugene".

Top right:
The original figures (here Providence) adorning Georg Raphael Donner's fountain on Neuer Markt are cast in lead and have been moved to the Marble Room at Unteres Belvedere. The fountain now sports copies in bronze.

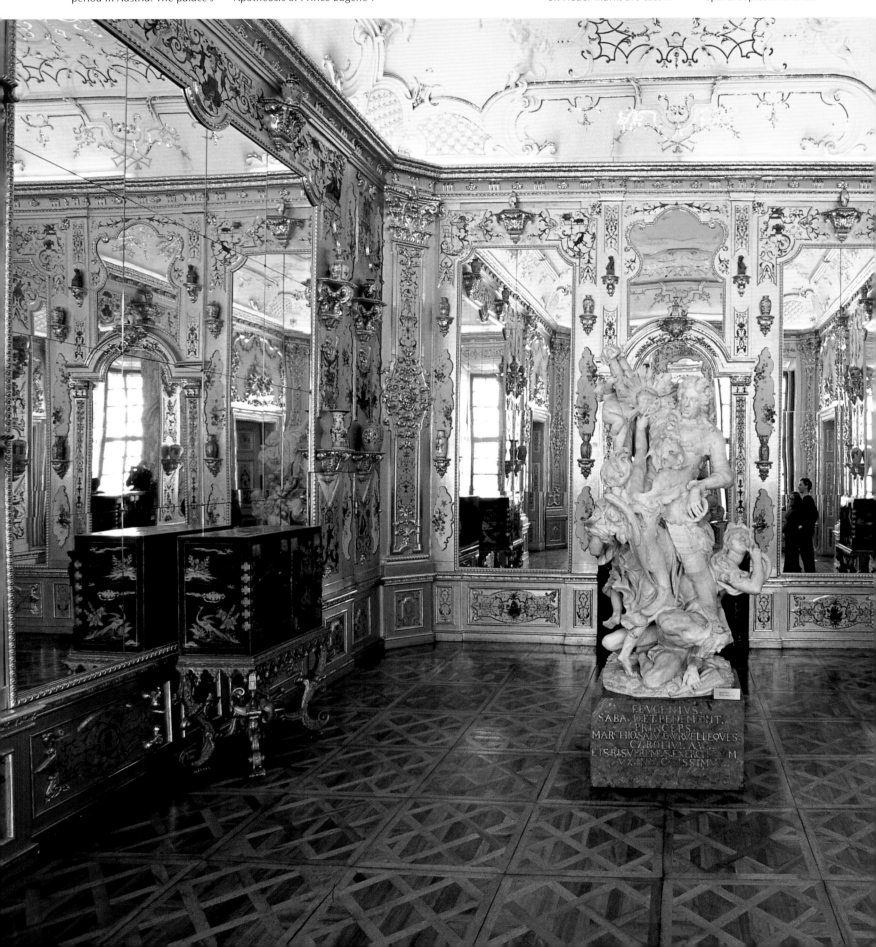

Centre right:
The Marble Gallery originally held Prince Eugene's collection of antiquities. Its rich stucco ornamentation and marble flooring no doubt provided an impressive setting for his exhibits.

Bottom right:
The decor in the Grotesque Room emulates the motifs of Ancient Greece and the Renaissance in Jonas Drentwett's festival of the baroque.

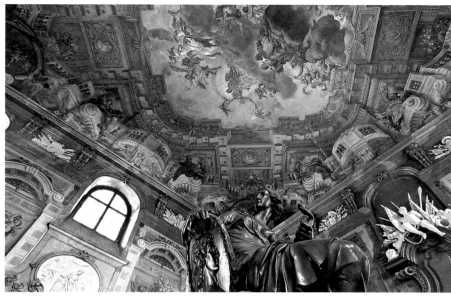

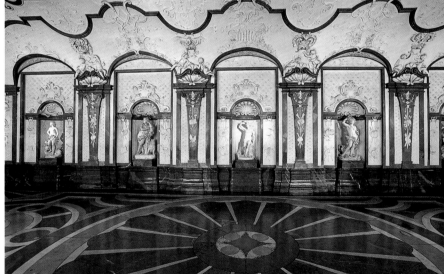

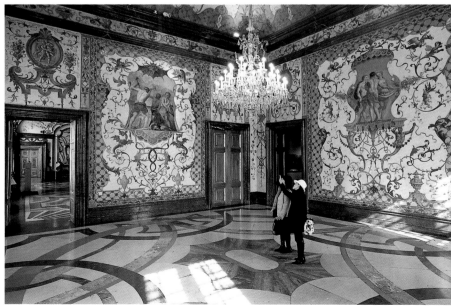

Above:
Count Johann Adam Andreas von Liechtenstein I (1657–1712) was one of the most prolific builders of his day and age. In Vienna he had two palaces erected in his name: the Stadtpalais (city palace) on Bankgasse and the Garten-palais (garden palace) on Fürstengasse. The latter is now the Liechtenstein Museum holding the art patron's private collection which includes 30 paintings by Rubens.

Right:
The museum also has plenty of baroque craftsmanship on display, such as Count Joseph Wenzel von Liechtenstein's Golden Coach, built by Nicolas Pineau in 1738.

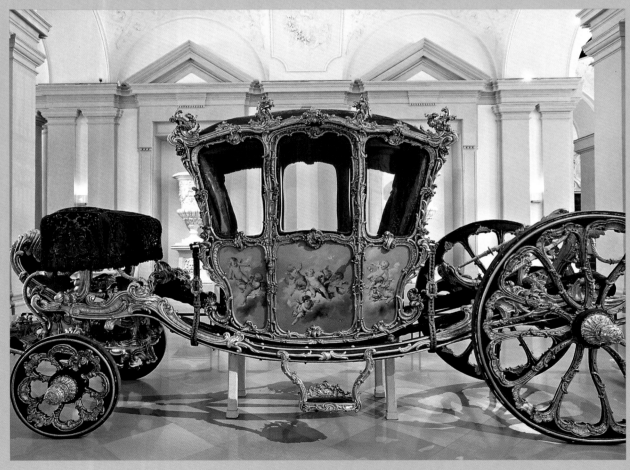

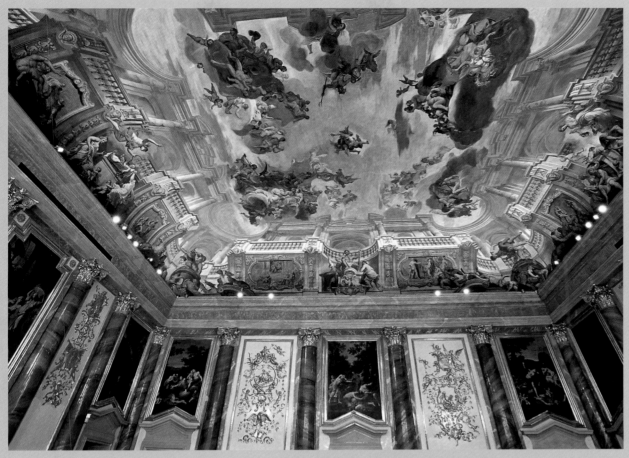

Left:
The Hercules Room of the
Liechtenstein Museum is
named after this ceiling fresco
of Hercules entering Mount
Olympus, the work of the great
master of the Roman baroque,
Andrea Pozzo.

Below:
The neoclassical library of the
museum has been preserved
in its entirety. The ceiling
frescos are by Johann Michael
Rottmayr.

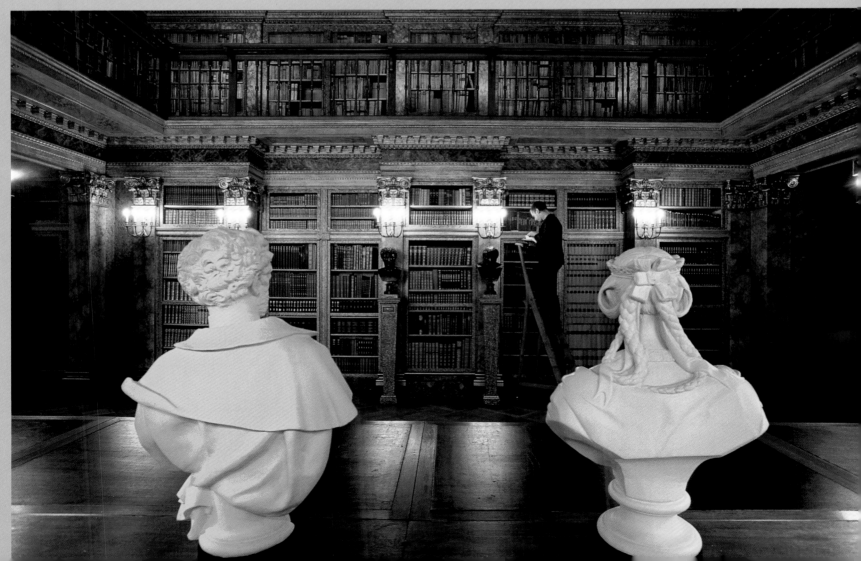

Between Rechte and Linke Wienzeile lies what is probably Vienna's oldest market: Naschmarkt. If you want to see Vienna as it really is, then this is the place to come. There's nothing edible the stalls don't sell. This is where the locals buy their fresh fruit and vegetables and specialities from all over the world, munching a sausage or two between stalls, some of which date back to the mid-18th century and are classified as a historical monument.

Sigmund Freud, the "inventor" of psychoanalysis, worked from this house on Berggasse. Through careful study of his Viennese patients Freud was able to develop his revolutionary theories on the human psyche in which, he ascertained, sexual drive played a major role. His practice has been turned into a museum: here the waiting room.

Above right:
Even Freud's original name plaque at the entrance to Bergasse 19, where he lived from 1891 to 1938, has been carefully preserved.

Below right:
One of Freud's standard works is "Traumdeutung" (The Interpretation of Dreams). His theories on the ego and superego greatly influenced the scholars of the 20th century.

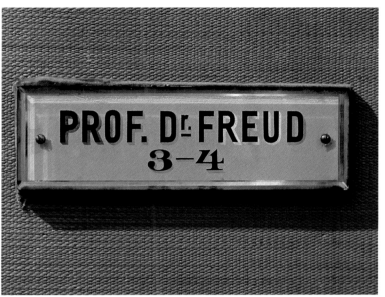

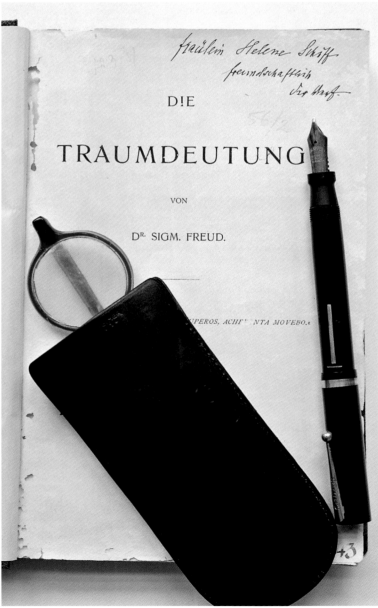

131

A PLACE TO DIE FOR –
DEATH IN VIENNA

Vienna and death go together like Sachertorte and cream. The Viennese are obsessed with their own demise; even their irrepressible "joie de vivre" is tinged with a morbid irony, the expression "Today's a day to die for!" not an uncommon utterance on a fine, sunny day.

Above:
This is the final resting place of Johann Strauß the Younger, king of the waltz and world-famous ambassador of Viennese music. He was buried under this splendid tombstone in 1899.

Centre:
The Biedermeier cemetery of St Marx is a place of beauty and calm, its elegant tombs a homage to the mortality of man. Appropriately now, it seems, this is where Mozart was laid to rest.

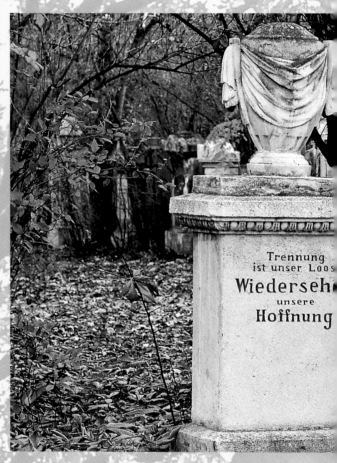

"I never go to bed without thinking – as young as I am – that I may not be here the next morning," Wolfgang Amadeus Mozart once wrote to his father. How right he was; when the composer died on December 5 1791 he was just 35. The funeral of the musical genius was simple but he was by no means buried in a pauper's grave as many believe. His body was blessed the following day at St Stephen's Cathedral, then taken by coach to the Biedermeier St Marx Cemetery a couple of miles away and interred in an anonymous grave as was common in Vienna during the reign of Emperor Joseph II. Where exactly isn't clear; a monument pays homage to the cemetery's most famous inhabitant. The other 6,000 headstones, romantically smothered in ivy, effuse a gentle melancholy – usually drowned out by the six lanes of motorway zooming past just outside the cemetery walls.

When in 1860 the existing graveyards were unable to cope with the deceased of the rapidly expanding metropolis the new Zentralfriedhof, the city's main cemetery, was laid out. Opened in 1874, it covers a surface area of 2.5 square kilometres (about one square mile), providing over three million people with a final place of rest. 500 work here and thousands make their private pilgrimages here on All Saint's Day to pay their respects. Local personalities are commemorated in honorary graves erected outside the Jugendstil Karl-Lueger-Gedächtniskirche.

CEMETERY OF THE NAMELESS

Perhaps the most moving place of rest in Vienna is the cemetery of the nameless. On the edge of town, along the banks of the River Danube, is a small field with the graves of those washed up by the current between 1854 and 1940. Compassionate locals gave the unknown a decent burial and to this day this simple graveyard is tended with loving care.

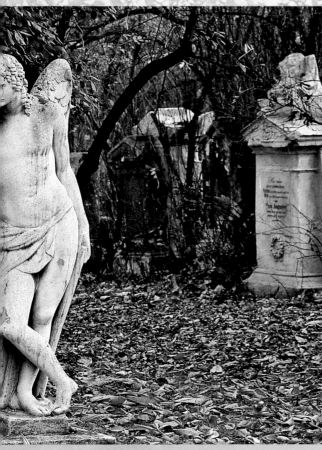

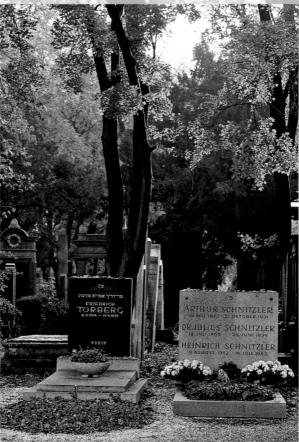

Vienna's preoccupation with death is epitomised by the weird and wonderful Bestattungsmuseum (Funerary Museum). Here the uninitiated can observe just how much pomp and circumstance goes into a proper Viennese burial. One of the more comical exhibits is the "alarm of salvation", a mechanism which was supposed to alert the undertaker if his charge turned out to be not

quite dead, and pictures of the black tram of 1918 in which twelve coffins could be transported simultaneously. Perhaps the most unique contraption is the 18th-century municipal coffin with its trapdoor bottom. In 1784 Emperor Joseph II decreed that the dead be buried naked, sewn into cloth sacks. The bottom of this practical receptacle opened up on the pull of a lever, unceremoniously jettisoning the body into the pit below. The emperor's decree elicited such a wave of protest that six months later he withdrew it. Another anomaly are the photographs taken by Albin Mutterer in the 19th century, who portrayed his models as if they were still alive – propped up in a chair, for example. The rather dry comment in the museum catalogue remarks: "There was no danger of the subject blurring the photograph."

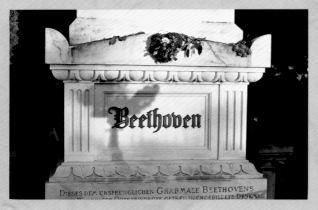

Enjoying the summer at
Amerlingbeisl, a tavern in
the suburbs serving good
simple Viennese cuisine and
excellent wines.

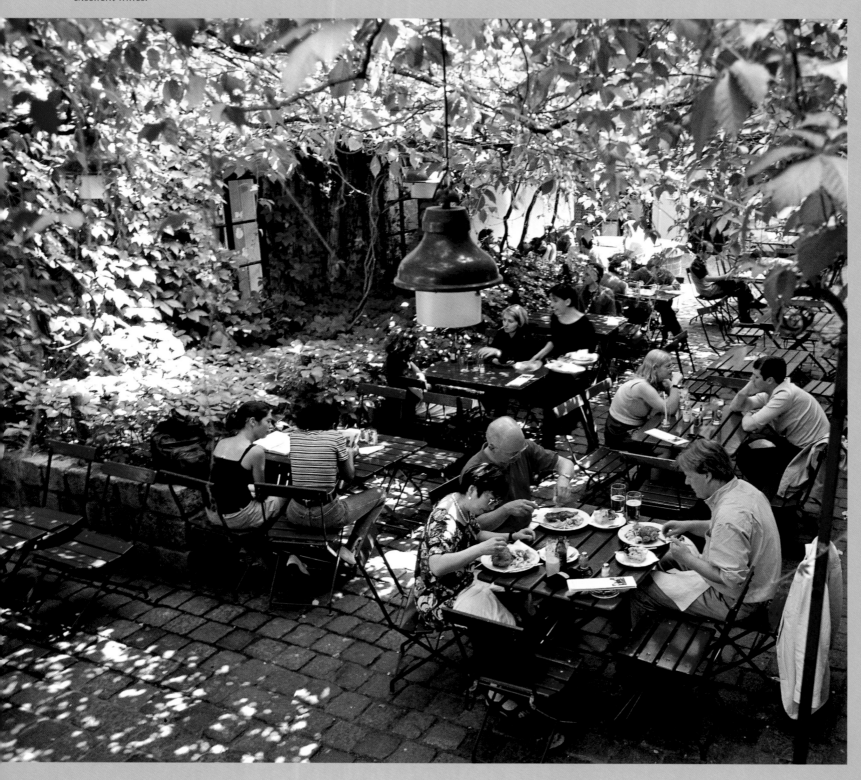

134

Vienna may be a bustling metropolis but in some corners life can be very quiet – exhaustingly so, as Hermann Bahr once wrote: "In no other city does laziness hold such charm, such great attraction, even such spiritualism ... Those who have idled away a day in Vienna are dead tired by nightfall."

Page 136/137:
Friedensreich Hundertwasser wanted to set contemporary architecture an example, turning what he considered to be "soulless" buildings into habitable edifices which pleased the eye and engaged the mind. His Spittelau power station, more fairytale palace than incinerating plant, certainly does just this.

Left and far left:
Leopoldstadt was once the booming Jewish quarter, home to the families Emperor Ferdinand II had banished from the centre of Vienna in 1624. Ca. 180,000 Jews lived in Vienna in 1938; by 1945 there were just 2,000 left.

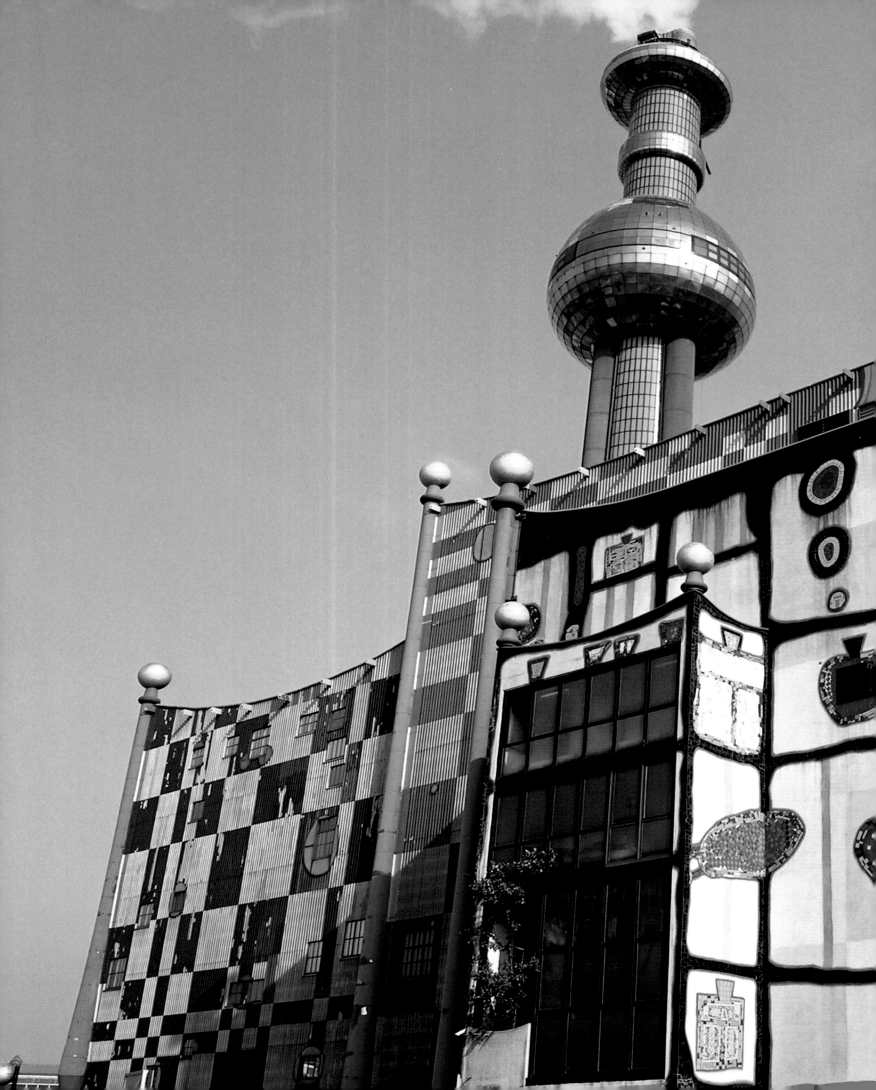

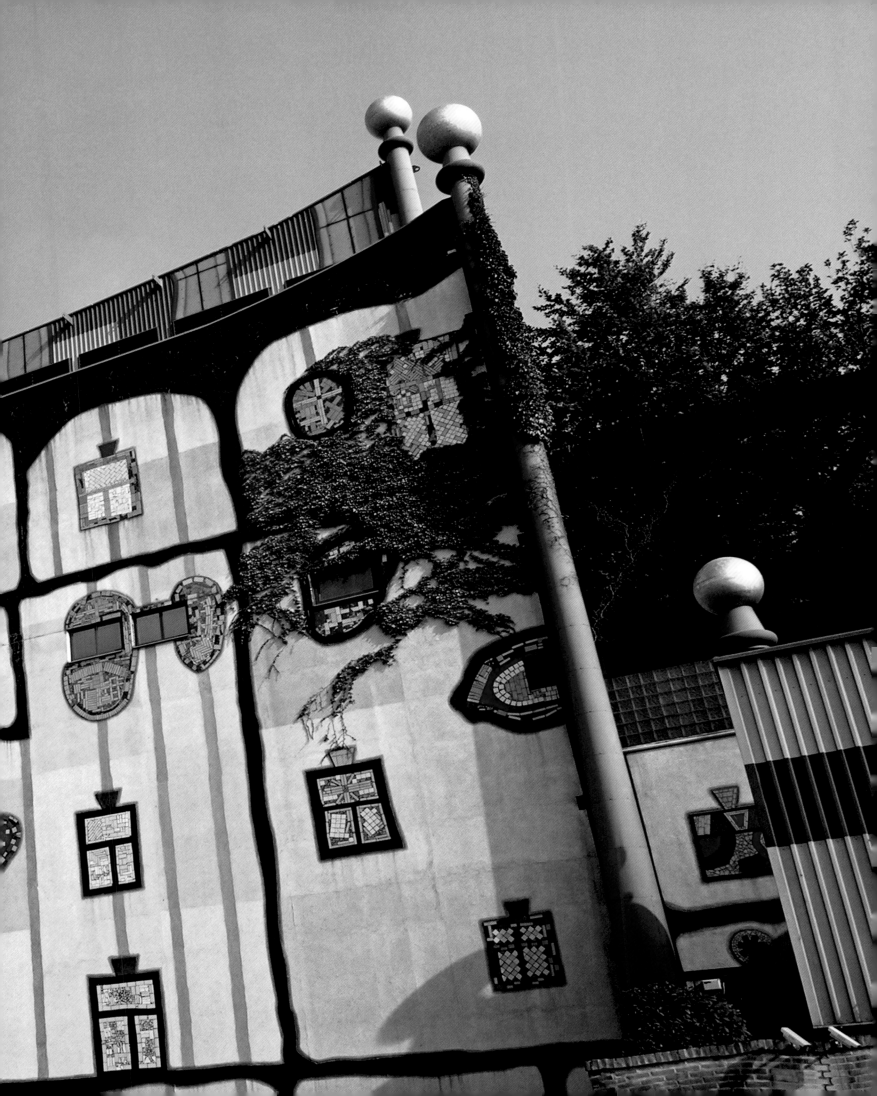

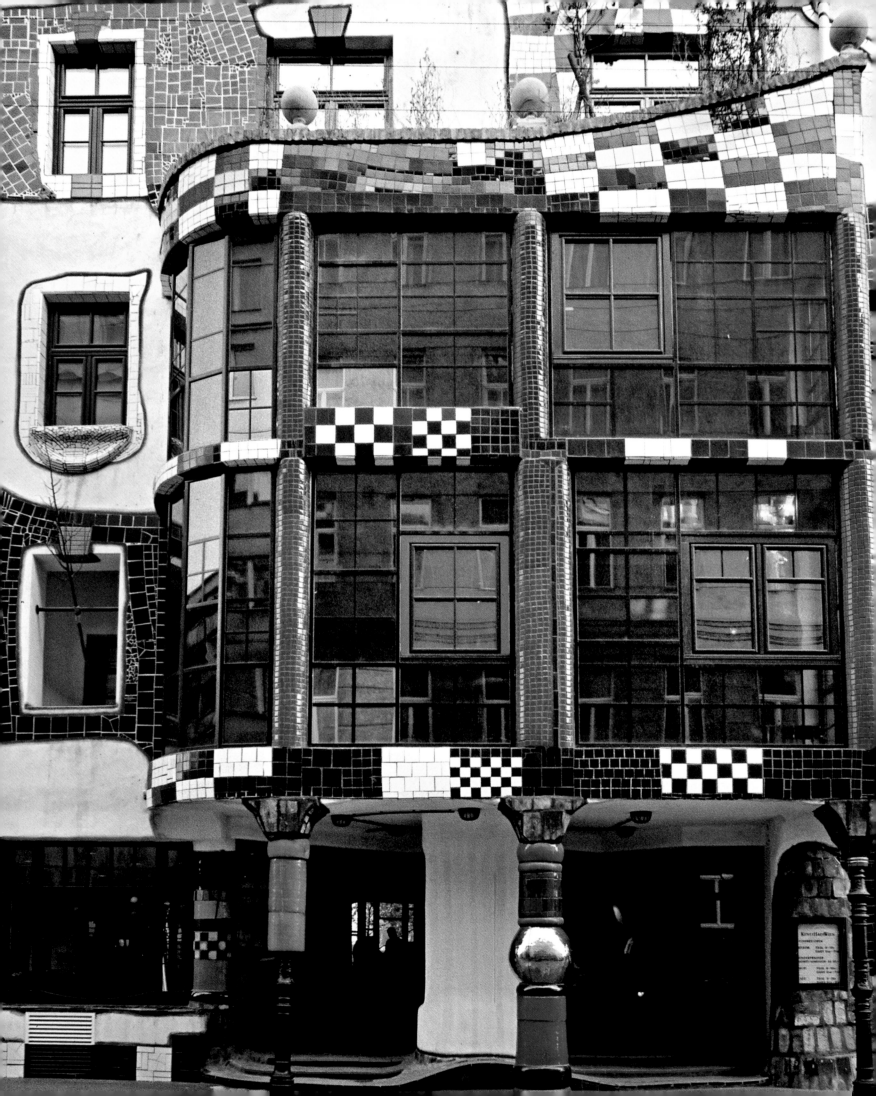

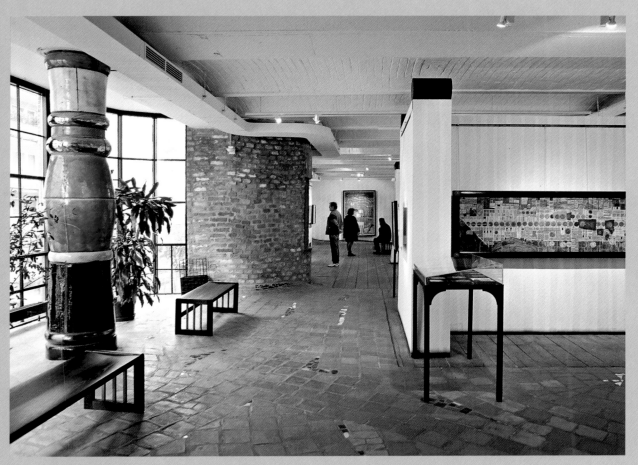

Left page and left:
The facade and exhibition at the KunstHausWien. The old furniture factory was bought by Hundertwasser and rebuilt in his extremely distinctive style during the early 1990s. Of the project he wrote: "The KunstHausWien is the first bulwark against the false order of the straight line, the first bridgehead against the grid system and the chaos of nonsense ... Art must again create lasting values [and have] the courage to be beautiful in harmony with nature. The KunstHausWien has set itself this ambitious goal."

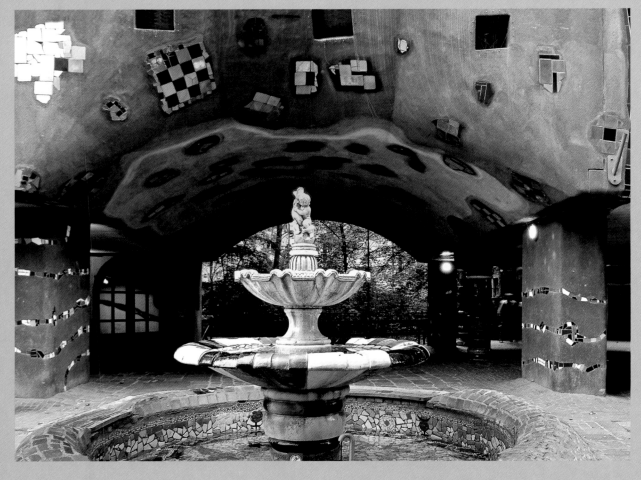

Left:
Between 1983 and 1985 Friedensreich Hundertwasser was commissioned by the city of Vienna to build a house which was devoid of synthetic materials. With its green roof, colourful facade, golden turrets and eight different types of window the Hundertwasserhaus on the corner of Löwengasse and Kegelgasse is a local landmark. Even the fountain is the work of the master.

Right:
Vienna may be the historic home of imperial pomp and splendour but it's by no means behind the times. These skyscrapers are definitely 21st century: here the Florido Tower.

Far right:
The Hochhaus Neue Donau by Harry Seidler is actually a block of council flats.

The Vienna skyline is dominated by skyscrapers, among them the Donauturm, UNO City and Seidler Tower.

Far left:
One of the highlights of contemporary architecture in Vienna is the Millennium Tower, at 202 metres (663 feet) the third-tallest building in Europe.

Left:
Coop Himmelblau's Viennese version of the Tower of Pisa: a dog-leg block of flats built onto Gasometer B in Gasometer City, where disused industrial holdings have been turned into chic homes and offices.

Right page:
What the Eiffel Tower is to Paris and Big Ben to London the Ferris wheel is to Vienna. In operation for over a hundred years, it has become the stuff of legend.

The giant Ferris wheel in the Prater park. In the final days of the Second World War it caught fire; half the cabins were subsequently removed for safety reasons.

Fun at the fair all year round – and nearly all day long, with the big wheel at the Wurstelprater funfair lighting up the sky at night like an enormous clock dial.

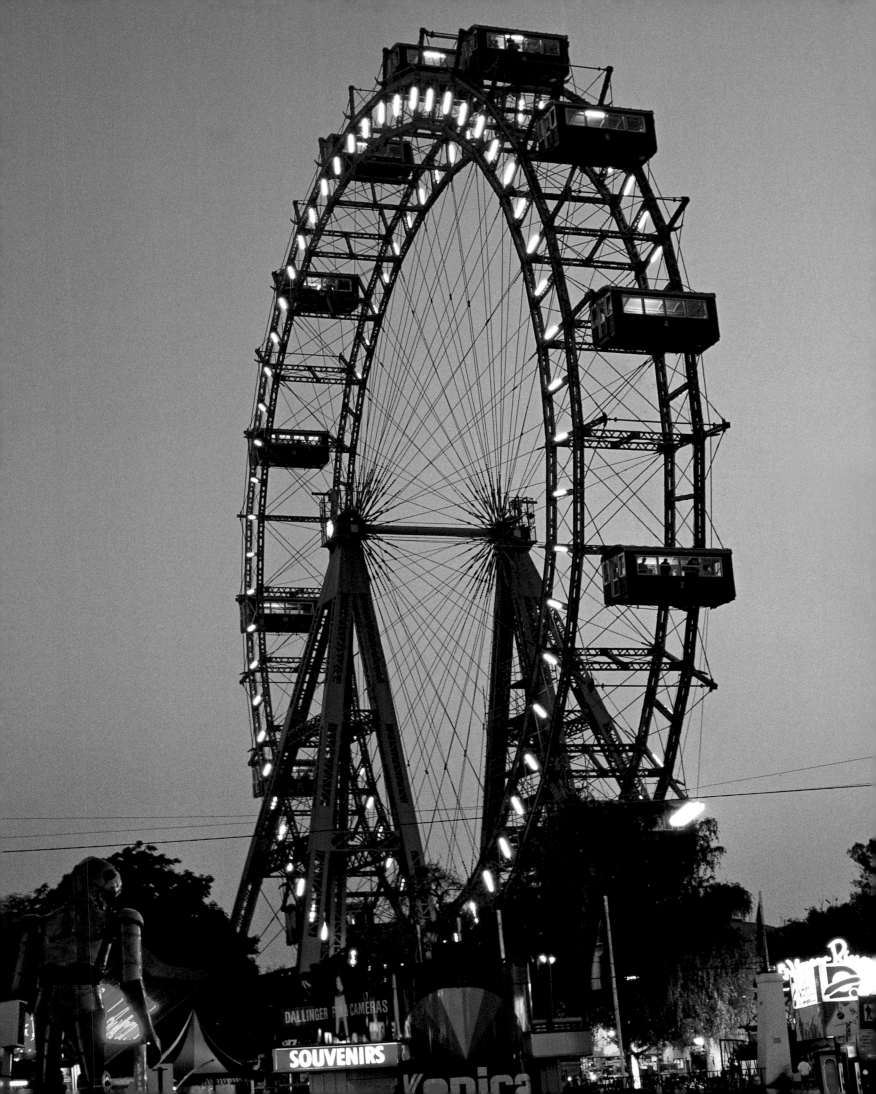

Top and centre left:
Locals at the Gelsenbar in
the Prater enjoying a quiet
drink and a good old chinwag.
The bar is named after the
mosquitoes ("Gelsen")
which plague guests here on
humid summer evenings.

Bottom left:
Sunday morning jazz with the Mrozil Brass-
band is guaranteed to get the day off to a
swinging start.

Below:
Heustadelwasser is one of the lakes in the
Prater where you can hire a boat or watch
the more energetic race round the shore.

Top right:
The little chapel of Maria Grün (St Mary's "in the green") was built in 1924 to mark the spot where a yearly pilgrimage took place.

Centre right:
Emperor Francis Joseph granted permission for this sculptor's studio to be built in the Prater with money from the state coffers.

Bottom right:
Just a stone's throw from the city centre the Prater is a great place to relax, go cycling, play tennis and golf – or even ride a horse.

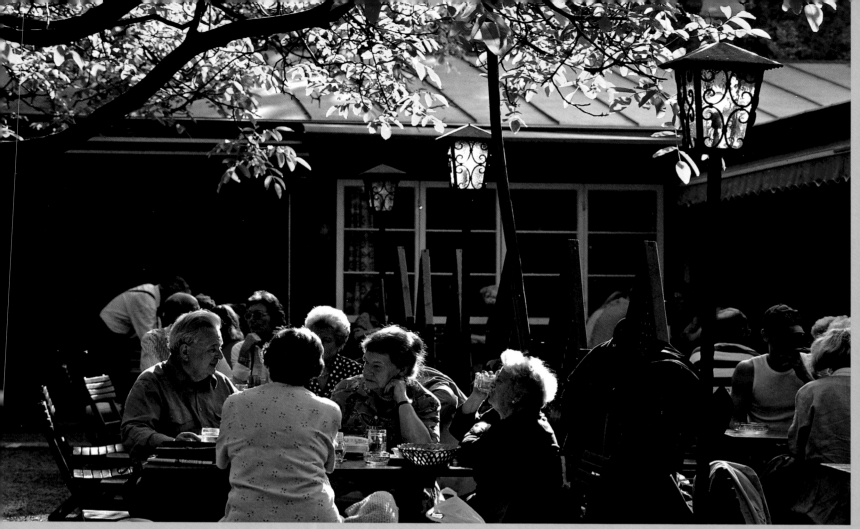

Above:
Another great Viennese institution is the wine tavern. This is the place to come to savour the year's new vintages out under the trees.

Right:
"Heuriger", new wine, is traditionally sold at a Straußenwirtschaft or private tavern run by the vintner at his vineyard, where simple food and a selection of vintages are also served.

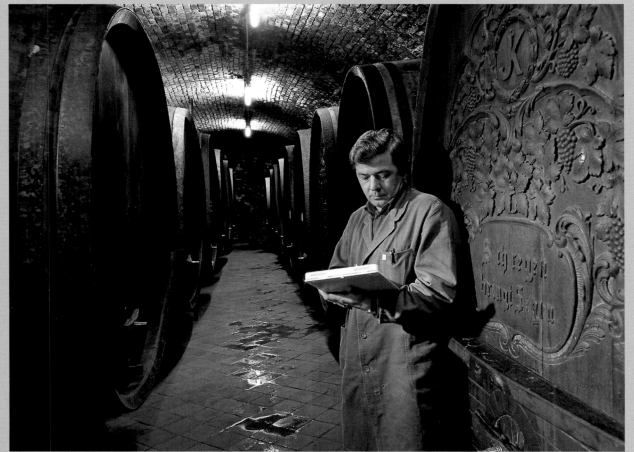

Above:
If you don't happen to be at a "Heuriger" when the village choir is giving its famous rendition of drinking songs (and there are many), then a summer evening tasting local wines by candle-light can be a quiet and romantic affair.

Left:
The cellarer at the Johann Kattus vineyard, once purveyors to the imperial and royal court, tests the maturity of the wines in his charge.

Right page:
A wine tavern on the edge of town on Sieveringer Straße, where you can come to wind down and relax after a long week at work.

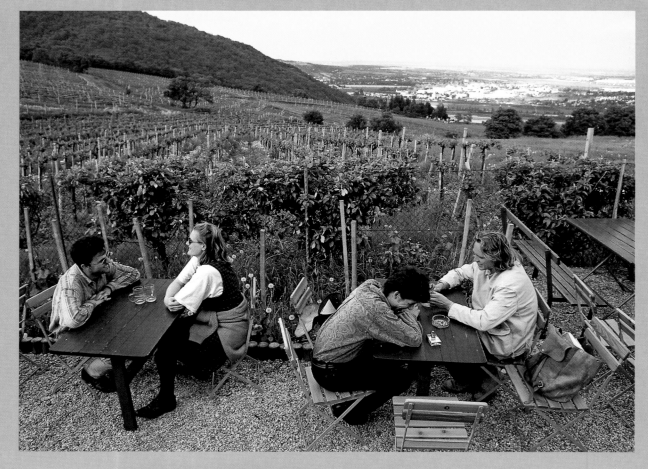

With vines almost growing onto the tables and magnificent views of Vienna in the distance, the Sirbu "Heuriger" on Kahlenberg is an idyllic spot indeed.

Right:
This 200-year-old statue of St Florian protects the Beethoven Haus in Heiligenstadt, now the Mayer am Pfarrplatz wine tavern, from fire.

Far right:
Entrance to a "Heuriger" in Grinzing where the wine tavern enjoys a particularly long tradition.

Far right:
This board on Naschmarkt isn't issuing a storm warning but advertising the sale of the new September wine, known locally as "Sturm", which is fully fermented by October.

Below:
Looking down from on high
at a tiny village beneath
the Kahlenberg, surrounded
by shady forest and lush
vineyards.

Small photos, right:
Right on their doorstep, the
Vienna Forest is extremely
popular with the Viennese.
In early summer the woods
of the Hermannskogel are

carpeted with wild garlic
(top). The high-lying plateau
of the Sophienalpe is an
eldorado for hikers and
mountain bikes (centre).

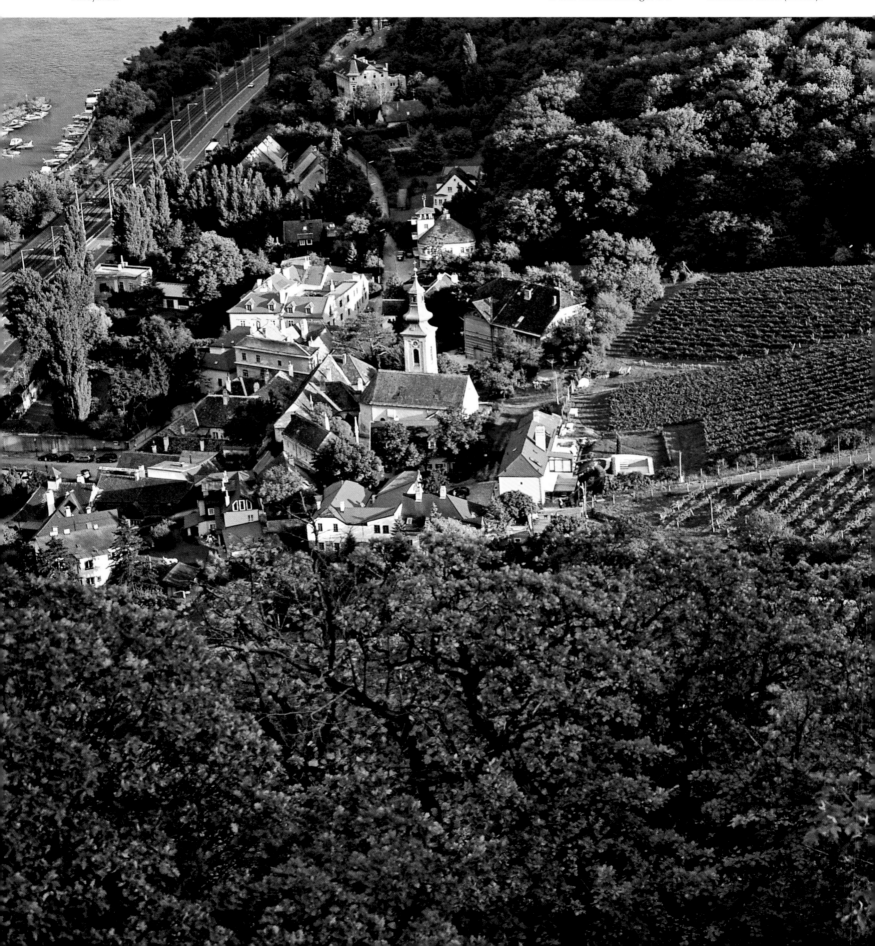

And on the sunny slopes of the Kahlenberg the vines positively thrive, introduced to the area by the Celts and Illyrians (bottom).

151

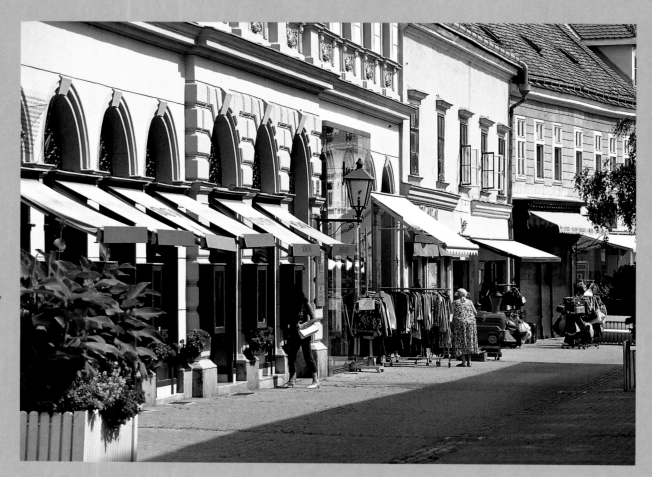

Right:
The southern part of the Vienna Woods is the "front garden" of Vienna, with the green countryside peppered with health resorts and wine villages. Baden, depicted here, is just one of the spa towns where the world-weary of the city come to take the restorative waters.

Below:
The village of Gumpolds-kirchen lies ca. 20 kilometres (12 miles) south of Vienna. The romantic village centre with its Renaissance wineries and arcaded town hall dates back to the 16th century.

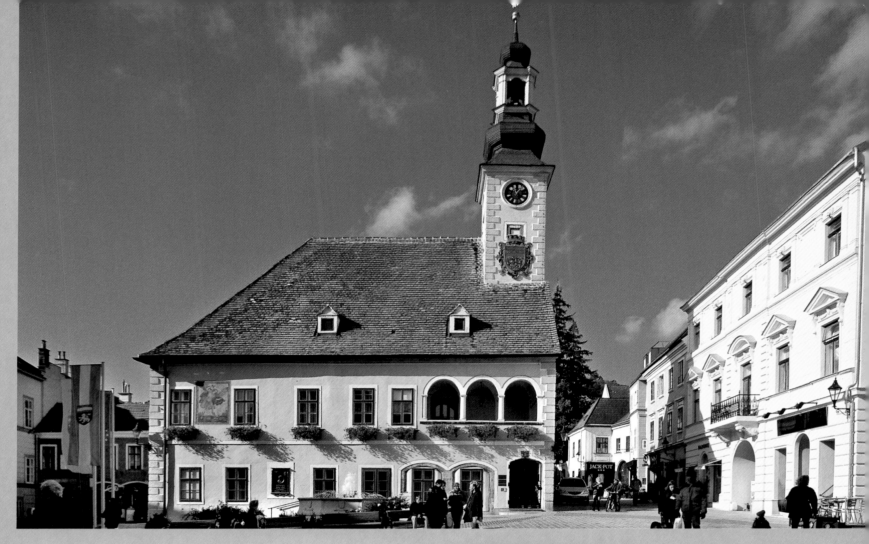

Above:
The Renaissance town hall in the heart of Mödling, lauded in all the brochures as the "pearl of the Vienna Woods".

Left:
The Wilhelminenberg rises up at the edge of the city, with the Hotel Schloss Wilhelminenberg perched on the summit. The 18th-century hunting lodge was rebuilt in the neo-colonial style in 1904 and turned into a hotel in 1988.

153

INDEX

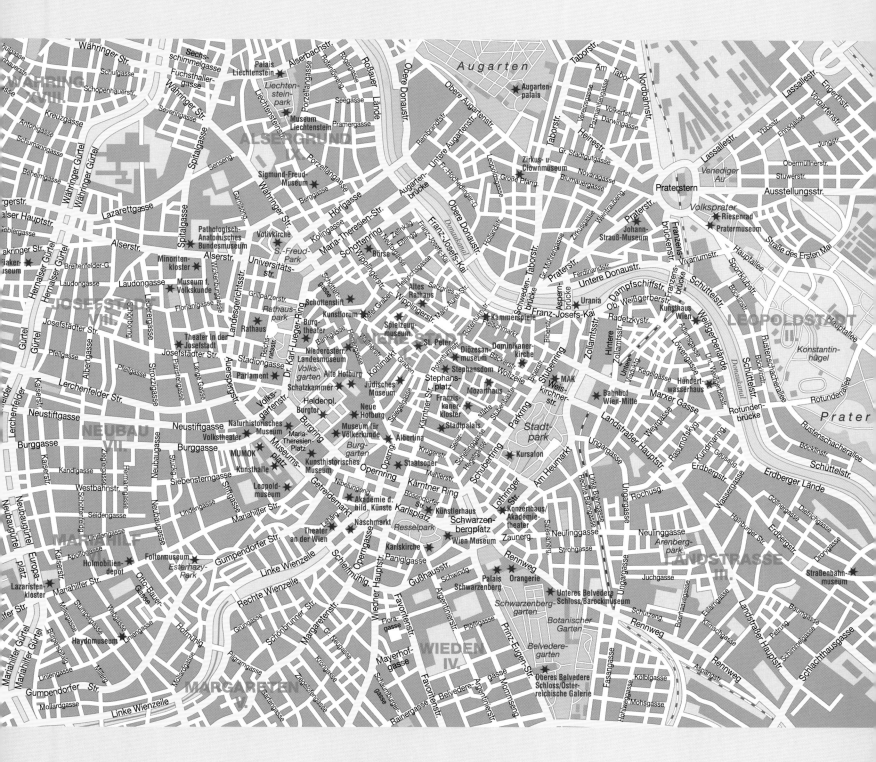

CREDITS

Design
SILBERWALD
Agentur für visuelle Kommunikation, Würzburg
www.silberwald.de

Map
Fischer Kartografie, Aichach

Translation
Ruth Chitty, Stromberg

Printed in Germany
Repro by Artilitho, Lavis-Trento, Italien – www.artilitho.com
Printed/Bound by Offizin Andersen Nexö, Leipzig

© 2009 Verlagshaus Würzburg GmbH & Co. KG
© Photos: János Kalmár, info@janoskalmar.at
© Text: Georg Schwikart

ISBN 978-3-8003-1957-2

Photo credits
All photos by János Kalmár except:
Schloss Schönbrunn, Kultur- und Betriebsges. m.b.H.:
p. 28/29, p. 84, p. 118/119 (4 photos).
P. 92/93: Luke Daniek/iStockphoto.com; p. 112/113:
Herbert Kratky/iStockphoto.com; p. 136/137:
Carsten Madsen/iStockphoto.com.

Details of our programme can be found at:
www.verlagshaus.com

A waiter serving a "Melange" coffee and plum flan on the Sophienalpe in the Vienna Woods. Jörg Mauthe once wrote of Vienna: "You can love it or hate it – or both. But you can't escape it."